3

769.9 SAV

PRINTS NOW

DIRECTIONS AND DEFINITIONS

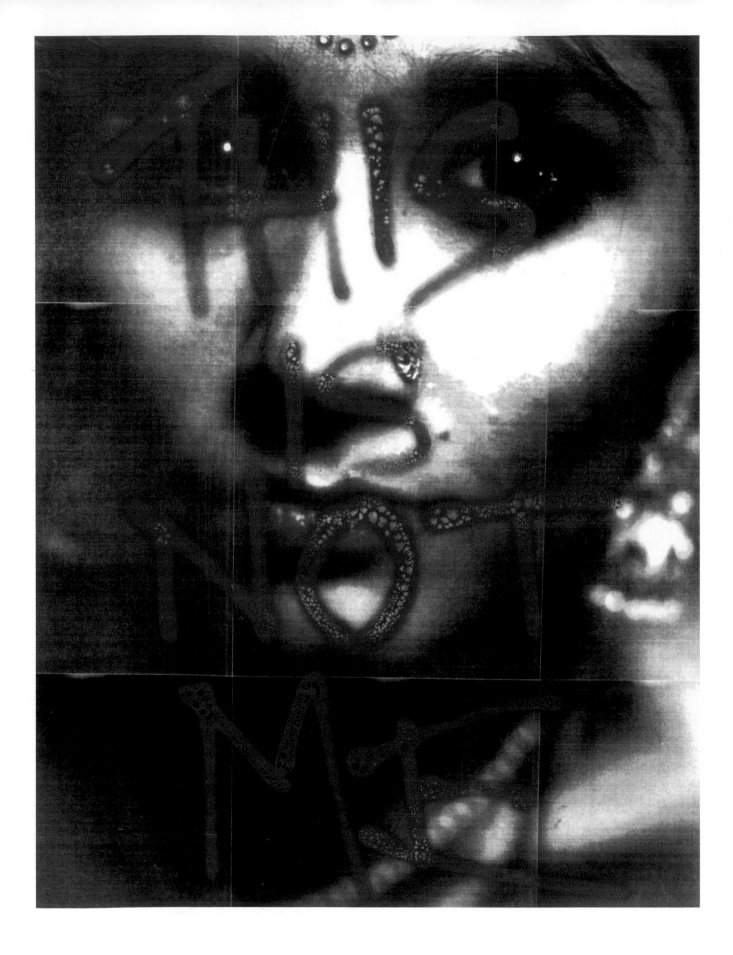

PRINTS NOW
DIRECTIONS AND DEFINITIONS

Gill Saunders and Rosie Miles

V&A Publications

First published by
V&A Publications, 2006

V&A Publications
Victoria and Albert Museum
South Kensington
London SW7 2RL

Distributed in North America
by Harry N. Abrams, Inc., New York

ISBN 1 85177 480 7

Library of Congress Control
Number 2005935061

10 9 8 7 6 5 4 3 2 1
2009 2008 2007 2006 2005

A catalogue record for this
book is available from the
British Library.

Catalogue & typefaces designed
by A2/SW/HK

New V&A photography by Ian Thomas,
V&A Photographic Studio

Back jacket illustrations, clockwise from
left: Sonia Boyce, *Umbrella* (1995); Beck's
beer bottles by Tim Head (1992), Damien
Hirst (1995) and Rebecca Horn (1994);
Ken McDonald, *Untitled* (1998); Kelly
Mark, *Everything is Interesting* (2003);
Anne Rook, *The Book of Golden Delicious
4021 and 4020* (2002)

Frontispiece: Chila Kumari Burman,
This is Not Me (1992)

Printed in Hong Kong

V&A Publications
Victoria and Albert Museum
South Kensington
London SW7 2RL
www.vam.ac.uk

For Julie

HOW TO USE THIS BOOK

This book has been arranged in chapters, each of which addresses a different aspect of print production, display and marketing, and each has been appended with a number of 'case studies'. However, these studies are frequently relevant to more than one chapter; thus, for example, **Willie Cole** is attached as a case study to the chapter 'Community-Based Workshops', but should also be considered in relation to the chapters 'New Media' and 'New Narratives'. The authors would like the reader to bear this in mind.

References to artists are made in **bold** where first mentioned in a chapter, thereafter in regular type.

Where footnotes refer to other texts full details are given in the bibliography.

CONTENTS

INTRODUCTION

Fine-art prints were once a peculiarly private art form, designed for connoiseurial contemplation, published in limited editions and hidden away in portfolios. The twentieth century saw the development of a more public role for prints, with the adoption of affordable processes such as linocut, and the production of editioned lithographs for public display such as those commissioned by J. Lyons & Co., as well as for the much-loved 'School Prints' series in the 1940s. Until the 1960s, however, printmaking was rarely an artist's main focus. For the majority it tended to be a peripheral activity, secondary to painting or sculpture. In the 1960s and '70s, the rise of print studios like Gemini GEL and ULAE in the United States and Kelpra Studio in Britain encouraged artists to explore the potential of printmaking, and to use it to produce works that represented major breakthroughs as creative statements, placing print, arguably for the first time, alongside sculpture and painting as a primary means of expression. Furthermore, printmaking – silkscreening in particular – was appropriated by artists such as Rauschenberg and Warhol for unique works on canvas, and 'combined' with painting and installation pieces. Thus the boundaries that once defined printmaking began to blur.

From the cutting-edge experiments of the 1960s, printmaking has developed in many new directions, and over the last twenty years prints have become more visible, accessible and affordable than ever before. No longer merely secondary, supplementary or reproductive, print is now a central part of many artists' activity, the equal of their output in other media, conceived as integral or complementary to it. The American artist Kiki Smith is an outstanding example, although there are many others. [1]

New technologies have been swiftly co-opted for fine-art printmaking, and traditional techniques have been supplanted and modified (and sometimes facilitated) by the photocopier, the fax and the inkjet printer attached to a PC. As the range of new media grows, some artists perversely seek to explore the untapped potential of more traditional methods, whether it be by printing on surfaces other than paper, by working on an unprecedented scale or simply by working in a way that expands the definitions of 'print'. The rise of new media – viewed by some as a threat to the future of printmaking –

has simply extended the options available. Just as the invention of lithography did not render woodcut and engraving redundant, and photography did not spell the end for traditional graphic media, so digital technologies have not replaced other methods, but extended choice and capacity. As one print curator has put it 'The zeal [...] to reach and stretch convention, coupled with other instances of protecting that old order, and the freedom to do either and find excellence in both, is the attraction that print-making holds today as an exciting and constantly challenging medium in the visual arts.'[2]

Printmaking is of course renowned for being a collaborative activity, and workshops and studios themselves have played a crucial role in the development of artists' ideas around print. The internationally renowned Fabric Workshop, Philadelphia and the community-based London Printworks Trust are just two of the organizations that have generated a range of imaginative print projects, collaborations, interventions and cooperative ventures.[3] In their own ways, both have used print as a strategy for social and political engagement, a policy which could almost be described as a mission statement for the London Print Studio. Meanwhile, the Rutgers Center for Innovative Print and Paper, attached to a university, encourages artists from under-represented communities into an environment where students can learn enormously from the new narratives these artists offer to the mainstream.[4]

Printmaking – especially processes such as woodcut and linocut, which are cheap and relatively easy to produce and require little in the way of materials or studio facilities – has also been adopted in cultures and communities where it was previously unknown, such as Botswana, the Torres Strait Islands and mainland Australia. This has been welcomed as a means of preserving or reviving traditional imagery, and of disseminating such imagery through the international (largely Western) art world, and equally importantly, participating in its art markets.

The audience (and the market) for prints has shifted radically in recent years. The connoisseur's appreciation of editions, states and proofs still holds sway, but much contemporary printmaking operates outside this structure. On the one hand there are artists making virtually unique works, such as Lee Wagstaff's *Shroud* prints or Ken McDonald's modified tramp's coat. On the other, the unlimited un-numbered edition – whether of an artist's wallpaper printed specifically for an exhibition, or of printed flyers, badges or carrier bags – is now commonplace. At the same time, with the adoption of print for site-specific projects, notably Thomas Kilpper's work at Orbit House, London, the various printed floors and facades by Richard Woods and public art commissions such as Julian Opie's drop-sheet concealing building works at a London hospital, the circumstances for viewing prints – and the definition of 'print' itself – have changed considerably. These developments, together with strategies such as self-publication, have taken prints outside the established critical context, the gallery system and the art market.

Indeed, prints may now be purchased from market stalls or vending machines, or over the Internet. Look carefully at your paper coffee cup, for it may be a public work of art. As stickers, magazine inserts, flyers and postcards, prints can be acquired at little or no cost. Even those visitors who were unable to afford anything from the 2003 Frieze Art Fair might have pocketed a copy of the re-issued London Underground map printed with Emma Kay's

specially designed target motif, and carried home a catalogue in a bag designed by Turner-Prize winner Jeremy Deller. There have also been opportunities to collaborate with an artist online, as in Peter Halley's project to produce a print from a series of image options which anyone could then colour to their own specification, and print out at home.

Another consequence of the many technical and conceptual developments is that printmaking is now disputed territory. The rise of artists' multiples and of print marketing via the Internet has led some to dismiss such editions as mere 'reproductions'. There has been some debate about whether prints produced by artists such as Damien Hirst, through the mediation of print publishers such as the Paragon Press, can be considered the equal of prints that are not only conceived by the artist, but also worked on and printed by them. This argument, however, may be thought parochial and has had little influence on sales, critical opinion or museum acquisition policies.

The tradition of artists working with and being dependent on the technical skills of master printers and specialist print studios is centuries old, even if it only became more obvious as a means of production with the establishment of major lithographic studios in the United States from the late 1950s. 'Originality' is really only a matter of degree, evolving with the changing applications of traditional processes and the introduction of new ones. Similarly, new tools such as the computer and the inkjet printer may be regarded simply as the means to an end – chosen for their own particular qualities and their potential to deliver what the artist has in mind.

All these innovations prompt the question: what is a print? It now encompasses everything from the stencilled guerrilla graphics of graffiti artists, to museum-sponsored billboards, appropriated or found material that is then modified, a cake iced with a laser-jet printed image, functional floors printed from MDF blocks with household emulsion, digitally manipulated screen-printed papers and 'paintings', as well as wallpapers and soft furnishings designed for installations. Printmaking has co-opted painting and sculpture, dress and domestic furnishings, commerce and cyberspace. Dynamic and democratic, the world of printmaking now includes the billboard and the badge, the masterpiece and the multiple, the priceless and the give-away. Prints are a vital and vibrant link between the museum and the marketplace, the elite and the everyday. *Prints Now* explores some of the new directions in printmaking today, and shows a selection of the many original and innovative works of art that fall within the ever-expanding definition of 'print'.

1. NEW MEDIA

Harold Cohen
(born UK 1928)
0305-03, 2003. Edition of 5
Digital print by AARON,
a computer program
written by Harold Cohen
127 × 90 cm
E.263-2005
Given by Harold Cohen

The history of printmaking has been marked by invention, innovation and technological advance, a process that continues to this day, most obviously through the various applications of computers.

Computer-aided printmaking, which has led to the development of the inkjet print, has seen dramatic advances over the last decade. A great deal has been published, especially on the Internet, on the different qualities of computer-aided printers.[1] They include non-impact inkjet, laser, solid ink, dye sublimation, thermal wax and thermal autochrome printers, in which no mechanism actually touches the paper; and dot matrix or character printers, in which pinhead mechanisms transfer ink from one surface to another by physical impact. This is not the place for a detailed analysis of the technical differences, but it is important to note that with all of these there are many factors that affect the final quality of the print.

The application of the computer to fine art became a reality in the mid-1950s with analogue computers, and in Britain computer-aided and computer-generated art was confirmed as a radically important movement through

11

the 1968 ICA Cybernetic Serendipity exhibition. Work with computers continued to spark growing art-school interest throughout the 1970s and '80s, although the status of the work as art was considered by some to be compromised by the close involvement of programmers, scientists and technologists. The United States led the field in experimentation, but some artists in Britain, notably **Harold Cohen** and **Paul Brown**, contributed significantly to progress.

Cohen's major contribution was the creation of AARON, a computer program utilizing artificial intelligence (the branch of computer science concerned with making computers behave like humans) as a means of exploring the capacity for expressivity of various programming languages. At first AARON produced drawings, which Cohen then coloured. More recently he has been able to modify the program so that the colours are also chosen and applied by AARON, resulting in digital prints that are the unmediated work of the program. Cohen insists that labels and image credits for these prints should read 'Digital print by AARON, a computer program written by Harold Cohen'.[2]

While he was studying at the Slade School, Paul Brown became involved with a group that used generative systems to produce works of art. Much of his subsequent work has made use of computer algorithms and routines known as cellular automata. The Iris giclée (another term for inkjet) print *Swimming Pool* (1998) was created using a computer technique known as 'tiling'. In the words of the artist, 'each tile is a cell in an automaton which develops over time according to some simple rules. The resulting image was a vector graphic, or line artwork, that was subjected to a number of continuous tone raster graphics filters to create the coloured and textured surface that composes the final print.'

Prescient collectors preserved some of this early work.[3] However, mainstream institutions and curators were slow to collect in this field; they were either suspicious of its credentials as 'art', its validity as 'print', or anxious about the life expectancy of the printing inks. Until the mid-1990s, museums and galleries acquired relatively few prints of this kind, and most prints that they did collect were images photo-mechanically transferred to traditional printing plates.[4]

James Faure Walker, who taught computer-aided art and design at the Royal College of Art from 1988 to 1992, and first printed digital images from

a computer-aided design around 1988, has identified artists such as Lawrence Gartel, David Em, Barbara Nessim, Joan Truckenbrod, Yoichiro Kawagucho and Anna Ursyn as leaders in the field of digital printing in the late 1980s.[5] Faure Walker's account of his progress from one printer to the next gives an idea of the rapidly shifting technology in the digital printing field. After borrowing an Okimate printer (which used a heat transfer rather than an inkjet process) linked to the Apple II,[6] he graduated in 1988 to a Xerox 4020, which was in fact an inkjet printer, linked to an Amiga (famously launched by Warhol); this was replaced around 1994 with an Apple A3 (from technology developed by Canon). He progressed to an Epson Stylus 3000, which can print up to A2 size, in 1998, and then to an Epson 4000. He began using an Iris printer in 1999, but since, as he says, 'these became virtually extinct a couple of years ago', he now works with an Epson 9600, which is highly accurate and able to print on sheets up to 44 inches wide.[7]

The Iris printer was developed in the United States in the 1980s for commercial use. After Apple were persuaded to take one into their research laboratory to link up with their computers, Iris printers really took off as a fine-art vehicle.[8] Master printer Jon Cone, who had been working with digital technology since 1986, acquired one in 1992 and rapidly built a following among artists, developing complementary inks and software for fine-art productions.[9] Over the next ten years or so Iris held a front-ranking position in the fine-art field, but it was gradually

superseded in popularity, maybe because it took only dye-based inks, which are archivally less stable than pigment inks.[10] However, the American artist **Willie Cole** did use one in 2002 for a major series of prints (see Case Study, page 120) although even then it may have been reconfigured.

There are several other printer names in the market place, Encad, Canon, Epson and Hewlett Packard being perhaps the best known in Britain. Each has its particular characteristics, which are responsible for different textures, colour and tonal values, archival qualities and dimensions of the finished print. **Peter Kennard** and **Cat Picton Phillipps** used an Epson 9600 to print *Award*, for example (see Case Study, page 22). In 1996 Susan Tallman heralded the potential of digital print while recognizing that 'as with photography, of course, inkjet or laser-printed images are not properly prints: there is no fixed matrix, no physical press of paper against a template.'[11] Nearly ten years on, however, the kinds of images that artists are creating through the use of digital manipulation via the computer can be (and often are) transferred to lithograph or screen with a very similar result to that given by the Epson or Iris printer. Purists may dispute whether inkjet is truly print, but the distinction seems irrelevant in current practice and has largely been glossed over by printmakers, curators and professional organizations such as the International Print Center in New York (which has regularly included inkjet and Iris prints in its selected print exhibitions). There are echoes here of the response to screenprint, which was rejected as

not 'original' by curators in the early 1960s on the grounds of its lack of 'gestural' or 'autographic' imagery. However, as print historian Pat Gilmour pointed out, 'it produced a new genus of print …. conceived in the terms of the medium'.[12]

In 1995 the group of art and design colleges known as the London Institute established a research programme into the application of computer/digital technology to printmaking. **Paul Coldwell** now heads this. When he started working with computers (also in 1995) 'they would crash every five minutes', but he speculates that 'the power in a conventional PC today with installed image-making programs is greater than that used to put man on the moon'. Aficionados of digital media, Coldwell and his fellow London Institute tutor **Charlotte Hodes** are nevertheless aware that the PC has limited students' opportunities for developing the manual dexterity that comes from practising traditional intaglio, relief and planographic plate-making; they therefore encourage the combination and integration of more traditional with state-of-the-art processes, a practice evident in Coldwell's own work (see Case Study, page 18).

Coldwell has also worked extensively with the Centre for Fine Print Research (CFPR) at the University of the West of England. The CFPR, led by **Steve Hoskins**, has been granted more than fifteen awards by the Arts and Humanities Research Council since its establishment in 1998. It is developing the fine-art applications of digital technology and other commercial

Catherine Yass
(born UK 1963)
Northwest D6, 2001
Printed by Chromograph,
Wolverhampton, and published
by the Alan Cristea Gallery
Edition of 40
Digital inkjet print
59 × 80 cm
E.1100-2002
Purchased through the
Julie and Robert Breckman
Print Fund
Courtesy the artist and
Alan Cristea Gallery

and industrial processes, particularly
the photomechanical collotype and
ceramic printing processes that have
all but died out in commercial use.
The CFPR has access to the very latest
technology and runs a programme
of artists' residencies through sponsor-
ship from Hewlett Packard. Among
those with whom it has recently worked
are **Cecilia Mandrile** (see Case Study,
page 24) and the grand old man of
computer-aided design (CAD) in Britain,
Richard Hamilton, on a new piece
relating to his ongoing engagement
with Duchamp's *Large Glass*. Arguably
Hamilton, more than any other
British artist, has led the way in
inspired use of digital technology,

and has described working at CFPR
as 'printer heaven'.[13]

The computer's capacity to layer
imagery, and to manipulate imagery
derived from other sources, makes it one
of the most useful tools now available
to artists and printmakers. **Julian Opie**,
for example, creates his painted and
printed images by drawing over photo-
graphs using a computer, to achieve
a final balance between the realistic
and the formulaic. **Catherine Yass** works
with photographic images that combine
both negative and positive. Her print
portfolio *Invisible City* (2001) consists
of six images developed from tiny
details taken from a single photograph

Chila Kumari Burman
(born UK 1957)
This is not me from
the suite of 8 images
Confrontations commissioned
by Walsall Museum and
Art Gallery, 1992
Laser print incorporating
car spray paint
77.9 × 59.7 cm
E.2070-1997

of a Tokyo street scene. The details were enlarged, each with positive and negative versions layered to create the final image, and then output as a suite of digital inkjet prints, characterized by vivid saturated colours.

While some artists were developing a practice that merged digital printing with computer-aided design in the early 1990s, others were using analogue laser printing. This had been developed from photocopier technology and was first marketed in 1984. The process relies on a laser beam creating an electrostatic image on a charged photoreceptor, which then attracts the powdered ink or toner to its design. Susan Tallman's caveat regarding the definition of print (see page 13) would apply here too, but although the process is allied with photography, it cannot be properly described as such. Although popular with artists and photographers (notably Helen Chadwick, 1953–96, for whom it became a primary medium), the peculiar cultural undercurrents implied in its use have been overlooked by many.

Chila Kumari Burman, however, is an exception. Speed and accessibility (machines could be found in the high street, and in offices) enabled her to manipulate a single self-portrait image into numerous variants of colour and scale with relative ease, to suggest the conflict between assumptions about the social and behavioural positions that black and Asian Britons have been expected to assume over the last thirty years or so, and those that they actually have. Burman used laser printing in works such as *28 positions in 34 years* and *This is not me* (in which car spray-paint graffiti simultaneously negates and proclaims the artist's existence). Both are dated 1992. Her approach was one of the most intelligent and aware, not only of the technical potential of the medium but also – by favouring it over more conventional fine-art printmaking processes – of what it could convey about popular culture, style and stereotyping.

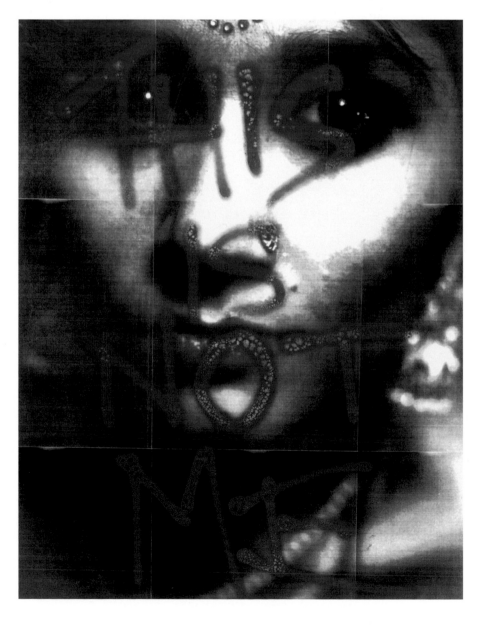

Richard Hamilton
(born UK 1922)
*Just what is it that makes
today's homes so different...*
QED, 1993
Distributed by the BBC
Edition of 5,000
Laser print
17.6 × 26.7 cm
E.1075-1993
Given by the artist
© Richard Hamilton 2005
All rights reserved. DACS

Richard Hamilton's now iconic image of Pop culture, '*Just what is it...*', a poster for the 1956 exhibition *This is Tomorrow,* was a collage of magazine cuttings, made up as a domestic interior furnished with state of the art objects of desire – vacuum cleaner, tinned ham, TV and so on – inhabited by a famous muscleman suggestively sporting a giant lollipop and a pin-up girl in a lampshade hat.[14] In 1992-3, at the invitation of the BBC, Hamilton used a new computer program, brought the icon up to date and distributed it as a laser print, as his ultimate riposte to the numerous pastiches it had suffered over almost four decades.

In *Word Not Found* (1995), **Lubaina Himid** exploits the layering of imagery possible through laser printing and puns on the gendered and racialized constraints on access to knowledge through computer programs and sup-posedly educational textbooks. Using the laser process, she was able to layer images taken from medical encyclope-dias, herbals and treatises on witchcraft over sheets copied from an atlas. The result forms an enigmatic commentary on the classification and control of populations and their various cultural practices, by colonization, chauvinism or religious fundamentalism, across the world.

Other new media – or new at least to fine-art printmaking – include lenticu-lar plastic, which has already been used in advertising. Basically an overlay of ribbed plastic 'lenses', this is used to 'animate' or give an illusion of depth to a conventionally printed image. It has been put to spectacular effect by **Julian Opie**, who has used it to make a singular printed image the equivalent of his computer films, showing single figures in motion (see Case Study, page 26). Painter **Dan Hays** has made a lenticular print (*Sanctuary*) as a multiple (published by the Multiple Store); his use of it suggests not so much that the image is moving (as Opie does) but more that the object depicted – a hamster cage – is a three-dimensional object existing in real space, not merely a two-dimensional representation.

While many traditional fine-art print and photography studios have taken on digital equipment, some commercial studios catering to the business market are now taking fine-art production in a new direction. Omnicolour, located near Chancery Lane in London, special-izes in cutting-edge digital technology, and works in tandem with K2 Screen (as the name implies, a screen-printing business), which shares the same building. With a personal enthusiasm for contemporary art on the part of the directors, the partnership regularly produces the increasingly popular editions by public galleries (see Case Study, Chris Ofili, page 136), as well as other public art commissions (see Chapter 6, page 78, Chris Ofili and Oscar Wilson; and Chapter 7, page 95, *Is Art Beneath You?*).

PAUL COLDWELL

(born UK, 1958)

Case Studies, 2002
Printed and published
by London Print Studio
Edition of 20
Etching and blind
embossing from a CAD
Plate 17.8 × 23.7 cm
E.165-2003
Purchased through the
Julie and Robert Breckman
Print Fund
© Paul Coldwell

Below:
Night Sky from the suite
of 8 plates *Constellations*, 2002
Printed by Barbara Rauch
at Camberwell College of Arts
Published by the artist
Edition of 7
Digital inkjet print
from a CAD
34 × 45 cm
E.164-2003
Purchased through the
Julie and Robert Breckman
Print Fund
© Paul Coldwell

Paul Coldwell heads a leading research programme at the University of the Arts, London,[15] on the integration of computer technology into fine-art practice. His own work involves layering and integrating techniques as different from each other as drawing and photography, to ultimately produce a print that may be an inkjet print, but could as easily be a screen-print, lithograph, etching or a combination of any of these. The journey – from original source materials, repeatedly modified and reformed – to final print, could almost be read as a metaphor for his imagery, which reflects upon the plight of refugees, migrants and others for whom staying put is not an option.

This said, Coldwell's imagery can sometimes be interpreted as hopeful. In *Constellations* (2002), a suite of eight digital prints of domestic still lifes featuring, for example, basic foodstuffs and household cleaners, he superimposes on each group of objects the pattern of an astronomical constellation. This is made by joining points in a screen of half-tone dots that have been varied in prominence and colour through computer-aided manipulation. The layered imagery signifies the feeling of being in two places at once, the mundane here and now, and a more aspirational reaching towards the distant and unknown.

Case Studies, however, although made with formal devices similar to those used in *Constellations*, is less ambivalent in its message. *Case Studies* addresses the condition of exile and homelessness through the ironic use of a tourist postcard (the kind sent to friends to announce the pleasure of being away from home) showing mountain scenery, to suggest a distant homeland. The diagrammatic outline of a floating, open, empty suitcase is the poignant constellation here, invoking both the idea of travel and the idea of travelling with nothing. The pixels of the original image have been manipulated to create a pattern of dots through which the mountains are barely recognizable; one feels a need to reach for a control and bring them into focus. As in *Constellations*, other dots have been enlarged. These have been deep etched after transfer to the etching plate and thus, as white and embossed 'stars', they appear to fall in front of, rather than beyond the mountains. Their physical substance against the depth of the picture space creates a kind of 'inside-out nature' suggesting that landscape, and by association, homeland or distant sanctuary, is something beyond reach, less accessible even than the stars themselves.

19

PETER HALLEY
(born USA, 1953)

Exploding Cell, 1997
Digital inkjet prints, printed
by Gill Saunders from online
programme, 2005

Computer-generated – or computer-manipulated – imagery is now commonplace in printmaking, and artists have used this facility not only to make conventional prints, but also to create artworks which can be viewed only in digital form and have no output version, even though there may be capacity for interactive engagement with the work.

Peter Halley has experimented with alternative uses of the Internet, and published his first online project in 1993 at www.thething.org, following this with a Web-print project designed to exploit the interactive potential of the Internet. As part of his exhibition *New Concepts in Printmaking #1* at the Museum of Modern Art (MoMA), New York in 1997, he devised *Exploding Cell*. Visitors to the site (www.moma.org/onlineprojects/halley) were able to select features and colours for a composition by Halley, which they could then 'sign' alongside Halley's facsimile signature and print out at home.

The *Exploding Cell* print adapts the cell and conduit motifs that have been constants in his paintings since the early 1980s, when he emerged as part

of the Neo-Geo tendency of geometric abstraction in New York. These images are intended as equivalents for the covert systems and ideologies that underpin and influence post-industrial society. The original sequence of nine screenprints from which he generated the online imagery read as a comic-strip narrative, showing a cell mutating from intact entity through contamination and explosion to dissipation and obliteration.

Halley has talked about the new emphasis on collaboration in creative production, a development that he considers 'pretty exciting', although he also admits to being disturbed by the 'utopian claims being made for the Internet',[16] the primary tool of this collaborative ethos. Although it is on one level a metaphor for the breakdown in social structures which, ironically, has been accelerated and exacerbated by the Internet, the *Exploding Cell* Web project also endeavours to reach out and engage the isolated individual in this fragmented society in a collaborative exchange, offering a virtual thread of connectivity with a tangible outcome in place of the ephemeral on-screen activity.

Still hosted on the MoMA website, *Exploding Cell* has lost some of its interactive potential and thus its capacity to connect, since it is impossible to print from the site with today's most commonly used browser, Microsoft's Internet Explorer. Now, inadvertently, it also symbolizes the redundancy so often generated in society by technological advances.

PETER KENNARD
(born UK, 1949) and

CAT PICTON
PHILLIPPS
(born UK, 1972)

Plate 2 (below) and Plate 15
(facing page, detail) from the
boxed set of 15 plates *Award*, 2004
Printed by the artists in an edition
of 100 at K and C Printmakers
Published by the Martello
Press in association with Henry
Peacock Press and Gimpel Fils
Digital inkjet prints from an
Epson 9600 on Hahnemühle
cotton rag paper
Each sheet 46.4 × 35.9 cm
E.237.7-2005 and E.237.20-2005
Purchased through the
Julie and Robert Breckman
Print Fund

Over almost forty years, Peter Kennard's brilliant juxtapositions, integrations, over-layering and editing, chiefly on issues around armaments and poverty, have been published everywhere – in the press, and on posters, leaflets and banners. He could convincingly claim to be one of very few artists who have politically influenced public opinion and government action. Through his chosen medium of photomontage, he has in many respects anticipated much computer-aided design (CAD) but now he feels that maybe photomontage has had its day, having been effectively superseded by the speed and facility of CAD processes. Thus, teaming up with Cat Picton Phillipps, whose technical skills made the whole project possible, Kennard set out on one of his most ambitious projects to date, a fifteen-plate digital inkjet suite addressing the war in Iraq.

For this suite Kennard and Phillipps researched the *Guardian* newspaper's photography archive. Kennard also purchased old war medals from a stall in Camden Market and 'distressed' them, tearing and fraying the ribbons and partially removing the actual medal:

We had been on anti-war demos. Now the flatbed scanner became our stage on which we could let rip with our feelings of outrage ... We were told the war [in Iraq] was over, as the Occupation continued with more killing and torture we covered the scanner with the grit and grime of the street outside our studio, asking how to represent this filthy war from a street in East London.

As the Occupation became filthier our prints became denser and denser. The scanner became like an etching plate and through using the newest technology our practice became strangely more and more connected to printmakers of the past. We looked at Rembrandt and Goya etchings, at how the etching, aquatint and drypoint layers on their metal plates became our dust and fabric, set layer upon layer on the computer. We looked at how their etchings developed from state to state, becoming darker, denser and more concentrated. Some of our prints went through twenty states, becoming more and more imbued with physical matter. We gritted the scanner; bled on it; threw torn-up rags, flags and ribbons on it; poured oil, then stamped on the stuff, burnt it and spat on the lot. On some of the images we used photographs taken with great bravery by documentary photographers in Iraq. Their commitment to keeping us informed often showed us the extreme degradations that this war has brought upon the Iraqi people.'[17]

CECILIA MANDRILE
(born Argentina, 1969)

Doll from *Strategies for Departure* project, 1998
Digital inkjet print on cotton cloth, acrylic stuffing, thread, found object
Irregular to 11.5 × 9 cm (diameter)
E.214-2005
Purchased through the Julie and Robert Breckman Print Fund

I-D Cards (3 from a set of 30) from *Perfume of Absence* project, 2002-4
Digital inkjet print on archival paper, offset lithography, plastic wallets
Dimensions: each wallet opens to 7.1 × 21 cm
Old Ad' Diriyah, Buenos Aires, Bath
E.215 to 217-2005
Purchased through the Julie and Robert Breckman Print Fund

The unsettling realities of the economic crisis in Argentina encouraged Mandrile's departure in 1995 and have, she feels, been partly responsible for her nomadic attitude to life. She uses her PC as a portable studio and with her Hewlett Packard printer she can work almost anywhere, from airport to bus station; her quip that 'home is where the printer is' is not so far from the truth. Migrants carry little, but often among their few possessions, as reminders of a former home, are photographs. Mandrile travels with a small collection of dolls made by scanning and manipulating a photograph of her own face, taken shortly before leaving Argentina.

To emphasize its status as mere fragment from a once-complete life, Mandrile blurs the features of the photographic image and from this makes a number of digitally printed impressions by taping linen to an A4 sheet of paper fed through the printer. This cloth is then trimmed to the margins of the image, stitched, stuffed and attached to a 'body', usually an object, or fragment of an object, found or given in various locations 'along the way'. Gathering these fragile creatures together (some have their heads bandaged against the exigencies of suitcase life), Mandrile creates tableaux, the public expressions of her life as an artist and also the raw material of further expressions in the form of digital prints. One's own image, she suggests, is the most portable tool in the world and, suitably manipulated, can speak both to the idea of 'disappeared' multitudes (surely a reference to the activities of the Argentine Military Junta of 1976–83) and the lost soul, at once everyone and no one.

Expanding the theme of migrancy, Mandrile created I-D (Intensively Displaced) cards for her troupe of dolls. Each has its portrait on one side of an authentic plastic wallet. On the other side the same doll (sometimes a couple) reflects Mandrile's own travels in a specific place – Bristol or Buenos Aires, for example. Using the format of tourist snapshots, the cards remind us of those for whom the places pictured are neither comfortable homes nor exotic holiday resorts, but places where resources are scant and existence is hard. Many have fled repressive regimes with no formal I-D, but others, Mandrile suggests, 'search for their dreams... re-visiting [their] countries [of origin] that cannot recognize them as citizens anymore'.[18]

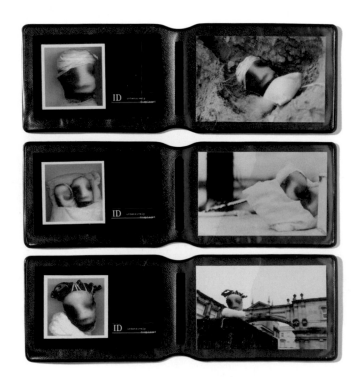

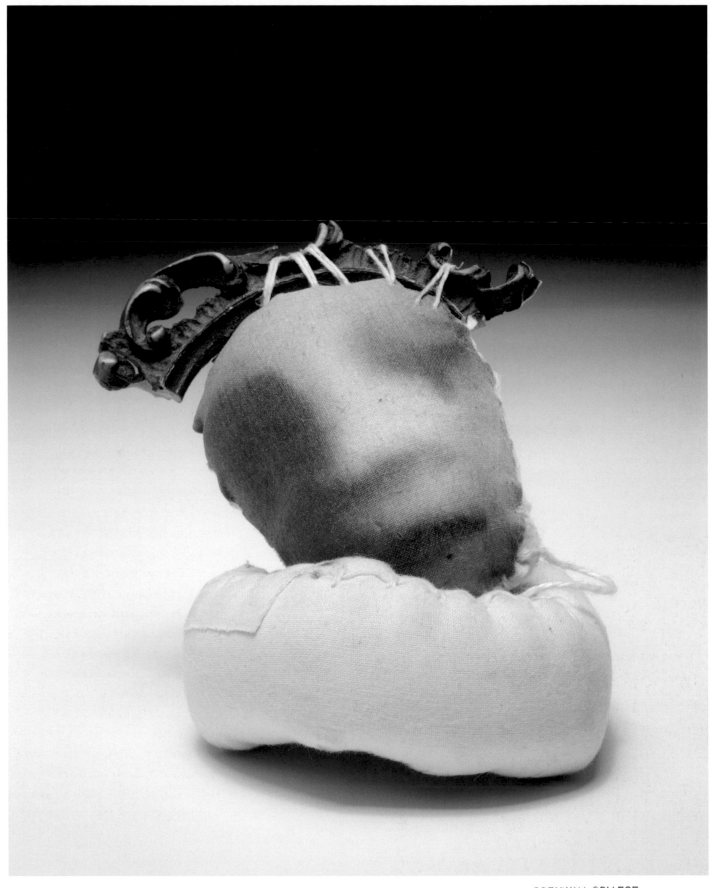

JULIAN OPIE
(born UK, 1958)

*Sara dancing,
sparkly top*, 2004
Continuous computer
animation
Courtesy Julian Opie
and Lisson Gallery,
London

Below:
*Sara gets undressed
(lenticular)*, 2004
Lambda print overlaid
with lenticular plastic,
edition of 25
Framed: 199.2 × 85.4 cm
E.3712-2004
Purchased through the
Julie and Robert Breckman
Print Fund
Courtesy Julian Opie
and Alan Cristea
Gallery, London

Much of Opie's work has explored ways in which a motif can be pared down to its essence and yet remain recognizable not only in generic terms, but also in terms of retaining an identifiable individuality. His images of people – as portraits or as figure studies – are drawn by him on a computer, using photographs of real people he has taken himself, in the process reducing each to its characteristic essentials described by solid, even black lines and a graphic language of basic symbols. Below, Opie's Sara enacts a passive striptease as we watch. She belongs to a long tradition of representing the female body – and especially the nude – in the history of art. As a familiar and instantly recognizable motif, the female body can serve as the site for experiments with form and modes of representation.

This is a Lambda print (a laser print on photographic paper), which has been overlaid with lenticular plastic, so that different views of the image are visible as the viewer shifts their position in relation to it. The first step in making a lenticular print is to prepare two or more images (here Opie has used three), which must be the same size, and using a computer program, cut them into narrow strips and interlace them in

strict sequence. If, as here, the artist wants three views (also known as 'flips'), then the first strip is taken from image 1, the second from image 2, the third from image 3, and then the fourth from image 1 and so on. It is this interlaced image that will be printed and then mounted behind a lenticular lens screen. This is a sheet of plastic on which a series of cylindrical lenses (or lenticules) have been moulded in parallel, rib-like columns. Each of the lenses has a focal length equal to the thickness of the clear plastic sheet from which it has been moulded. Each lencticule thus magnifies one of the narrow strips of the image behind it. If you change your angle of view, then the strip that is being magnified also changes, creating an illusion of animation just as flip-books do.

Advertisers have previously used this simple method of 'animating' a static image for posters and billboards. Its other common use is for kitsch souvenirs and postcards – often of the 'now you see it, now you don't' kind, in which pin-ups 'lose' their clothes, or 'move' into sexual positions. Opie has co-opted these commercial techniques and their associations with popular culture for a print that has the graphic economy of a poster or a comic strip, and connects his printed output to his computer animations. Sara – a professional model – has also been the subject of some of Opie's computer films which use LED (light-emitting diode) technology to present animated versions of his pared-down portraits.

2. OLD MEDIA MADE NEW

Margaret Lanzetta
(born USA 1958)
History Map II, 2002
Digital print on hand-made
linen paper comprising
pigmented pulps, and
screen-printed acrylic paint
29.2 × 20.3 cm
E.835-2002
Given by the artist

Printmaking is inherently a practice open to experiment and innovation, with artists continually finding new applications for traditional print media, whether by accident or design. Quick to co-opt new methods, materials and formats, artists and printmakers often use these to push the boundaries of the possible with the established print processes.

The computer linked to digital printers has offered new directions for artists, but it also has another role in printmaking, and that is to modify source material, which may then be printed by more traditional means. This was a role that photography had assumed in conjunction with printmaking processes up to at least the 1980s.[1] For many artists, the computer is a drawing tool, providing an unprecedented facility for manipulating imagery, and for bringing together compositional elements from diverse sources.

Painter and printmaker **Margaret Lanzetta** derives the patterns that characterize her work from a variety of sources: contemporary industrial metal screens, details of Indian architecture, motifs from historic Mughal carpets and plant forms. Her own studies or existing photographs are scanned into a computer, manipulated to achieve the desired scale and proportions, and transferred to screens. In the case of *History Map II* (2002), Lanzetta began by making a sheet of handmade linen paper, which carried an embedded pattern. This ground pattern was first transferred to the nylon screens used for papermaking. A base sheet of white linen pulp was laid down, and then pigmented linen pulps were squeegeed through the screens layer upon layer, wet on wet. Once this sequence was completed, the paper was pressed to extract water and dried against aluminium panels to achieve a polished matte surface. Once dry, the surface was sealed and the final elements of the composition were added using paint applied through silk-screens. Lanzetta's prints embody an innovative marriage of digital technology with the traditional methods of papermaking and printing that mirrors her amalgamation of contemporary and historic imagery, the machine-made and the handmade, industrial and organic forms.

Computer technology has been responsible for mediating in the delivery of some spectacular works in more traditional media, such as **Anya Gallaccio's** print pair *White Ice/Black Ice* (2002). Gallaccio is interested in metamorphosis, and her installations are typically of living or mutable matter that will change or decay through time and changes of temperature. Frequently she presents a beautiful or monumental object, of flowers, chocolate or ice, for example, which over a period of days or weeks decays, moulders, melts, transforming or literally disappearing before our eyes. Her work reflects a world in which climate change and disease reach us at lightning speed on a global scale, but also mutate rapidly. Hence print, conventionally a static medium, would at first sight appear to have little appeal to her sensibilities. However, when approached by Dundee Contemporary Arts, she was attracted both by their mission and the challenge of working in a new medium. As is the case with her installation pieces, the printed work suggests the passage of time from pristine to despoiled, but here she plays on the difference in qualities of two processes, screen-printing and etching, applied to different supports – acrylic for one, paper for the other.

For *White Ice* a photograph by Gallaccio was scanned and separations were made for each screen using Photoshop software. Then a four-separation

Anya Gallaccio
(born UK 1963)
White Ice / Black Ice, 2003
Printed and published by
Dundee Contemporary Arts
Edition of 30
White Ice: screenprint on
mirror acrylic with glitter;
Black Ice: etching on paper
Each 61.5 × 85 cm
E.3553 and E.3554-2004
Purchased through the
Julie and Robert Breckman
Print Fund

photomechanical screen-print in six
runs, on mirror acrylic, was made,
using acrylic inks: first pearlescent,
then two runs of blue gloss white,
two of opaque matt white and then
finally pearlescent again. To finish,
the print was lightly sprinkled with
glitter. *Black Ice* is also from a scanned
photograph by Gallaccio, and again
Photoshop software was used to create the
positive. It is a one-colour photo-
mechanical etching on steel, printed
on Somerset Velvet White paper using
Intaglio Printmaker Cool Black ink.[2]

Spanish artist **Cristina Iglesias** has
chosen to print on metal, effectively
co-opting as support a material that
is usually an intermediary tool in the
printmaking process – the printing
plate. This allows her to exploit the
characteristic qualities of the metallic
surface – its colour, sheen and so on –
and to play with mirroring and reflec-
tions (see Case Study, page 38). **Faisal
Abdu'Allah** has a strong affinity with
both metal and glass, which he has used
as substrates in a variety of prints, with
glass in particular offering qualities
that extend the resonance and potential
of the work through the interplay of
transparency, reflection and shadow
(see Case Study, page 46). Acrylic has
similar virtues: **Marilène Oliver** has
made print-based sculptures by printing
with bronze inks on to sheets of acrylic
stacked one above the other with small
gaps between them. Each layer is a
scanned 'slice' through a human body,
and the finished piece is a shimmering
'virtual' portrait, as if the body is
dematerializing or perhaps held in
a vaporous suspension (see Case Study,
page 40).

Emma Stibbon
(born UK 1962)
Carrara, 2001
Edition of 35
Woodcut
118 × 142 cm
E.219-2003
Purchased through the
Julie and Robert Breckman
Print Fund

Woodcut – the oldest print process, and one of the most labour-intensive and arduous – has seen a concerted revival in recent years. Although the technique is used to very different ends, the factor that frequently unites some of these new woodcuts is their unprecedented size. **Peter Howson** was a leading exemplar in the later 1980s, making dramatic images of Glasgow's down-and-outs. **Emma Stibbon** has been making enormous woodcut landscapes. Her method is to make large-scale drawings on the spot, which she then transfers on to sheets of plywood; she then chisels into the sheets to make her printing blocks. *Carrara*, an epic view of the cavernous marble quarries in northern Italy, implies that the sheer physical effort involved in chiselling the design into the wood is a kind of equivalent for the labour of the quarrymen and the sculptors. The German artist **Thomas Kilpper** has specialized in producing enormous woodcuts, some made conventionally, others by printing from designs cut into parquet floors in redundant buildings (see Case Study, page 82).

Laura Owens
(born USA 1970)
Untitled, 2001
Printed by Anthony
Zapeda, Los Angeles
Published by Counter
Editions, London
Edition of 90
Lithograph with
handcut collage
Image 30 × 22 cm

E.260-2005
Purchased through the
Julie and Robert Breckman
Print Fund
Courtesy Counter Editions,
London and copyright
the artist and Counter
Editions, London

There is, however, a kind of perversity in the choice of woodcut for large-scale works, the more so when an artist chooses to eschew the naturally expressive character of the medium for a photo-realist exactitude or machine-made aesthetic. Whereas Stibbon's prints embody the textures and physical presence of the woodcut medium, **Franz Gertsch** has been making vast woodcut portraits in a photo-realist style since the 1980s. **Christiane Baumgartner** employs woodcut rather differently. Here – again on a vast scale – Baumgartner uses woodcut, the oldest and most intractable of print media, to reproduce images derived from video footage of subjects such as motorway traffic (*Lisbon I – IV, 2002*). She meticulously translates a digital medium via a manual process to something fixed on paper, moving from virtual to material by a gradual slowing down. The end product is a curiously simultaneous evocation of speed and stillness.

Others have experimented with unconventional pigments and inks. **Richard Woods'** domestic interventions – floors, 'wallpapers' and exterior cladding – are produced from blocks cut from MDF and printed with an ordinary household gloss paint, deliberately chosen for its associations with DIY and renovations (see Case Study, page 84). For his two life-size self-portraits screen-printed from photographs on to linen, **Lee Wagstaff** used two pints of his own blood as the printing ink. Like Marc Quinn's famous cast of his own head, modelled in his own frozen blood, Wagstaff's prints are the most literal embodiments of self-portraiture

Sonia Boyce
(born UK 1962)
Lover's Rock (chorus)
Wallpaper from a suite
of 6 drops printed with
alternate verse and
chorus from the song
Hurt So Good (1975), 1998
Printed by Early Press,
London on paper supplied
by Sanderson PLC.

Blind embossing
Width of roll 56.2 cm
E.465-1999
Copyright the artist

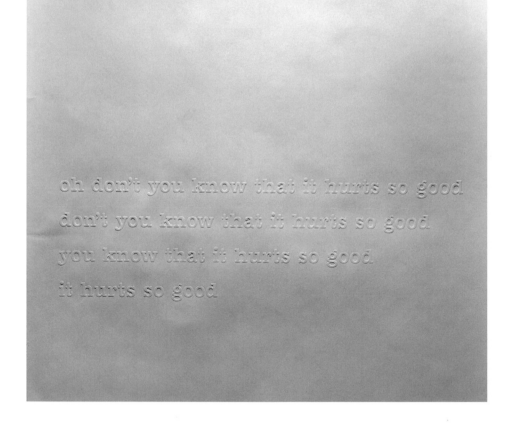

(see Case Study, page 36). His choice of pigment – and of cloth as the support – transforms the implications and associations of an otherwise straight-forward screen print into something intensely personal.

Innovation can be achieved by introducing unique elements to stand-ard processes. **Laura Owens**, a painter, has made prints that are the equivalent of her paintings – incorporating hand-made unique elements, and designed to mimic the fugitive translucency of watercolour. *Untitled* (2001) published by Counter Editions, is a lithograph with hand-cut collage pieces used to represent flowers. Each print in the edition is subtly different, with different patterns and combinations of patterns used for the collaged petals. There is a further level of illusion at play here

too – the collaged pieces *look* like fabric samples but are in fact *papers* printed to look like fabrics.

To print is not only to apply ink or pigment to paper or some other support, but also (in the relief processes) to make an impression. The processes of relief printing and blind embossing have been exploited by contemporary artists and printmakers in ways that evoke materiality, texture and touch. **Peter Ford's** paper casts made by apply ing paper pulp to tree stumps take on the character of fragile sculptures in low-relief (see Case Study, page 34), while **Sonia Boyce** has designed lengths of wallpaper, blind embossed with the words from a popular song, to conjure the elusive physical memories of dancing, embracing and loving. Exploring the sensual quality of

the embossed surface, Boyce remarks the way it invites touch, as dance does, but a touch which, in line with the lyrics of the song, is also a pressure.[3]

PETER FORD
(born UK, 1937)

Evidence 1, 1996
Six blind-embossed prints
on handmade paper
Overall dimensions:
55 × 69 cm
E.1098-2002
Purchased through the
Julie and Robert Breckman
Print Fund

Blind embossing, in which a design is impressed into paper without the use of any pigment, is not precisely a new technique; as a mechanized process it was widely used for Victorian Christmas cards and Valentines. However, contemporary artists have been inventive in applying the technique creatively, and Peter Ford's use of it in the *Evidence* series is self-reflexively organic, representing a simple but resonant response to a specific commission. He was invited to contribute to the exhibition *In Praise of Trees* (2002, at the Salisbury Festival and Stephen Lacey Gallery, London). The premise of the show was that each exhibit would be made of wood and/or paper, and would in some way respond to or illuminate the place of wood and woodlands in our culture.

Evidence 1 is the product of Ford's complementary interests in papermaking and printing. In this work, he made a pulp of recycled paper, which he left to drain for some time in the mould and then applied directly to the surface of two cross-cut tree stumps. When dry the pieces of paper were removed from the wood; the tree-rings, cuts, grain patterns and other indentations were thus preserved in the dried paper casts, which are faintly stained, presumably with natural pigments absorbed in the process. These relief-printed paper fragments are like archaeological evidence – pottery shards, perhaps, or plaster casts – but as the unique physical traces of organic materials, they also resemble fossilized remains or sections of bleached bark. Subtle, ambiguous and austerely beautiful, they are clearly influenced by a Japanese craft tradition in which the natural qualities of paper are explored and revered.

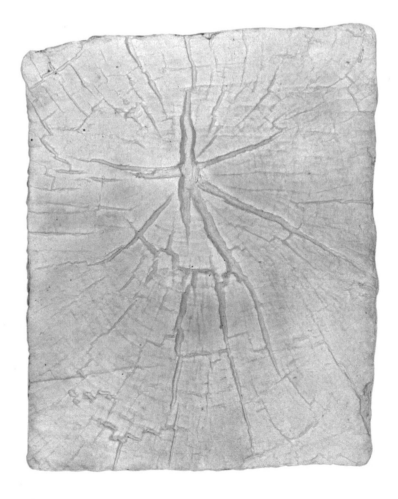

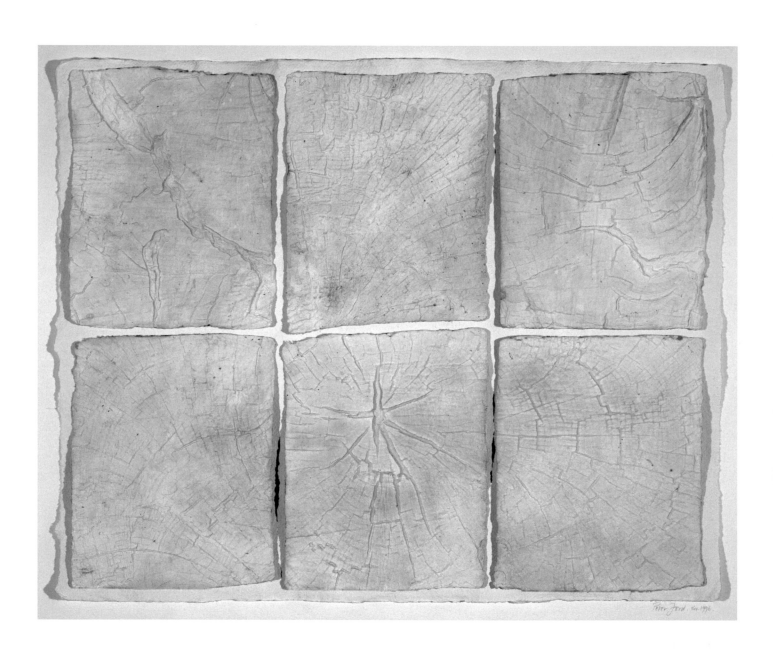

LEE WAGSTAFF

(born UK, 1969)

Shroud, 2000
Screen print (printed with blood)
on Egyptian linen
259.3 × 126.4 cm
E.1203-2000
Given by the artist

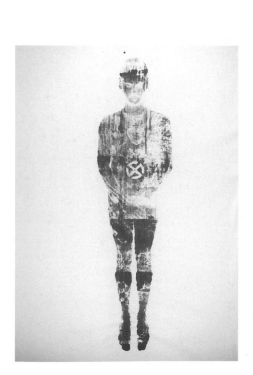

Shroud is a self-portrait of the artist. Wagstaff uses his own body as subject and material for his art, and also literally as a canvas: he is extensively tattooed with motifs and patterns that he devised himself. It was in the process of being tattooed that he got the idea for this print, when he noticed that tissues used to blot the blood took the imprint of the pattern being needled into his skin. Inspired by this observation, he made a silkscreen from a negative photograph of a full-length frontal view of his body. Under the supervision of a nurse, he drew off two pints of his own blood, which provided enough pigment to print two of these life-size 'shrouds'.

Both the title and the image itself, of a prone wounded male body, underline Wagstaff's deliberate reference to the famous Shroud of Turin, a mysterious relic that many believe bears the imprint of Christ's crucified body. The Shroud of Turin belongs to a group of relics and bodily traces – the marks of Christ's knees where he knelt to pray, his footprints in the dust on the Mount of Olives, his face imprinted on St Veronica's veil – which are often cited to testify to Jesus' actual physical presence on earth. This obsession with physical proof is paralleled in the art world, where not only is the artist's signature required as proof of authenticity, but where also at least one artist has now reputedly begun incorporating his own DNA into his work to thwart forgers. With editioned works such as prints, those made during an artist's lifetime, regardless of the extent of his involvement in the making, have an aura of authenticity lacking in those

made after his death, even in cases where an edition was previously approved by him. Prints are especially vulnerable to forgery by means of re-using cancelled plates, or extending editions beyond the original print run.

Printed with his own blood, Wagstaff's *Shroud* is indisputably authentic and almost unique, and its production was a kind of performance analogous to the bloodletting rituals of artists such as Franko B, and equally concerned with the artist's body as the site of experience. This use of the body in the process of printmaking – leaving an authentic physical trace – imbues the work with a kind of magical power. Like the impression of the artist's fingers on a printing plate, with this use of his own blood as printing ink the print becomes the embodiment of its maker as well as a picture of him.

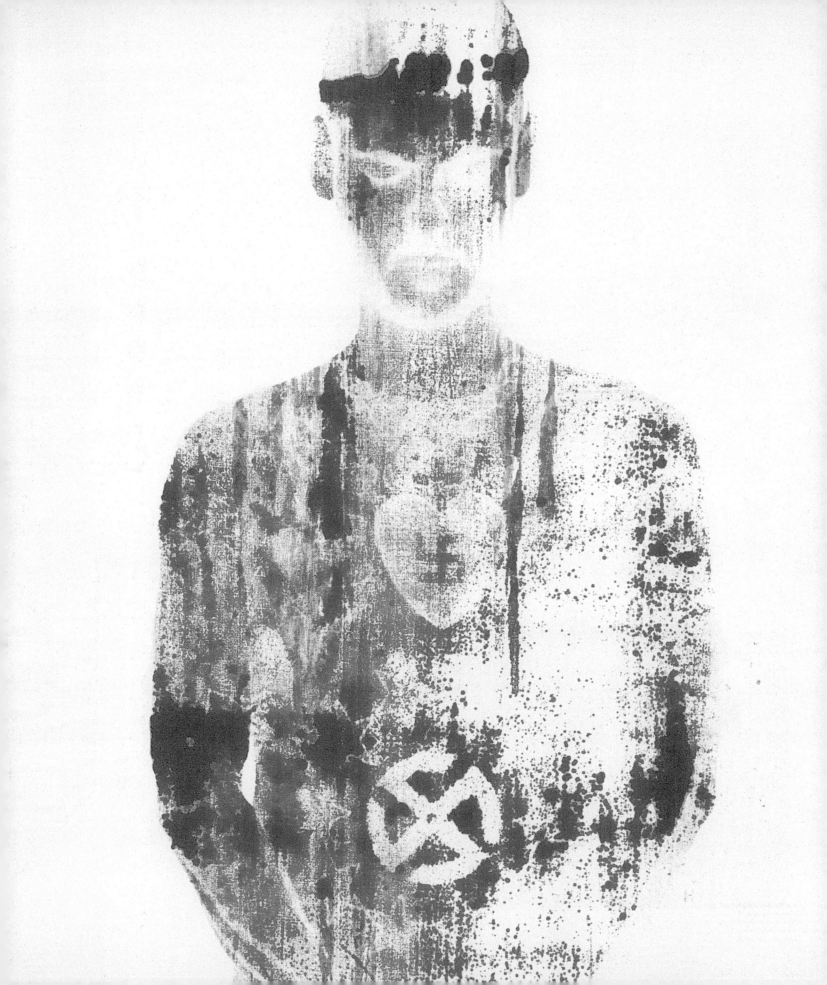

CRISTINA IGLESIAS
(born Spain, 1956)

Untitled (Habitation XIII), 2003
Printed by Pepe Albacete,
Madrid
Published by the
Whitechapel Art Gallery
Edition of 200
Screen print on
aluminium
36 × 50 cm
E.3735-2004
Purchased through the
Julie and Robert Breckman
Print Fund

Cristina Iglesias is best known as a sculptor and her work includes a number of vast screen-printed copper sheets, which she began making in the 1990s. These average 2 or 3 metres in height and width, and are often juxtaposed to cover a whole wall. The imagery itself represents a kind of urban landscape – at first glance the viewer sees deserted temples, warehouses or villages of adobe houses, but then discerns that these are made-up places. These 'landscapes' are taken from photographs of carefully manipulated, upside-down cardboard boxes. 'Doorways' have been unevenly scored away, and fold lines, corrugation and printed lettering are all in evidence. Nevertheless, we still willingly suspend disbelief. Viewing these printed sheets of copper is like looking through a window at a real landscape; the natural vegetation, which Iglesias pictures, cunningly positioned to be seen though the 'doorways', heightens this illusion, but the peculiar nature of the space is established by more than scale and location on the gallery wall.

As substrate, the polished copper panels retain their subdued reflective quality, but their role in the process of creating printed images has been transformed from that of 'middleman' to end product in the process of creating printed images. Iglesias disrupts conventional awareness of print, and of pictorial and sculptural space, by printing directly on to the reflective surface. Thus 'concepts of copy and original, negative and positive, of idea and reality, are radically and lyrically destabilized'.[4]

Untitled (Habitation XIII) is a scaled-down variation of one of these wall screens, conveying similar illusions. In this work cardboard 'buildings' are articulated with the 'jalousies' (fretwork screens), which Iglesias had created as independent sculptural objects, but introduces here as 'architecture'. Inspired by the symbolist writings of Raymond Roussel, who described alluring and fantastic landscapes and played with the meanings of words by changing grammatical or textual contexts, these jalousies are formed from alphabetical letters, which almost but not quite make sense. The screens are fashioned after those in Arab houses that provide a means of seeing without being seen. Disguising the watchful or 'jealous', such screens themselves become a form of dissemblance – a concept that fascinates Iglesias: 'I'm not interested in truth to materials', she has declared. 'I used a lot of materials that lie.'[5]

MARILÈNE OLIVER
(born UK, 1977)

Self-Portrait, from *Family Portrait* series, 2002
Screen print in bronze
ink on acrylic
182.9 × 71.1 × 50.8 cm
E.379-2005
Donated by Robert Breckman
in memory of Julie
© Beaux Arts London

Below:
Self-Portrait and *Sophie,* from
Family Portrait series, 2002

Inspired by medical-imaging processes, Marilène Oliver conceived a series of printed portraits that combine print and sculpture. At her MA degree show at the Royal College of Art in 2001, she exhibited the first of these, *I Know You Inside Out.* This was a reconstruction of a thirty-nine-year-old convicted murderer, Joseph Paul Jernigan (known to the medical world as the US National Library of Medicine's Visible Human). Before his execution, Jernigan was persuaded to donate his body to medical science. After his death, his body was frozen and sliced into 1,871 cryosections, which were photographed and uploaded on to the Internet in 1994. Oliver selectively downloaded images and 'reconstructed' him by screen-printing these sections on to sheets of acrylic and stacking them at 2 cm intervals. The result is a print in three dimensions; viewed at certain angles the body appears as a solid entity, but viewed at eye-level it dematerializes. The clinical abstraction of medical imagery is reconfigured to evoke an ethereal presence.

Using medical resonance imaging (MRI) scans, Oliver created a group portrait of her family – mother, father, self and sister – in the same fashion. The figures are nebulous, immaterial, held in suspension between the real and the virtual, the solid and the illusory. By printing with bronze ink, Oliver makes a deliberate reference to the weighty solidity of conventional sculpture, but subverts the allusion by employing it in the creation of images that play off opaque against translucent, and fluctuate between solid and insubstantial. In adapting scientific modes of picturing the body, and in the structure of the work, she also draws on the visual tropes of science fiction – the processes of suspended animation and the dematerialization and reintegration of bodies through teleportation.

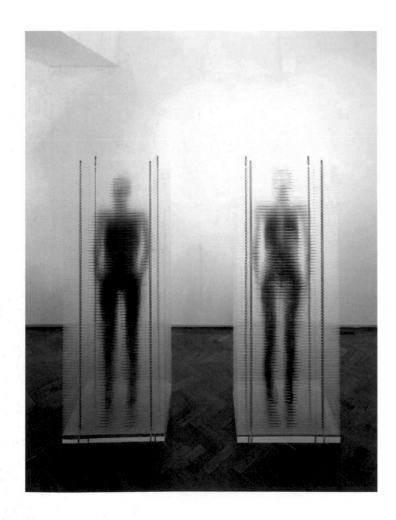

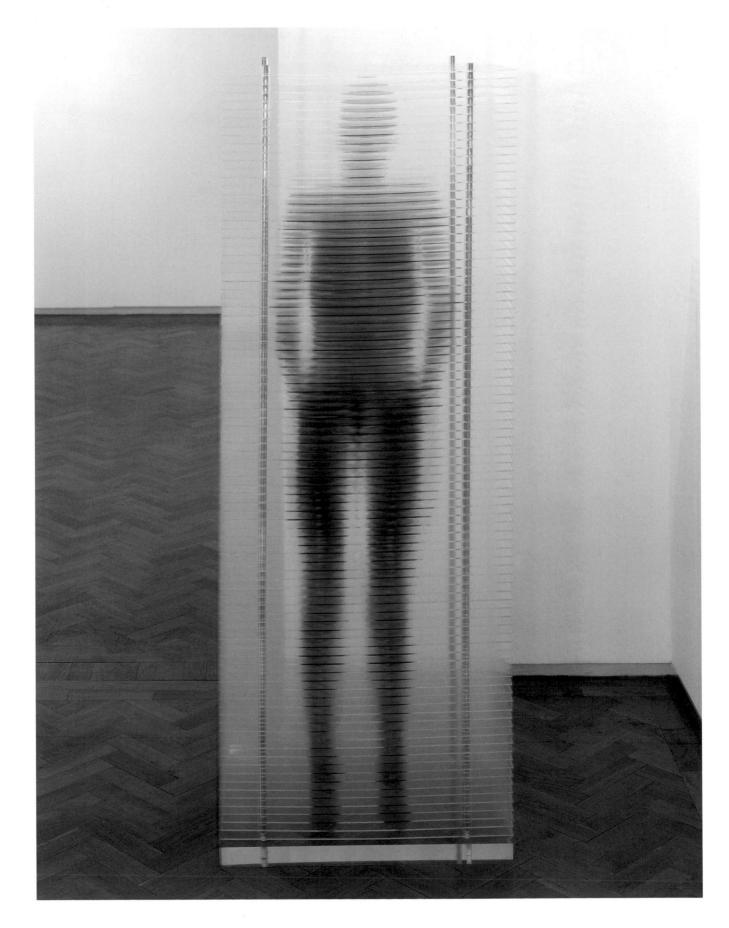

3. PRINT IN 3-D

New technologies – and new ideas – have liberated prints from the confines of the portfolio, and print is now being incorporated into sculpture, installations and other three-dimensional formats. Those artists applying print to surfaces such as glass, cloth and ceramic are exploiting form and material as an essential part of the message.

Faisal Abdu'Allah, who uses glass and sheet metal in much of his work, began printing with glass as substrate while still a student at the RCA (see Case Study, page 46). Another artist who has investigated the possibilities of a transparent substrate is Natasha Ramjoorawon, whose *First Lesson in Love* (1993) brings together a diary of objects sealed within nine variably interlocking perspex blocks. In this piece, which operates in the territory between bookwork and sculpture, print plays a small but integral part. There are rose petals, threads of an old scarf, strands of hair and a fragment of copper, but there are also screen-printed verses from a poem to the Hindu goddess Kali and images of Kali herself with her consort Shiva. Not quite eighteen when she made this piece, and in love for the first time, Ramjoorawan expresses nostalgia, hope, faith and happiness. Each encapsulated fragment

has a personal resonance for her, relating to identity and to family. The blocks may be rearranged at will, to suggest the way in which an event will trigger a chain of memories in a particular order, while another event may trigger a sequence with a different emphasis. There is, too, the suggestion of a common fantasy – each of us, if we could, might revisit the past and construct our lives a little differently.

Ceramic as substrate for print has come to prominence recently in the work of the Turner Prize winner Grayson Perry, and has been fundamental to recent work by Charlotte Hodes. In one project Hodes has relied on the classic form of Spode china as part of her feminist message. The polite rituals of dining in wealthy middle-class or aristocratic homes have historically been accompanied by special porcelain and chinaware. On a residency at the Spode factory, still manufacturing in Stoke, Hodes had access to numerous print-transfer designs for such china, dating from the nineteenth century. She printed copies from the original engraved plates, cut these up and then printed them in the traditional transfer manner on to tea and dinner services. At first glance the china simply looks badly printed, but then it becomes

apparent that the design contains patterns of ecstatic dancing female figures to suggest broken taboos and a deliberate subversion of historically repressive codes of conduct.

A large part of the total oeuvre of Nigerian/British artist Yinka Shonibare is composed of garments made from batik fabric overprinted with 'African' designs and worn as a signifier of African roots, although batik in fact originated as an export to West Africa from Britain, via Indonesia and the Netherlands. In using such fabric made up as nineteenth-century-style European costume or tableaux based on famous European paintings, Shonibare questions notions of cultural pedigree and purity. Extending the idea further, he has also created families of printed fabric dolls which he describes as aliens, while a pair of fabric-covered dancing pumps offers a more complicated take on a history of African modernity.[1] In *Victorian Philanthropist's Parlour* (1996), Shonibare created an entire room setting (not unlike Renée Green's 1994 *Taste Venue* project, see page 54), For this the fabric was overprinted with images of black footballers, suggesting the crucial role the game plays in upward social mobility, notably for black Britons, and its

Yinka Shonibare
(born UK 1962)
The Victorian Philanthropist's Parlour, 1996
Three-dimensional installation produced by London Printworks Trust
Furniture with screenprinted fabrics and wallcoverings

Approx. 250 cm high × 450 cm deep × 500 cm wide (excluding buttressing)
Courtesy of the artist and London Printworks Trust
Courtesy of Stephen Friedman Gallery, London

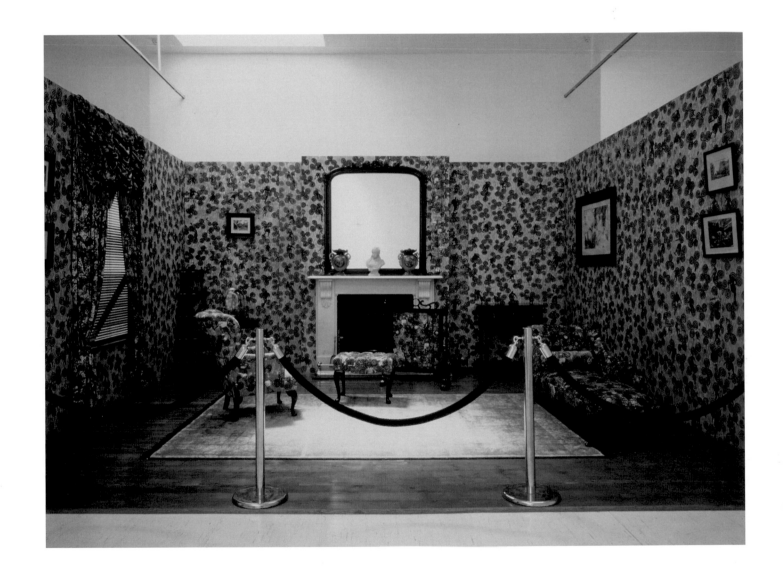

Rachel Whiteread
(born UK 1963)
Herringbone Floor, 2001
Produced by Lasercraft,
Huntingdon
Published by Counter
Editions, London
Edition of 450
Laser-cut relief in Finnish
Birch plywood
Cut surface 35.3 × 29.5 cm

E.20–2002
Purchased through the
Julie and Robert Breckman
Print Fund
Courtesy Counter Editions,
London and copyright
the artist and Counter
Editions, London

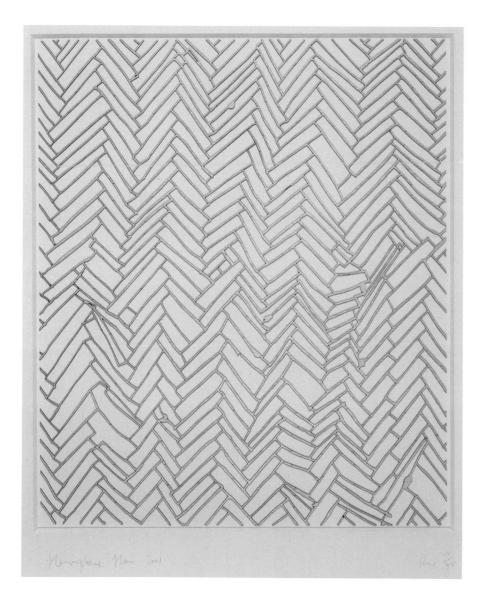

role in transcending national borders.[2]

In *Made in England, Miss Holmes* (1999), the French/Algerian artist **Zineb Sedira** printed Islamic arabesque patterns on to a handbag, shoes and a headscarf – perfectly ordinary items of a Western woman's wardrobe, but here charged with cultural ambiguity. The pieces can be read not only as a celebration of Arab culture, apparently male dominated but subtler in terms of gendered authority than European society may understand, but also as Sedira's own positioning of herself as culturally hybrid in Europe. As Salah Hassan puts it, 'Sedira transgresses the traditional codes of dress among North African Muslim women to explore issues of cultural memory, sexuality and nostalgia.'[3]

Native American artist **Lynne Allen** has also used footwear as a vehicle for print (see Case Study, page 50) to protest the depredations of colonization, and fellow Native American **Jaune Quick-to-see Smith** questions conventional assumptions about 'American-ness' in a work that takes the form of a traditional buffalo-hide accessory (see Case Study, page 72).

American culture is also part of the subject matter of *The Nam* (1997), a major piece by British artist **Fiona Banner**, described as a 1,000-page all-text flick book. Printed in offset litho in an edition of 1,000, *The Nam* is thick, unwieldy and heavy; it is a detailed text description, written by Banner herself, of six epic Hollywood films about the Vietnam War: *Full Metal Jacket, The Deer Hunter, Apocalypse Now,*

Born on the Fourth of July, Hamburger Hill and *Platoon*. Its premise has been described as the 'sublime crisis of representation in which books can be described as unreadable, images as unframeable and experiences as unrepresentable.... Although the structure of each film is replicated on the page, the result is not a book of the film but something else that acknowledges both the manufactured emotion inherent in the framed, seductive vastness of the widescreen epic and the unframeable horror, excitement and boredom of war.'[4] When exhibited in the Frith Street Gallery in 1997, stacked as a kind of library, the edition created a vast sculptural presence.

More recently Banner turned to pornographic movies as a similar kind of source from which a text can be derived, in the process transforming, yet also repudiating, the experience of the film. To make *Colour Blind (Arsewoman)* (2001), she watched the film herself and recorded the actions meticulously in text. She screen-printed the text in neon pink on to paper that approximates in size to that of a cinema screen. This approach has been used in other works, but here she additionally slashed the paper into vertical strips and suspended them from the ceiling

to resemble the blind at an entrance to a strip club. Close printed, in small-point font (relative to overall size) and in glaring colour, the text is difficult to read with any continuity. Banner recounted both her fascination and yet ultimate boredom with the film, and as phrases and individual words jump out at the viewer we begin to see why. From a sense of voyeuristic transgression we move to one of overloaded endless repetition. The subject of much tabloid-type criticism when exhibited for the Turner Prize in 2002, *Arsewoman*, like *The Nam*, points to deeper societal problems, but it also belongs to Banner's ongoing exploration of the limits of written communication.

As a sculptor, **Rachel Whiteread's** curiosity about the way things are made has led her to use a variety of industrial processes, often pushing materials beyond the limits of their conventional applications. Recently she has made two works that, if sculptural in feeling, also question the boundaries between print and sculpture. *Herringbone Floor* (2001) exploits modern laser technology to produce an editioned work that also reflects Whiteread's interest in the flat surfaces of floor, wall and ceiling as sites of sculptural investigation.

By using her template drawing, technicians from a specialist laser-engraving company (Lasercraft in Huntingdon) cut away areas from a block of Finnish birchwood ply, leaving behind a delicate fretwork representing the 'space' between the wood blocks of a parquet floor and echoing the spatial inversions that characterize her major sculptural works. The process has recognizable affiliations with the traditional ones of engraving, embossing, dye-stamping and relief-block cutting. Her second 'print', developed with and published by Counter Editions, and using a process called stereolithography has been an even more radical departure from conventional printmaking (see Case Study, page 52). Counter Editions have a track record of producing 'prints' that adapt commercial or industrial processes to the purposes of art. Among their most innovative pieces are the iced cakes produced with **Sarah Lucas** (see Case Study, page 48).

FAISAL ABDU'ALLAH
(born UK, 1969)

Thalatha Haqq (Three Truths), 1992
Screen print on sheet-glass pyramids
sealed with silicone sealant
Unique work
Each 56 × 56 × 56 cm
(pyramidal)
E.1886 to E.1888-1993

Like Cristina Iglesias (see page 38), Faisal Abdu'Allah is intrigued by the qualities of metal as substrate, but also by those of glass. In *Thalatha Haqq,* his earliest print on glass made while he was still a student, he explored ideas around the continuum from subjective to objective truth. Here, as a recent convert to Islam, Abdu'Allah sought to celebrate his faith, his identity and the need for global understanding and tolerance.

Thalatha Haqq takes the form of three pyramids, the latter of course a universal signifier for one of the most ancient civilizations in the world, located in Africa. They act both literally and metaphorically as a conduit for enlightenment, challenging the viewer to recognize histories around African-rooted communities that have hitherto been hidden, distorted or ignored. A self-portrait is screenprinted onto each surface of each pyramid. The first shows the artist preparing for prayer, the second at prayer and the third rising from prayer. Repetition and gentle progression of image and form echo the ritual of prayer itself.

Often described as a photographer, Abdu'Allah sees himself as an artist who uses photography and for whom printmaking has an equally important role, as here, where the grainy quality of the images taken from photo-based screens rest like shadows on the glass, yet also cast shadows *through* the glass, and inside the pyramid, adding yet another dimension to the work. As we move around the pyramids, so the light – and hence the images – change. The combination of glass with print enables Abdu'Allah to express a sense of constantly shifting perspectives around religious faith, historical roots and enlightenment.

Abdu'Allah's subsequent work developed away from what might be described here as a conciliatory stance to a more confrontational one between his own position as a young black man and social stigma and stereotyping. He has now moved on to explore more generic issues of inequality. Nevertheless his favoured (but by no means exclusive) materials remain glass and metal combined with the processes of print and photography. Signifying the often invisible but very real dividing line between privilege and exclusion, glass is for him the perfect material, functioning simultaneously as substrate, as a sculptural element and as architectural structure.

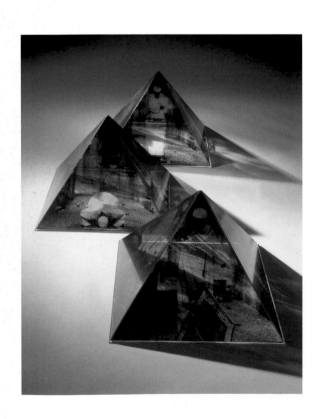

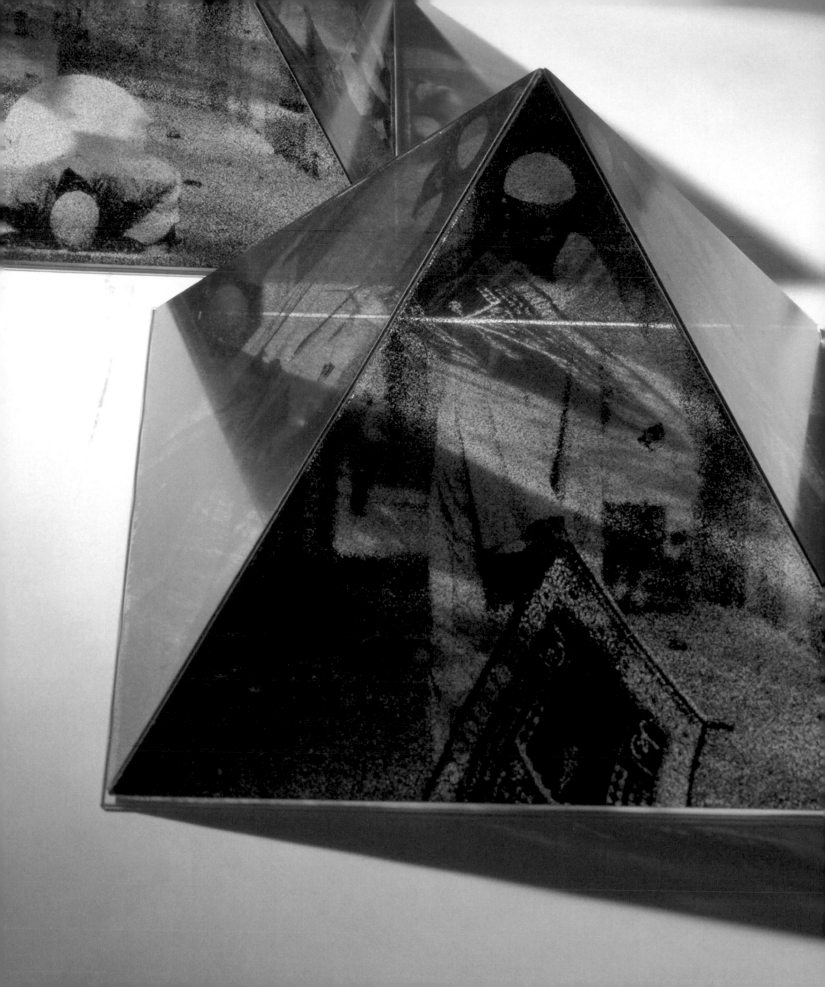

SARAH LUCAS
(born UK, 1962)

Set of 12 fruit cakes, iced
with images of the some
of the artist's earlier
works in other media
Digital inkjet prints
in edible ink on icing
sugar; fruit cakes
Printed by Cakes Direct,
Ilford, Essex
Published by Counter
Editions, 2001
Edition of 25
Each 35.5 × 35.5 × 10 cm
Courtesy of Counter Editions,
London and copyright
the artist and Counter
Editions, London

Below:
Finger, 2001

Approached by Carl Freedman of Counter Editions, who wanted to make a print with her, Sarah Lucas mentioned her fascination with a particular baker's window in the Kingsland Road (in London's East End), where cakes decorated with pictures of anything from footballers and frogs to pop stars might be ordered on a whim. Notorious for her gruesomely witty use of food to critique sexual stereotyping and 'laddish' behaviour, Lucas evidently regarded the iced fruitcake as a medium with potential. Freedman located a specialist firm in Essex, which uses digital technology to *print* cake decoration and was prepared to produce what could loosely be described as a mini retrospective of Lucas's earlier works. Among the images are semi-naked figures clutching raw meat or crushed beer cans between their thighs; self-portraits picturing Lucas smoking, suggestively eating a banana or loutishly sprawled in aggressive boots; a filthy toilet cistern and a 'soup' of penises.

The appearance of a real cake as an exhibit in an art gallery does not seem too unlikely, but its celebration of such 'bad taste' was definitely breaking a taboo. The combination of something that is not only edible but also usually considered to be a treat or self-indulgence, with images of the nauseatingly obscene, made this work literally a little difficult to swallow. Rich fruitcake is considered to be one of the most luxurious kinds of cake, usually only produced for special occasions like weddings or christenings, so the contrast of these associations with the grotesque images that decorate them brings us into head-on conflict with our baser needs and desires.

Lucas's fruitcake itself seems to underscore the very nature of this enterprise, 'nutty as a fruitcake' being an affectionate slur frequently applied to creative types like Lucas herself by the less imaginative. Its being 'soaked in rum' reminds us that drinking is another favourite theme for Lucas. Many collectors have doubtless put their cakes in glass cases, but Lucas and Counter held a tea party in elegant surroundings in Spitalfields to celebrate the publication of the edition in 2001, where the cutting and eating of the cakes actually took place.

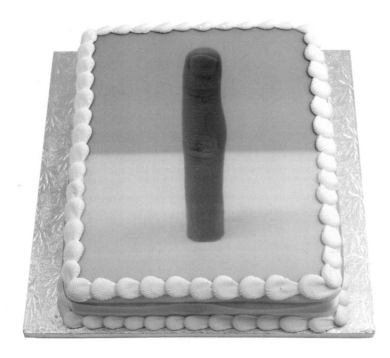

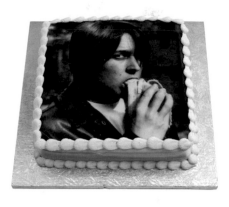 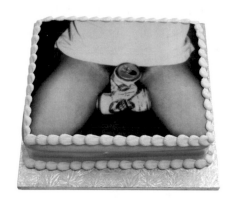 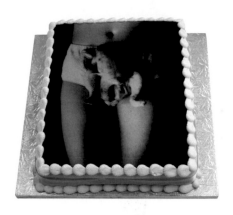

 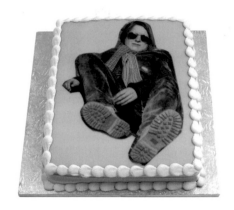 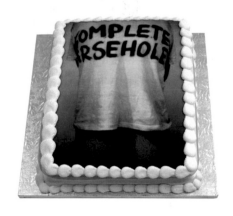

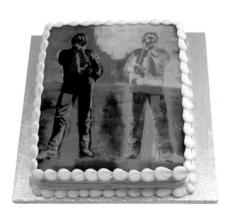 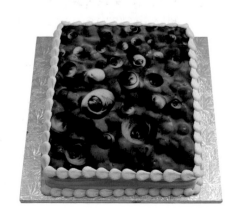 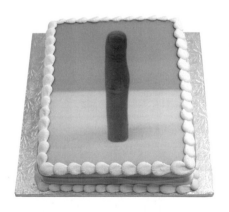

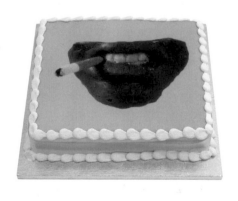 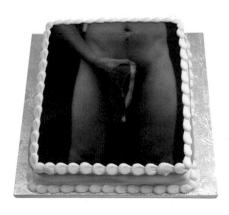 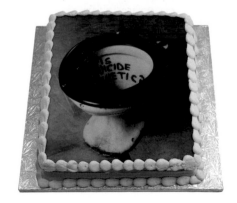

LYNNE ALLEN
(born USA, 1949)

Untitled. Moccasins, 2000
Unique prints. Printed by
the artist at Rutgers Center
for Innovative Print
and Paper, New Jersey
Etching on handmade
paper, cut and stitched with
linen thread to shape; shellac
Sight measure, H: 6.5 cm
W: 8.5 cm L: 20.5 cm and H: 7 cm
W: 8.1 cm L: 21 cm
E.3584.1-2-2004
Purchased through the
Julie and Robert Breckman
Print Fund

Lynne Allen is descended from the Native American Hunkpapa tribe of the Teton Lakota, also known as the Dakota or Sioux, and was raised as a white American. Widely travelled, she has worked first-hand with people making art under hostile circumstances, and issues of alienation have always been central to her own practice. However, it was only around 1998, after reading the journals of her great-grandmother, Josephine Waggoner, that Allen began working with Native American history.

Waggoner learned to read and write at the Hampton Institute, opened in 1868 for the education of freed slaves, and later taking Native Americans in a bid to inculcate 'white' values. Subsequently marrying a white army carpenter (he made the coffin for Sitting Bull!), Waggoner remained acutely aware of the problems facing her own people and kept careful records of events affecting their lives. These records were passed on to her daughter, Allen's grandmother, and only came to Allen's attention after her grandmother died.

In several flat paper works, Allen has addressed disease and decimation resulting from colonizing incursions, but she has also made a number of three-dimensional objects with similar themes, using the vellum of some nineteenth-century English land documents found in a New York flea market. Allen was intrigued by an implicit relationship between these documents and the herding of natives into reservations, since they came from the same time frame. She soaked, etched and stretch-dried the vellum before stitching it up into little purses or arrow slings. Texts and pictogram-style drawings found in Waggoner's journals were transferred to the etching plate by scanning or photomechanical means. Further decorations were added by hand.

Allen printed similar designs onto sheets of handmade cotton paper, some decorated with pulp-painted stencils of cowboys chasing Indians.[5] The sheets were cut and stitched into moccasins and coated with shellac, both as protection and to give an appearance of authentic deer hide. In some pairs she used a collé technique to incorporate other found material. This pair has a transferred image from a rubber stamp found in a craft store. The stamp looks like handwriting at first sight, but on closer inspection turns out to be meaningless scribble. It appealed to Allen, for in both its allusory and illusory aspects 'it suggests lost history, the fate of so much Native American culture'.[6] Allen associates the feet with 'moving on... with letting go of the misery of their history, rising above horror and inequity'.[7]

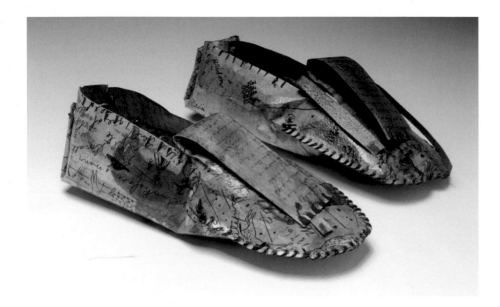

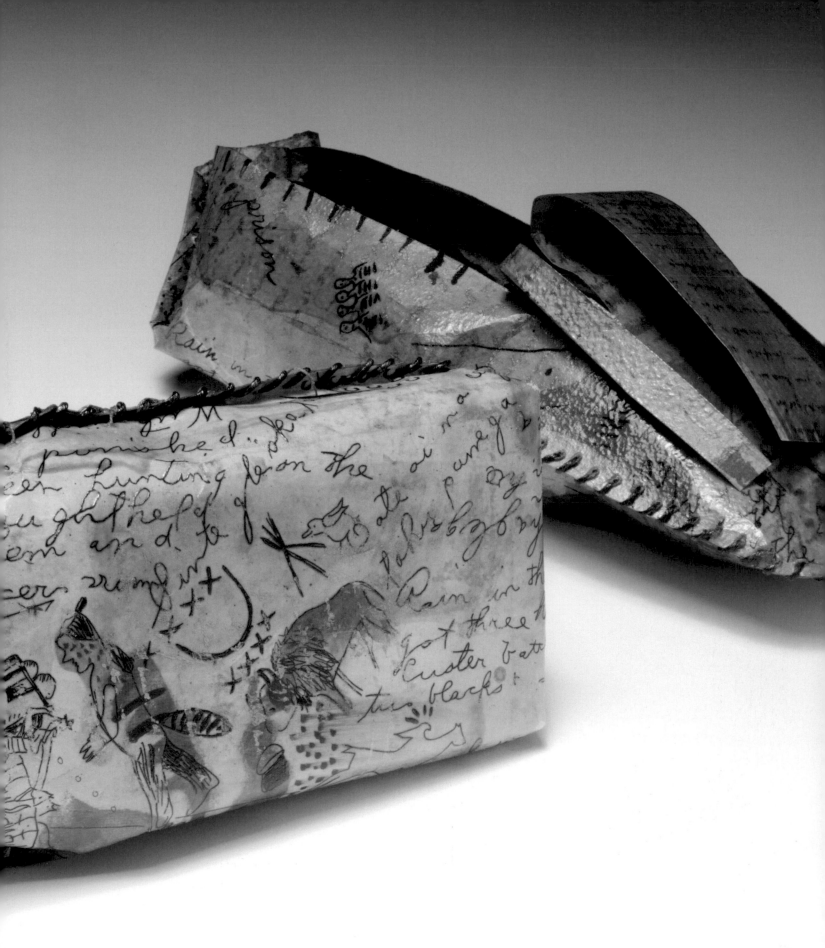

RACHEL WHITEREAD
(born UK, 1963)

Secondhand, 2004
Produced by 3TRPD,
Newbury, Berks
Published by Counter
Editions, London
Edition of 400
Stereolithography or
'rapid prototyping' in laser
sintered white nylon
H: 11 cm W: 16 cm D: 10 cm
E.502-2005
Purchased through the
Julie and Robert Breckman
Print Fund
Courtesy Counter Editions,
London and copyright
the artist and Counter
Editions, London

Rachel Whiteread is known for her casts of spaces inside and around household objects, furniture, interior fittings and even whole buildings. Such pieces have a strong metaphysical presence, summoning by their inversions a sense of history and previous lives in particular places. Work of such scale and dimension would hardly seem to relate to print, yet she has made not one but two works that push further the accepted boundaries defining the medium.

The first work was *Herringbone Floor*, an application of laser engraving in keeping with her abiding interest in industrial processes (see page 44). *Secondhand* uses an even more recent industrial process known as stereolithography. The end product is formed of a nylon photopolymer laid down in infinitesimally thin layers one on top of another (as lithographic ink might be transferred from plate to paper but multiplied hundreds or thousands of times). Gradually this process builds a 3-D object: it can be controlled to produce anything from low relief to the elaborately three-dimensional. The process is described in some detail on various websites and is constantly being developed, but to summarize, it works as follows: a 3-D model of an object is created in a Computer Aided Design (CAD) program. Software then slices the model into very thin layers, typically five to ten layers per millimetre. A 3-D laser printer 'prints' the first layer of light-sensitive (photo) polymer on to a base, and this is then exposed in a tank to ultraviolet light, to harden. After hardening, the process is repeated with the next layer, and so on until the model is complete. Overall time to completion depends on the size of the object, but the process can be repeated as many times as required. Smaller objects can be produced several at a time.

Secondhand was created from a collection of doll's house furniture of uncertain vintage but clearly invoking the shabby arrays of real furniture that tip on to the pavement in so many urban high streets. As a miniature, the piece is both jokey and endearing, but it has a subtle poignancy too. Like Whiteread's full-size plaster casts of rooms and domestic spaces, the solidity and translucent whiteness of this piece give it a tombstone presence – a kind of memorial to the thousands who once lived the lacklustre lives that this furniture so touchingly evokes.

4. FOUND AND APPROPRIATED PRINT

The appropriation of print as a creative strategy is a widespread contemporary practice. Artists have used a variety of approaches to found print, including the manipulation and alteration of an existing design; using the printed material as substrate, and physically modifying the material by cutting and reconfiguring it. The original image and its facture as print play significant roles in the meaning of the work.

One area where appropriation has been particularly effective has been in the use of recognized prototypes to subvert or reverse historical or cultural 'gaze' or viewpoint. African-American artist **Renée Green** is interested in the way in which our perception of history is moulded by the objects we see around us every day. By subverting this familiarity, Green underlines the fact that the survival of particular kinds of objects and images does not necessarily mean that they represent the only historical 'truth'. In *Commemorative Toile* she used print very effectively in this respect. She took an example of the popular plate-printed cotton fabric known as toile de Jouy (named after the town in France where it was first produced in the eighteenth century) and characterized by such motifs as girls on swings, courting couples

Renée Green
(born USA 1959)
Commemorative Toile
Furnishing fabric and
wallcovering designed
for the installation
Taste Venue at the Pat Hearn
Gallery, New York, 1994
Printed at the Philadephia
Fabric Workshop, Philadephia

Screen print on cotton
voile backed onto paper
Width of roll 144.2 cm
E.2320-1997

or bucolic idylls, framed by rococo cartouches, and replaced some of these vignettes with little-known scenes from 'black' history. These include a black man and a white one sitting at a table discussing the 'Code Noir', a legal document barring miscegenation; a black soldier lynching a white one, taken from images of the Haitian Revolution, the successful slave rebellion led by Toussaint l'Ouverture, and scenes from literature. These 'new' images were inserted into the original design through computer manipulation, and the whole was then screen-printed onto linen, which was then used for soft furnishings, a wall-covering and costume for gallerist Pat Hearn, for an installation, *Taste Venue*, in her New York gallery in 1994. **Yinka Shonibare's** tableaux, also reliant on printed costume and furnishings, are discussed in Chapter 3.

Although French-Algerian artist **Zineb Sedira** did not appropriate a specific printed pattern to make her wallpaper *Une Génération de Femmes (1997)* – a variant was also printed on tiles – she did adopt the basic design from one of the geometric patterns characterizing the surface of much Islamic art, craft and architecture, whether carved, moulded or painted. Into this design she incorporated portraits of her

daughter, mother and grandmother, and of her own eyes, suggesting that in Islamic society women have an integral role to play but one that is woven into its fabric, and not always visible. Her work critiques the male domination of Islamic society but also the Western perceptions of and fantasies about that society. She speaks too of how the use of computer technology 'to generate the images and the texts, extends the boundaries further – pushing the work into a contemporary language, a dialogue for a present generation, a radical transgression which does not represent a clear transfer from one cultural point to another.'[1]

Carrie Mae Weems' wallpaper *Looking High and Low* (1993) is recycled from a woodcut design by the English illustrator John Farleigh for the endpapers of George Bernard Shaw's *The Adventures of the Black Girl in Her Search for God*, first published in 1932. Weems felt this diminutive black-and-white repeat pattern of a girl's head and back among foliage was particularly appropriate as a backdrop for a photographic record of her own spiritual odyssey to the slave ports on the West Coast of Africa. The use of a white artist's 'Africanizing' design in this context underscores

the European appropriation of Africa, its people, culture and resources.

In some respects the technique practised by **Grayson Perry** – whose primary medium is ceramic – is not so very different from Renée Green's. He incorporates found print into the decoration of his pots as a potent signifier of 'real life'. Pots are objects that are 'nice', decorative and inoffensive, suggesting a cultivated and civilized environment, an association that Perry effectively subverts with his narrative decoration, introducing – or uncovering – unpleasant situations often obscured by the polite veneer of family values. Due to the flexibility of screen-printing, Perry has been able to transfer a variety of image types taken from comics or children's book illustrations, as well as family snapshots, fabric samples, labels and signage, to the surfaces of the pots, mixed in with his own tragi-comic drawings.

Another increasingly popular strategy is to take a printed page, book, poster or some other readymade graphic work, and 'treat' it – perhaps cutting, sewing, scorching or simply over-painting or drawing. This is not a new phenomenon, of course: the Dadaists were collaging bus tickets and newsprint

Zineb Sedira
(born France 1963,
lives and works UK)
Une Génération de Femmes
Wallpaper, 1997
Printed at London
Printworks Trust
Screenprint from CAD
Width of roll 71.3 cm
E.2319-1997

in the early twentieth century, and artists such as the Swiss American **Christian Marclay**, who collages or reworks record sleeves, have consistently worked with found print over many decades. However, there are a variety of imaginative contemporary applications, which can be considered under the rubric of 'printmaking'.

Georgia Russell uses books and their constituent parts for their associations, tapping into their invisible histories of ownership and use. She 'un-makes' books, book jackets and printed sheet music by simply cutting, folding and overlaying. The resulting works are extraordinary flowerings of fragile new forms, often analogous to organic material, with their feathered fronds like grasses or seaweeds suggestive of words and sounds breaking out of the confines of their conventional formats. As a Scot, she found a personal resonance in a book jacket taken from *The Clans and Tartans of Scotland*. She cut and shaped it, leaving the title intact and legible, in the process unlocking its latent potential. No longer subservient to the text it once wrapped, it became a new thing that holds in delicate balance both the associative traces of its past identity and the implications of its new form.

Anne Rook, on the other hand, 'makes up' books (and wallpapers and body stockings for trees!) from hundreds of replicated fruit labels (see Case Study, page 64).

The potential of the printed page has been explored by **Susan Stockwell** in her creation of modish gowns in a late nineteenth-century style, made from stitched-together pages of world atlases – signifying the siphoning of imperial wealth into the purses of the aristocracy. In a related work on commodity trading, she used a printed dressmaking pattern as support for a world map marked out with tea and coffee stains. In its mapping of the body, the pattern underscores the idea that we map the world to control and shape it to our own ends. Printed instructions, such as 'shorten or lengthen here' – which appears at the African Cape – mock cartographic imperialism. Another artist, **Jonathan Callan**, has made work where he pinpricks images through the folded sheets of maps as an ambiguous inscription of political commentary. **Cornelia Parker** has also used maps – in her case by taking the whole atlas and scorching it selectively (see Case Study, page 62).

Johannes Phokela used maps of a different kind – discarded architectural blueprints for a football stadium in Dakar – as foundations for a number of works, including a painted copy of Rembrandt's *Hendrickje Bathing*.[2] The stadium was built by the Chinese and Phokela suggests that its construction was connected to something far larger than itself. In Phokela's image, Hendrickje gazes introspectively at her private parts in the mirror of water, which the artist has turned blood red and disrupted by a Fontana-like slash.[3] This curious melding of images reflects on the enduring and problematic influence of seventeenth-century European puritanism, particularly in South Africa (Phokela was born in Soweto); on the questionable circumstances of economic aid to Africa and on the pervasive violence that is bound up with this history.

One of the practices of the Brazilian **Jarbas Lopes** is to subvert his country's prolific election posters showing portraits of the political candidates. He takes these posters (offset lithos on vinyl), layers and cuts them into strips, interweaves the images of opposing candidates and re-posts them on the streets. His work reflects the strategy of 'making do' that many South American, and in particular Brazilian, artists rely on in making work that

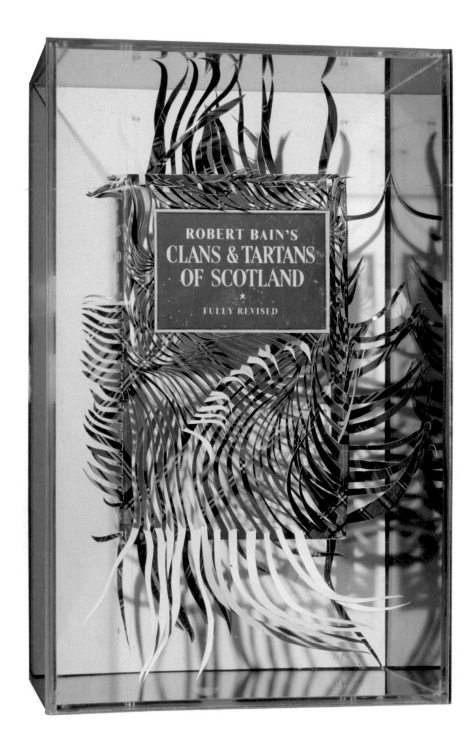

Georgia Russell
(born UK 1974)
*The Clans and Tartans
of Scotland*, 2002
Printed paper book jacket,
cut and folded
Unique work
32.1 × 20 × 12.7 cm
(in perspex box)

E.333-2003
Purchased through the
Julie and Robert Breckman
Print Fund

reflects a society and economy with huge inequalities and contradictions. Also using printed material in the public domain is **Angus Fairhurst**, who has appropriated billboard-sized commercial posters, and cut away all the original text and those areas of the image where any part of the human body occurs, creating an elusive palimpsest of absences.[4] These, and the similar works he makes using magazine pages, are part of his on-going critique of consumer culture.

Elsewhere, pursuing his interest in creating something new through a process of bringing objects to the brink of destruction, Fairhurst has appropriated the front pages of a year's supply of six different newspapers. Photocopied over each other so each panel represents a week's news, the process virtually destroys their legibility.[5] The Egyptian artist **Sabah Naim** has also reconfigured newsprint, folding papers so that only their rounded spines are visible, pressed close together and arranged in variants of diagonal and vertical patterns to suggest, as Fairhurst may also be doing, the multiplicity of views and information available in metropolitan life, while perhaps also indicating the impossibility of getting to the truth. Naim's arrangement also suggests the abstract patterning intrinsic to Middle Eastern visual culture.

For **Wangechi Mutu**, raised in Kenya but now living in New York, the printed fashion magazine provides subject matter and material. Cut-out fragmented limbs and faces are collaged together with blotchy ink and watercolour

Jarbes Lopes
(born Brazil 1964)
Untitled, 2004, from
the series *O Debates*
Offset lithographic posters
on vinyl, layered, cut
and woven
92.5 × 66.5 × 1 cm
(unstretched)

E.487-2005
Purchased through the
Julie and Robert Breckman
Print Fund

patterns. The deformed glamour of these surreal, decaying mutants questions the parading of attenuated female flesh as the ideal of beauty in Western print and television media, when real starvation exists in so many parts of the world. African American **Ellen Gallagher** also takes the fashion magazine as her point of departure for work in various media, much of it using print. Her 3-D additions, formed in yellow plasticine, to magazine pages showing hairstyles, highlight conflicting needs and desires around conformity and individuality, authenticity and artifice. Magazine pages – as well as labels, banknotes and other commonplace printed matter – are the raw materials for **Ellen Bell's** exquisite paper garments, some life-sized, others on the scale of fairy-tale miniatures. Like Georgia Russell, Bell chooses her printed sources with an eye to their specific associations or allusions – sometimes humorous, sometimes with narrative intent – as well as their decorative potential (see Case Study, page 60).

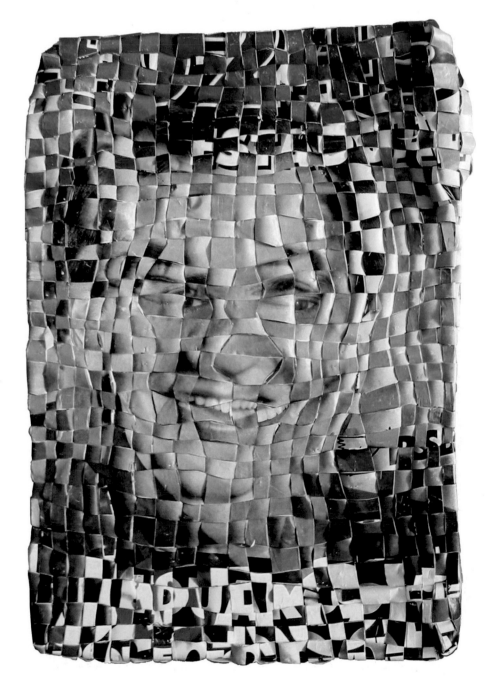

ELLEN BELL

(born UK, 1962)

The Journeyman, 2001
Unique work: paper, magazine
page, thread and wire
76 × 71.5 cm
E.1094-2002
Purchased through the
Julie and Robert Breckman
Print Fund

Artists have been using found materials since Picasso and Braque 'invented' collage, but many are now making 'prints' that incorporate, or are wholly constituted from printed materials culled from everyday life: books, magazines, posters, packaging, maps and stamps. These found materials – often used, discarded, damaged and ostensibly valueless – appeal because of the associations attached to them, the traces of a former life that they can import to the new work. They perform like souvenirs, embodying experience and evoking memories.

Ellen Bell makes paper sculptures, often in the form of miniaturized (or child-sized) clothing, incorporating everything from newsprint and labels to banknotes. *The Journeyman* illustrates the story of *The Six Swans*, a fairytale that survives in several versions. In summary, six brothers are turned into swans by their wicked stepmother.

They can only be set free if their sister remains silent for six years, while she sews a shirt for each of them. She is meanwhile courted by a king, marries him and is then falsely accused of killing her newborn babies. Unable to speak in her defence, she is condemned to death by fire. She has finished her sewing, but for the last sleeve on the shirt for the youngest brother, and as the swans swoop down to save her from the flames she throws the shirts over them, and they are transformed back into men. Only the youngest brother retains forever one feathered arm where the missing sleeve should have been.

By using a photographic image of swans, taken from a magazine and pieced into a paper shirt perfect in every detail, Bell gives the story substance and a connection with the real world. The found print works here to imbue the shirt with an aura of authenticity, as if it were the physical proof of a magical event, accidentally left behind.

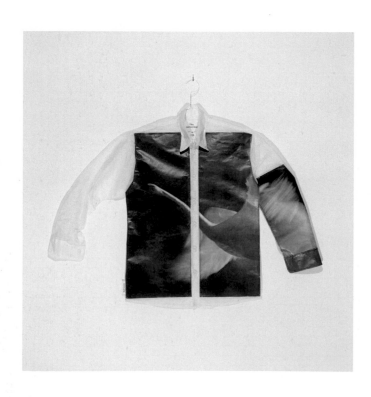

ANNE ROOK

(born France, 1945)

*The Book of Golden Delicious
4021 and 4020*, 2002
Sheets (6) [4 illus.]
plus title page in a clear
plastic food box
Printed and published
in an edition of 100
by the artist
(MM Visual Catering)
Inkjet on blueprint paper
Each sheet 14.9 × 10.5 cm; box,
H: 4.5 cm W: 13 cm L: 18.2 cm
National Art Library

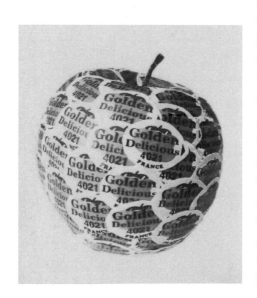

Anne Rook is concerned with the way the economics of agriculture and changing life styles have pushed food production and consumption into a kind of straitjacket. She questions the globalization of the food industry, and uses the production and preparation of food as a vehicle for exploring the relationship between language, culture and identity.

Over a number of years she has systematically collected and archived the tiny labels that now appear on fruit on every supermarket shelf. There is always a PLU (Price Look Up) number, coding the type of fruit and sometimes its size, to ensure correct pricing at the till. International in application, protecting the supermarkets' interests and possibly the customers', they implicitly declare the irrelevance of local production for local markets. Like Cecilia Mandrile (see page 24), Anne Rook combines computer manipulation and digital printout with hand-crafted cutting, stitching and sewing. Using a scanner and computer she reproduces multiple sheets of labels, which she then cuts out individually by hand. These are pasted over the surface of fruit, heat transferred to fabric, stitched into body stockings for trees, and made up into illustrated 'recipe books' or wallpaper patterns, where labels substitute for depictions of fruit, flowers and trees. The ubiquitous clear plastic boxes of the food trade are 'bindings' for her 'narratives'. Here, scanned, label-covered apples, digitally printed on translucent architectural blueprint paper, simultaneously suggest a certain opacity in the food trade and the 'designer' nature of these fruit.

Other plastic boxes hold transparent melinex sheets printed with a 'compote' of labels, tastefully arranged, complete with caption-as-menu-item. The aesthetic reflects the 'ready meal', which inherently devalues food preparation and the ritual of mealtime as key elements of our social and domestic life.

On the front page of another 'book' two chickens, all bound limbs and naked flesh heraldically speared on to carving knives, read as some kind of S&M ritual. Roasted flesh torn apart by human fingers on the following melinex 'pages' suggests a sinister, predatory aspect of human appetites. Between each transparent page an opaque one is repeat-printed 'Chicken Reluctant' in a typeface mimicking tombstone engraving. Both witty and poignant, *Chicken Reluctant* puns on such recipes as Chicken Kiev with its associations of glamorous dining, but also points to a disregard for the welfare of creatures on which we ultimately depend.

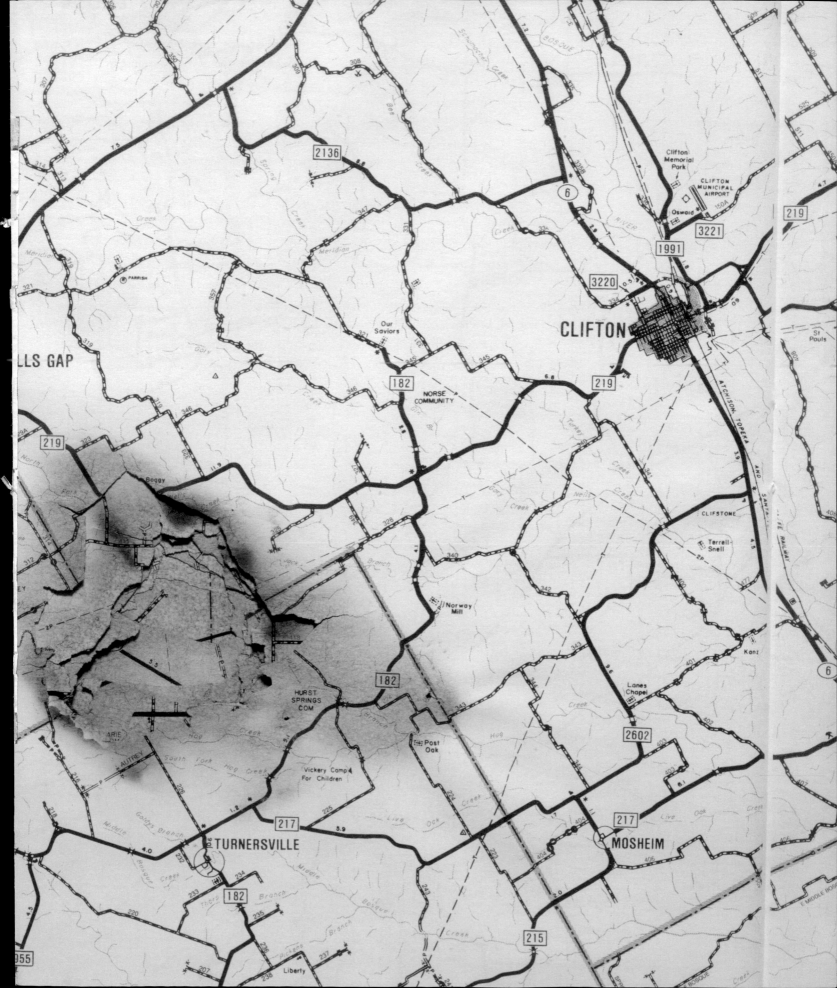

CORNELIA PARKER
(born UK, 1956)

Meteorite Misses Waco, Texas
From the suite of 6 map
works entitled *Meteorite Lands
in the Middle of Nowhere,
The American Series,* 2001
Published by the Multiple
Store, London
Edition of 20
Road Atlas scorched with
heated meteorite, framed
47.1 × 65 × 3.7 cm
E.262–2005
Purchased through the
Julie and Robert Breckman
Print Fund

Cornelia Parker is interested in the relationship between the very mundane and the earth-shatteringly significant. Things generally disregarded or discarded – dead spiders, feathers, lumps of chalk, for example – are isolated and captioned with texts that immediately freight them with meaning. Elsewhere she will drastically transform an object by subjecting it to extremes such as burning, crushing or guillotining. A gold wedding ring was drawn into the finest thread, a suit shot with pearls from a necklace, domestic silver steam-rollered. There is an aura of ghosts in such works – associations with a particular place, person or time that invite us to reconsider our own relationships, history and mortality.

For Parker, found print has been an important part of this cycle of appropriation, disfigurement and resignification. During the 1990s she made pieces with a dictionary and a Bible damaged by shot or fire, and in 2001 she made an editioned series of 'manipulated' maps.

These are from a number of works in which Parker explores our relationship with meteorites: she burned a shirt and hat with one, ground another and added it to fireworks, and threw a third into a lake. In their potential capacity to annihilate us completely, meteorites have assumed an almost obsessive place in the popular imagination, but their threat is no greater than that we pose to ourselves, and nowhere is this more clearly suggested than in these 'map' pieces. To make them, Parker heated a real meteorite and scorched six carefully selected place names in the United States in as many maps, several pages thick; in each case the meteorite scorches through not just one page but deeply into two, three or more, signifying both implosive force and a knock-on effect on other regions not immediately visible. Individual 'landings' are hit or miss. The scorch marks, of course, are slightly different in each of the twenty maps of each edition, but the 'landing place' remains the same.

The associative power of the chosen place names is self-evident: Bagdad (Louisiana); Paris (Texas); Bethlehem (North Carolina) (all 'hits'); Roswell (New Mexico); Waco (Texas) and Truth or Consequences (also New Mexico) (all 'misses'). In another series, meteorites hit Britain, landing on the Millennium Dome, Buckingham Palace, the Houses of Parliament, Wormwood Scrubs and St Paul's Cathedral.

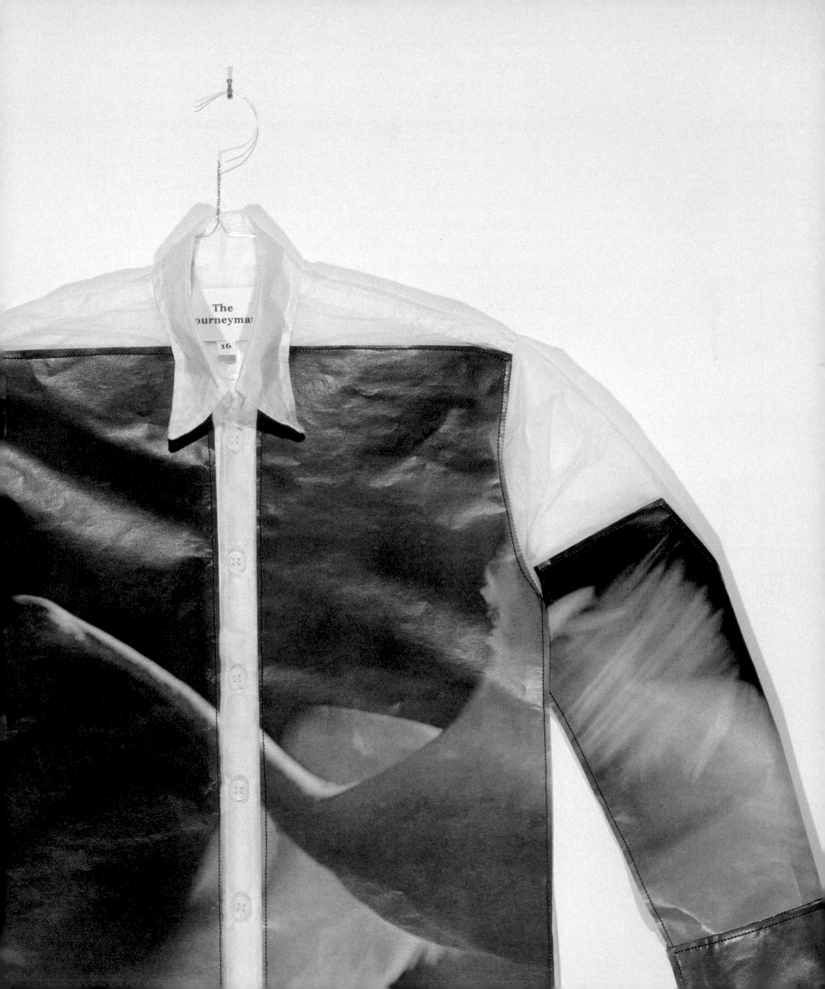

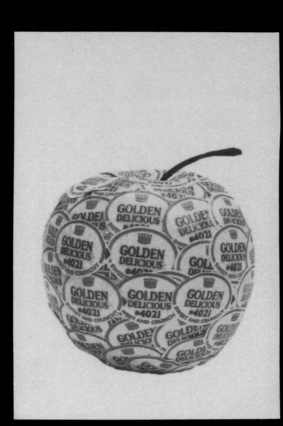

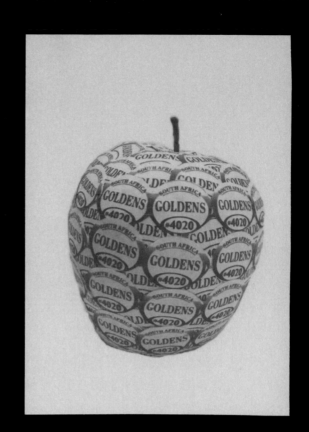

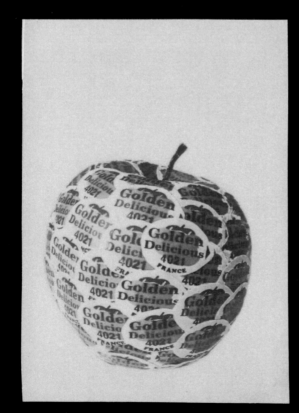

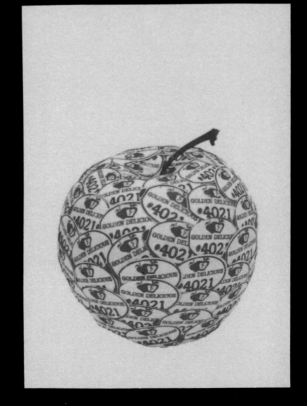

5. NEW NARRATIVES

Although in broad terms this book focuses on printmaking in Britain and the United States, many of the works discussed are by artists from under-represented communities in these countries. Although producing art and artists for generations, it is only comparatively recently that such communities have come to greater public attention with centre-stage positions at major international events such as the Venice Biennale and Kassel Documenta. Print, fundamentally democratic, has enabled many from these communities to reach a wider audience.

Wide-ranging facilities available at many workshops have also been responsible for encouraging artists or projects that contribute to new narratives in art history. Predating the period under discussion, Tim Rollins & his Kids of Survival (KOS) stand as an inspirational example. Rollins' work with a group of learning-disabled adolescents from the Bronx in the United States, a constituency with hitherto little or no say in public cultural discourse, was shown at the Venice Biennale in 1988. Their achievements are well documented, but the *Temptation of St Anthony* in 1989 was their first print series, for which they

worked at Crown Point Press.[1] More recently artists such as **Ellen Gallagher** and **Fred Wilson** have represented the United States in Venice, and both have produced print at Two Palms Press in New York, and Crown Point and the Rutgers Center for Innovative Print and Paper (RCIPP) respectively.

As RCIPP's founding director, **Judith Brodsky** has been an outstanding advocate of the under-represented. Trained as an art historian as well as a practitioner, she established the Center in 1986, motivated by her love of printmaking, which she wanted to see succeed at the university where she was teaching. Through feminism she became keenly aware of women's problems globally, and through this of the challenges facing the Latino, Native American and African American populations, both male and female. She set up a programme of residencies, regularly inviting artists from around the world, but especially from these latter constituencies, both as makers and teachers. Many students came from similar ethnic or racial backgrounds. Lynne Allen, an artist of Native American descent, whose own work is highly innovative regarding new narrative (see Case Study, page 50), is now the director.

Rutgers is interested not so much in engaging artists who have a track record of brilliant printmaking, as in supporting those who contribute new cultural narratives. Visiting artists such as **Maria Magdalena Campos-Pons** (see Case Study, page 74) need not have studied or made prints before taking up their residency, but RCIPP lives up to its claim for innovation, thanks to the most creative technical advice and collaboration. **Jaune Quick-to-see Smith**, for example, says she could never have realised *What is An American?* (see Case Study, page 72) without the truly imaginative and dedicated input from master printer Eileen Foti, although this crucial practical inventiveness from master printers and papermakers is often overlooked.[2]

Judith Brodsky herself is of Jewish descent. Trained as a printmaker, she continued to make prints while teaching, but in common with many Jewish artists working during the post-war decades, her own cultural heritage was not a subject for open discussion. Brodsky credits the opening up of identity issues by black and Native American artists as encouraging Jews to be more open about their own. In her own case, the exploration was triggered by

Thamae Setshogo
(born Botswana, c. 1970)
Insects in the Garden, 1993
Linocut
Printed surface 50.6 × 61.2 cm
E.729-1993

her students' interest in the philosopher
Hannah Arendt, prompting her to
research the relationship between
Arendt and her mentor, lover and
ultimately betrayer, Martin Heidigger –
resulting in a series of images engaging
with the Holocaust. However, living all
her life in the United States, Brodsky
did not experience the Holocaust at first
hand; she felt it more appropriate to
work with personal knowledge, although
implicitly taking in other experiences.
This led to a major series of photo-

etchings, *Memoir of an Assimilated
Family* (begun in 2000 and on-going),
using family snapshots to explore ideas
around family, immigration, assimila-
tion and difference. While the thread
of Jewish culture draws the whole
together, it also prompts consideration
of a more generic need of family and
cultural values for personal survival.
A plain, bold typeface for matter-of-
fact texts below each image militates
against sentimentality, while the
choice of intaglio, evoking the 'graven'
or permanent, together with the hugely
expanded scale, transform the snap-
shots from the personal and ephemeral
to the seriously historical.

Much of Europe and North America
is well endowed with workshops and
studios, whether focused on the needs
of independent artists, commercial
concerns or local communities.
However, in recent years there has
been an interesting development in
the so-called Third World, including
some of the aboriginal communities
of Australia. Printmaking on paper has
been encouraged where hitherto it had
not been part of traditional cultural
practice, and following the example
of Inuit communities in Canada's
Northern Territories, where print-
making was introduced in the 1950s

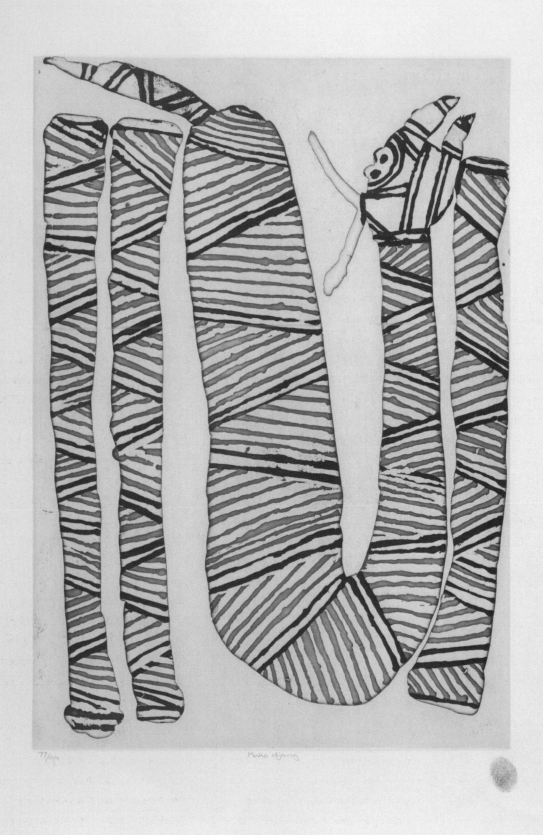

77/99 Maka djang

Peter Narbarlambarl
(born Australia, Oenpelli
Region 1930, died 2001)
Mako Djang [didgeridoos
and secret place], 1999.
Printed by Monique Auricchio
at Northern Editions,
Northern Territory
University, Darwin, NT

Edition of 99
Printed surface
49.2 × 34.2 cm
E.256-2005
Purchased through the
Julie and Robert Breckman
Print Fund

and continues today, other cultures have been encouraged to record their myths and characteristic imagery in printed form.

In 1990 the Kuru D'Kar Trust, a charity working to preserve the communities of the Kalahari region of Botswana, Africa, set up the Kuru Art Project, enabling local people to benefit financially from their artistic skills. The San Bushmen have been increasingly subject to the depredations of global market forces and have become pariahs in their own land, but the Kuru Art Project has survived, and at the time of writing, fourteen or so artists belong to it. One of them, **Thamae Setshogo**, is represented in the V&A's collection with two linocuts, *Womans Behind Elephant Head* and *Insects In The Garden* (both 1993). The latter is particularly accessible and moving, if we consider the tremendous achievement a garden must be in the arid Kalahari region. The imagery has a curious affinity with the description of a vegetable plot in *A Question of Power* (1973) by South African-born novelist Bessie Head: workers on an agricultural project in Botswana take touching pride in the neat rows of vegetables, the pattern of which is likened to that of New York streets described by an American volunteer worker.

The forces of nature, both menacing and delightful, are evoked in a row of huge dancing insects, which are nevertheless balanced, both pictorially and symbolically, by the loving husbandry of the plants. The work exhibits the formal traits that are found in Bushman decoration of leather, ceramic and textiles; however, the art project encouraged artists to work such patterns in linocut or lithography.[3] As print on paper the pattern-making becomes a saleable commodity, raising cash for tools and other resources to support subsistence farming.

In Australia, aboriginal communities have historically, as in the mineral-rich regions of South Africa, suffered an insurgence of white colonizers. However, as in Botswana, a number of communities have been encouraged to produce marketable objects. The original impetus behind the white interest in aboriginal art may have been different from that behind the interest in South African prints, but the outcome is similar and the development of printmaking as a cultural pursuit has encouraged self-respect in communities frequently riven by unemployment, alcoholism and suicide. A system of print workshops had been well established across

Australia since the 1960s, catering to white artists. Aboriginal artists also began experimenting with printmaking in the late 1960s, but gained visibility relatively slowly.[4] From the 1980s, however, an increasing interest in aboriginal arts, arising from a complex of civil and land rights activism, led to figures like Basil Hall, now at the university-based Northern Editions studio in Darwin, and Theo Tremblay, now in Bungendore in New South Wales, specializing in aboriginal printmaking, providing materials and professional guidance as well as brokering publication. Indeed, Tremblay has won awards from the Council for Aboriginal Reconciliation.

Printmaking on paper with the possibility of multiple images offers a wide dissemination of imagery and knowledge of the various cultures that make up the complex aboriginal populations. As land rights are a crucial and ongoing issue, the land, with its secrets and myths, is central to the visual culture. In *Mako Djang* (literally 'didgeridoos and secret place') (1999), **Peter Narbarlambarl** from the Oenpelli region in western Arnhem Land, Northern Territory, combines creation myth with formal characteristics typical of more traditional bark and body

painting. His brush bite etchings show a remarkable combination of delicacy, energy, control and spontaneity.[5]

In 2002, Hall and Tremblay both worked on *Yilpinji* (love magic), a portfolio of aboriginal prints that relate to the complex social relationships between men and women of many aboriginal groups (predominantly here from Western Australia and the Northern Territory). Described as 'a unique cross-cultural collaboration', *Yilpinji* involved remote art centre staff, community organizations, anthropologists and a publishing house, as well as the printers and artists.[6] The difficulties were legion and included not only providing printing materials but also getting the artist's signature, or in many cases, simply their thumb print, and keeping the print in good condition for the market.

As is the case with most aboriginal visual art, *Yilpinji* draws on 'Dreamings' – the narratives of indigenous myths that have profound societal and behavioural implications and in which land and landscape play integral roles. Instead of human and animal figures, they depict 'tracking' patterns (which aboriginals read as naturally as they speak) to denote activities such as walking, resting and hunting. Plants too are represented by similarly coded imagery to do with colour, leaf and seed shape, and so on. In the colour screenprint *Kaningarra* (2002), **Susie Bootja Bootja** shows a travelling couple resting after digging a waterhole in the bush. The picture shows small boomerang shapes (the shape people leave impressed on the ground after sitting cross-legged) beside a black disc (the waterhole) while around them a beautiful pattern of lilac, blue, black and white flecks represents bush onion and stones. Distant hills bathed in the late afternoon sun are brilliant loops of colour around the margin.

A different kind of pattern-making can be seen in the work of the Mualgau Minaral Artists Collective in the Torres Strait Islands, the population of which is ethnologically closer to that of Papua New Guinea than Australia, which has administrative authority over them. Over the last two centuries the islands have been a rich source of valuable commodities for both European and Asian traders, but increasing incursions, particularly through the fishing industry, have brought problems for the islanders themselves. Following the success of a high court action over land rights in the early 1990s, the islanders began a further battle over fishing rights in 2001; federally protected commercial fishing was forcing islanders away from their traditional livelihood and into dependence on welfare. The work of the Mualgau Minaral is helping to disseminate information about the unique culture and the threatened environment (see Case Study, page 76).

Billy Missi
(born Torres Strait
Islands, 1970)
Ap Au Aidal
[Cassava and Yam], 2001
Edition of 30
Lino-cut Kaideral
(coloured *a la poupée*)
Printed surface 29.5 × 44.5 cm

E.1093-2002
Purchased through the
Julie and Robert Breckman
Print Fund
Rebecca Hossack Gallery

JAUNE QUICK-TO-SEE SMITH
(born USA, 1940)

What is An American?, 2001
Printed with Eileen Foti
at Rutgers Center for
Innovative Print
and Paper, New Jersey[7]
Edition of 20. Published
by RCIPP.
Lithograph on 6 sheets
of Japanese Tableau paper
pasted together, with
chine collé, collage, hand
painting and grommets
175 × 101.6 cm
E.3582-2004
Purchased through the
Julie and Robert Breckman
Print Fund

Jaune Quick-to-see Smith was born on a Native American reservation in Montana. She is of mixed Salish, French, Cree and Shoshone descent. *What is an American?* takes the form of the *parflêche* (literally 'parry arrow'). This was traditionally made from buffalo hide, which was used for many purposes. The hide was dried, lye-soaked, folded, tied, painted in many decorative ways and used to carry anything from food to tools. Smith has printed, folded, then opened up again, a large sheet; the grommet holes at the top allow for hanging rather than framing. By association a *parflêche* would be an ever-present 'carrier' of messages about history and origins, but also about translation of the Native American into contemporary Euro-centric culture.

Smith feels comfortable with lithography; she feels it allows for the inclusion of a lot of other processes, including watercolour, collage, photographic imagery and charcoal. Here, she lays out the territory with 'pictograms': comics, labels and so on – all signifiers of contemporary popular culture – mixed in with Native American references such as medicinal herbs. The repeat buffaloes, taken from postage stamps, recall the trading stamps offered by supermarkets as an inducement to shop, but in fact worth virtually nothing, a reminder of the exploitative deals white traders made with the natives. Surrounded by this ragtag 'beadwork' of icons is the hand-drawn figure, taken in fact from an Indian ledger book. Cut off at head and feet, she is ambiguous (allowing that an American may be a sophisticated city girl with smart 'ethnic' accessories, but could equally be a disempowered 'Native' American). Intriguingly, the ledger-book drawing suggests both Egyptian tomb painting (ancient culture) and contemporary fashion illustration (modern life).

In the aftermath of 9/11 Smith observed a poorly thought through patriotism everywhere. Tattoos of Church Fathers and hand-painted spurts of red, white and blue from the figure's hand evoke 'Christian' stigmata and suffering but overall the image suggests the less obvious suffering of Native Americans. Those whom we think of as American are shaped by industry, commerce and technology (note the 'pictograms') and dominantly of European descent. The Native American community, mostly absorbed into this modern population, at the same time struggles to rise above it and preserve a connection with its historical roots.

Americans have big ideas"

Downloading your body

Shopping

What is an Ameri

12/20

MARIA MAGDALENA CAMPOS-PONS

(born Cuba, 1959)

Untitled, 1999
Printed by Gail Deery
and Randy Hemminghaus
at the Rutgers Centre
for Innovative Print
and Paper (RCIPP)
New Jersey
Published by RCIPP
Edition of 14
Lithograph and pulp
painting through stencils
on handmade paper
51.4 × 44.5 cm (printed
to the edge of the sheet)
E.878-2003
Purchased through the
Julie and Robert Breckman
Print Fund
© Maria Magdalena
Campos-Pons

Magdalena Campos-Pons is principally an installation artist who uses video and a combination of 'readymades' and specially manufactured objects to suggest different aspects of the artist's personal memory and history, and to symbolize a much larger history of black people in the Caribbean, and more specifically in Cuba. Negotiation of difference and commentary on tolerance are recurring themes in her work. The practice of Santeria, a blend of African, Yoruba religious traditions and Catholicism was (and still is) commonplace in rural villages like the one in which Campos-Pons grew up. Altars were covered with all manner of domestic objects, flowers and craftwork, while priests and priestesses performed ritual dance. In her installations, she 'layers' film and video over objects, evoking layered memories of such assemblages and ceremonies together with events of daily life and work. The materials and processes used allow one 'memory' to 'seep' through into another.

The planographic printmaking processes invite layering of different visual styles and materials, and here, Campos-Pons 'layers' screens of eyes both over and behind the photographic image of her own body.[8] She thus creates an ambiguity of pictorial space and a duality of meaning in the image. She describes this print as 'a quiet homage to the spirit of my father', who always said she had eyes in her back, an idea characteristic of the ancestral African beliefs that informed her childhood life. Subject of innumerable myths, the eye has enormous spiritual significance and a commensurate iconography. It appears as an isolated object in many cultures as a means of bewitchment, relating to ideas both of envy and of protection. Although Campos-Pons produced this print in two different colourways, according to which the eyes may appear brown or blue, on closer inspection it can be seen that a wide range of colours is used to suggest the complexity of the inner self and the returned gaze.

In his seminal work *The Souls of Black Folk,* W.E.B. du Bois, the great African-American scholar and proto-typical black nationalist, proposes that black people are perpetually aware of the inner self as the white viewer sees it. This divided self, to be constantly negotiated and reconciled, is evoked in this image of the black woman, seeing outside of herself in an unexpected and particular way, but at the same time the subject of a white (blue-eyed) gaze.

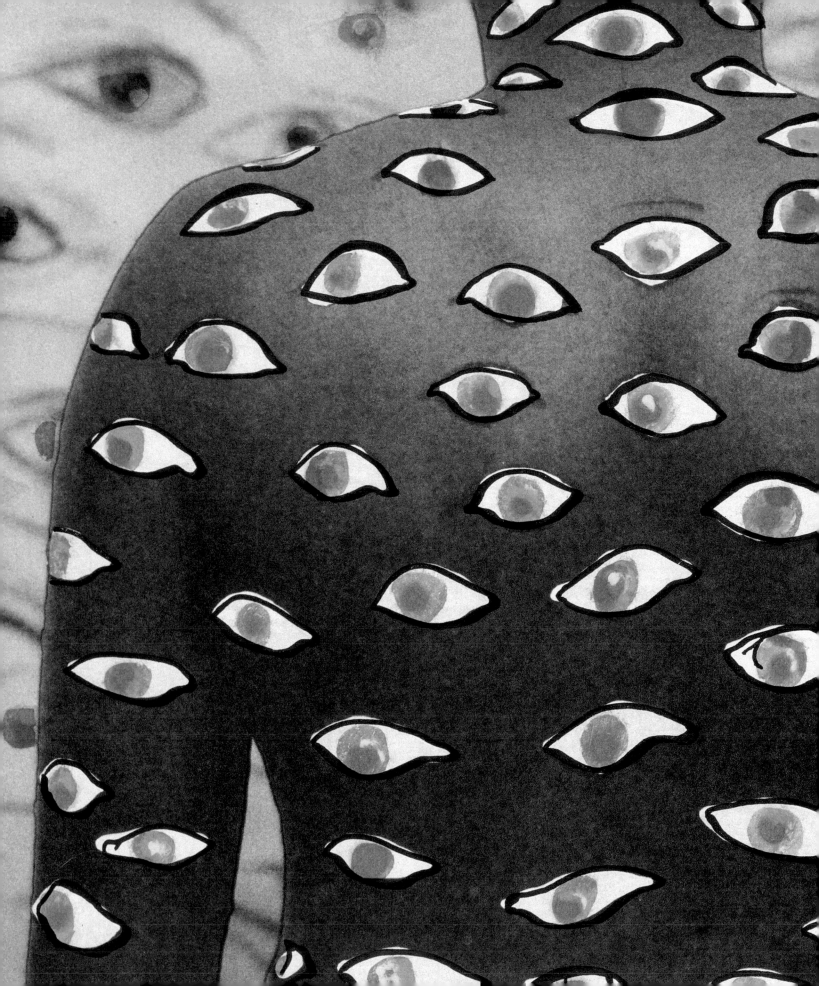

DAVID BOSUN
(born Torres Strait Islands, 1973)

Gelam Nguzi Kazi
[Dugong My Son], 2001
Colour linocut (Kaidaral)
Edition of 85
Printed surface 47 × 61.1 cm
E.1092-2002
Purchased through the
Julie and Robert Breckman
Print Fund
Rebecca Hossack Gallery

During the 1990s a group of young printmakers who had studied in technical colleges in mainland Australia were emerging in the Torres Strait Islands, between the northernmost tip of Australia and Papua New Guinea.[9] Exposure to a wider range of artistic influences than was available at home, combined with their knowledge of traditional story telling, led them to develop a trademark style that differed considerably from the fish and sea creature images that dominated a tourist-driven market. Denis Nona, credited with its initiation, describes how the idea came to him in a dream, to 'place around a single print all the elements of a large creation story… an entire narrative in one single work of art with all the characters and events linked by the clan patterning (or 'minaral'), that bound the entire story to its place of origin'.[10] The group became known as the Mualgau Minaral Artist Collective.

The 'minaral', specific to each birth group, was traditionally engraved on objects like ritual masks, but had been almost erased from the collective cultural memory through the proscriptions of nineteenth-century Christian missionaries and the removal from the islands of most material objects by anthropologists and missionaries in the 1870s and '80s. Its revived use within printmaking, where the pattern is cut into lino, allies it closely to its original form. The principal image is black and white. The process involves adding colour by lifting the print on three margins, and reapplying ink *'á la poupée'*.[11] It has been renamed *Kaidaral*, literally 'spirit that creates ripples on the surface of the water'.

In *Gelam Nguzi Kazi* we see episodes from a narrative in which a mother discovers her son keeping for himself the best of his catch (his fire burns brighter than hers with fat from his roasting pigeon). She punishes him. Disguising herself as a witch, she frightens him while he is hunting. However, he discovers her trick (cleaning lice from her hair he sees traces of the mud she has used to mask herself). Disgusted, he makes a raft in the shape of a dugong, which we see in the centre of the picture, and abandons her forever. Weeping on the foreshore, she is transformed into a rock – which can be seen on Mua Island to this day.

6. SITE-SPECIFIC PRINT

Through interventions and installations, prints are increasingly being adapted to site-specific projects of various kinds. Whereas artists using purpose-built public sites such as bill-boards are obliged to work with preset parameters in terms of size, format and location, those working in galleries and in specially selected public spaces are often producing print installations where the space itself is a constituent in determining the form, dimensions and even in some cases the subject of the work.

The German artist **Thomas Kilpper** has made a speciality of choosing redundant buildings as sites for his installations, using their contents as the tools and materials. He has realized two projects (one in Germany, one in the UK) where he cut into wooden floors to make his print blocks, and looked to the history of the site itself as inspiration for the imagery generated in the course of the project (see Case Study, page 82).

Others have used prints to colour our experience of a space, or to mediate between 'inside' and 'outside'. Printing on to adhesive vinyl film of the kind used on windows to filter out damaging ultraviolet light in museums and galleries, or to decorate shop windows,

Jennifer Wright has made prints that bring together the context and the content of the work by translating the visual experience of the world beyond the gallery into coded graphic languages of making and describing (see Case Study, page 90).

In 2002 **Chris Ofili**, working with architect **David Adjaye**, designed decoration for printed glass panels in Folkestone Library. The idea was taken further the following year, in the pavilion created by Ofili and Adjaye for the British Pavilion in Venice. On the occasion of the Queen's 2002 Golden Jubilee, **Oscar Wilson** covered the street-facing windows of Tardis studios in Clerkenwell with vinyl stencils adapted from the image of the first-class stamp. Incorporating an enigmatic linear pattern derived from 1960s-style psychedelia into the iconic royal profile, the design humorously suggested the monarch might have an interior life surprisingly different from her public face.

Since the 1980s, a rehabilitation of domestic themes in contemporary art, coinciding with the rise of the installation and the tendency for artists to co-opt commercial techniques, has contributed to the phenomenon

of 'artists' wallpapers'. These were designed not for commercial mass-production and domestic use, but to create a pretend version of domestic space for site-specific interventions, and as a shortcut to making the neutral space of a 'white cube' gallery look like home. Produced in unlimited editions as required for exhibition purposes, these wallpapers cut across conventional category definitions, being simultaneously functional wallpapers, fine-art prints, multiples and constituent parts of installation projects. Drawing on the physical characteristics and potential meanings of each category, they evade typecasting to create a vigorous, richly inventive hybrid with the power to transform spaces and subvert the viewer's expectations.

Late-1980s examples by **General Idea** (their AIDS-logo wallpaper uses a politically inspired transmutation of Robert Indiana's iconic LOVE screenprint) and **Robert Gober** were the precursors of what has become a distinct genre of contemporary printmaking. Wallpapers by thirty-four artists were shown at the 2003 celebratory 'retrospective' for the genre at the Philadelphia Fabric Workshop Museum and the Rhode Island School of Design. Artists have designed wallpapers that express

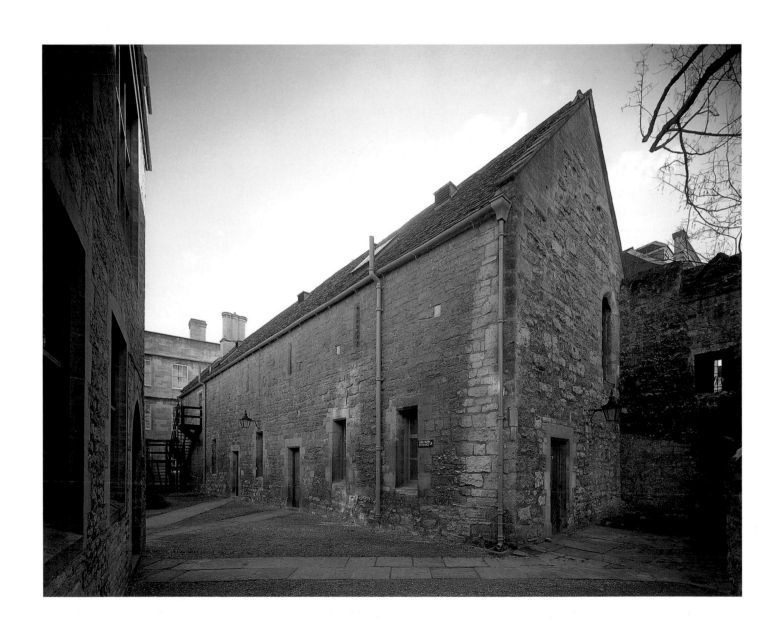

personal histories (**Carrie Mae Weems, Zineb Sedira**), explore the transformative effects of repetition (**Abigail Lane**) or incorporate a narrative or a sense of place (**Sonia Boyce, Anya Gallaccio, Lisa Hecht**). Others – notably **Renée Green** and **Virgil Marti** – have looked to wallpaper's own history and adapted historic patterns and styles to integrate social, political and cultural issues.

Marti has designed several wallpapers that use the visual language and associative potential of interior decoration in a revealing conjunction with a particular building, institution or locality. These include *For Oscar Wilde* (1995), a vivid pill-patterned flock for a Philadelphia prison, and *Beer-Can Library* (1997), which has been shown in a grandly proportioned, wood-panelled nineteenth-century interior, and also in the café of the London furniture store Habitat, as well as his famous fluorescent flock *Bullies* wallpaper (see Case Study, page 126).

Site-specific work also includes shop interiors and window-dressing. The design collective **Showroom Dummies** (which includes artist Abigail Lane and printer Bob Pain of Omnicolour) produced wallpapers and other printed furnishings for a Christmas-themed makeover for the Mulberry Company's London retail outlets in 2004. Folding screens printed with life-size reindeer were accessorized with limited edition blankets for sale, and walls were papered with delicate 'abstract' patterns based on arrangements of reindeer bones (see Case Study, page 88).

Life-size printed floors are a speciality for **Richard Woods** (see Case Study, page 84), and he has one installed on the ground floor of his own house, but he has used print for a variety of site-specific exhibits. His most recent project entailed the cladding of a building at New College, Oxford with his own woodblock-printed MDF 'wallpaper'; the simple, scaled-up red-brick pattern turned a sober seventeenth-century stone structure into something resembling a brash 'new-build' Barratt home, prompting questions about surface and substance, appearance and reality. At the 2003 Venice Biennale he installed an over-sized crazy-paving print in the courtyard of a medieval cloister. The simple process and handmade appearance of woodcut printing make it the ideal medium for Woods, with his avowed interests in DIY and domestic architecture.

Due to advances in technology that have made it possible to print on to almost any material, prints can also now be incorporated into permanent sculptural and architectural features. One of the most dramatic and engaging applications of print for an outdoor semi-public site is **Simon Patterson's** *Time and Tide*, an illuminated glass wall faced with a photo-etched image of a moonscape. Commissioned by British Land, this has been designed for and skilfully integrated into the otherwise abrupt juxtaposition of a high-rise office block (housing British Land's headquarters) and a seventeenth-century church in the City of London (see Case Study, page 86).

THOMAS KILPPER

(born Germany 1956)

The Ring, 2000
Site-specific print
installation, Orbit House,
London (detail)
Photo: Marcus Leith/
Tate, London, 2005

Below:
The Ring: Henry Cooper, 2000
Woodcut on fabric
189 × 159.2 cm
Tate Gallery
© the artist

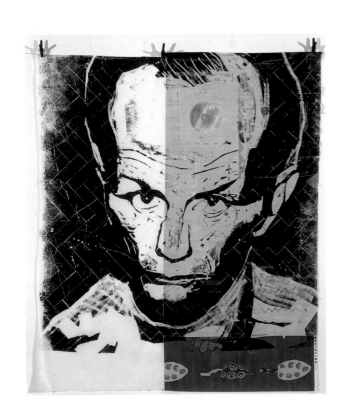

Orbit House (a 1960s office block that had formerly housed a secret printing office for the Ministry of Defence, as well as the British Library's Oriental collections) was abandoned and scheduled for demolition when Kilpper gained access to use it as the site for a print project in 1999. He chose Orbit House for the location's unusually rich history. A Wesleyan chapel had been built on the site in 1780; later tenants included an engineering firm, a furniture warehouse and one of London's first cinemas. In 1910 it became a boxing venue, the Ring, which was also used as a soup kitchen, music hall, and theatre and film set. In 1940 it was destroyed by a Luftwaffe bombing raid.

Kilpper carved a giant woodcut in the mahogany parquet on the tenth floor, an area of approximately 400 square metres, and then used this as his printing block. The central image was a boxing ring surrounded by portraits of eighty characters, mostly historic figures connected to the site, to the Southwark area or to Kilpper himself. Some famous, some obscure, they included artists, writers, actors, politicians and revolutionaries. Their portraits, derived from photographs and prints, were made into slides and projected on to the floor as templates for the designs, which he then cut into the parquet with chisels and a chainsaw. He printed from sections of the floor on to various materials, many found in the building, including old curtains, paper from advertising hoardings, and sheets of purple ultraviolet polythene film that had screened windows. The prints were made by inking an area of floor, covering it with the material to be printed and then applying pressure with a purpose-built roller weighted with cement.

As he proceeded, the finished prints were installed in a temporary display. A huge banner printed from the entire floor surface was suspended outside. The prints on ultraviolet film were reapplied to the windows, filtering the light and enhancing a theatrical sense of enclosure. Inside, he hung the prints from washing lines that criss-crossed the room, so they could be viewed from both sides, forming a web of connections between past and present, personal and political, high art and popular culture – a narrative maze in which Henry Cooper confronted Ho Chi-Minh, and Shakespeare rubbed shoulders with Marie Lloyd, watched by Nick Serota and Kate Moss, all with their relief negatives underfoot.[1]

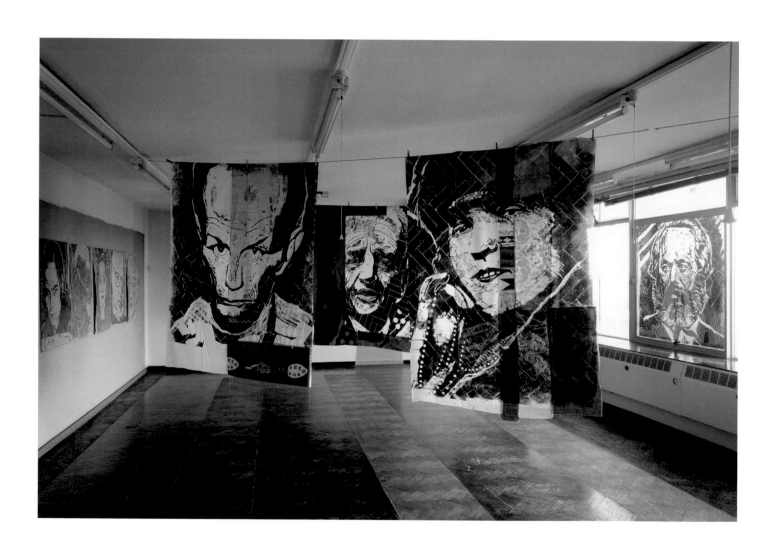

RICHARD WOODS

(born UK, 1966)

Installation view of
Super Tudor at Deitch
Projects, New York, 2003
Mixed media
© Richard Woods,
courtesy of Kenny
Schachter Rove

Below:
Re-fit, 2000
Installation at Tabley
House, Cheshire
Woodcut printed
in gloss enamel paint
on MDF
© Richard Woods,
courtesy of Kenny
Schachter Rove

Using the materials and methods of DIY, Richard Woods has adopted wood-cut for room-sized interventions where he installs printed floors, and 'wall-papers', and for site-specific works where he puts up temporary facades or external cladding. He makes these by cutting the pattern into large-scale MDF planks using a router, and then using them as blocks to print from (using a garden roller instead of a conventional printing press). His print-ing pigment is household gloss paint, chosen for its immediate connection with home decorating, but also, he has said, because 'I love the way enamel paint renovates things in a totally superficial way and draws attention to the surface of the object... so the renovation is only skin-deep.'[2] For Woods, the process is as much a part of the aesthetic effect as the motif. He prints on to thin sheets of MDF, which he then lays as flooring or fixes to battens on the walls. Of course, MDF is itself a material we have come to associate with the trompe l'oeil tricks that characterize the *Changing Rooms* aesthetic – it is cheap, adaptable and lends itself to all kinds of quick fixes.

Artists making woodcuts have often incorporated the impression of the grain of the block into the design of the print, but Woods uses the technique with a perverse wit. Since MDF has no grain, he fakes it, cutting his blocks into larger-than-life replicas of wood grain, reproducing the characteristic lines but making no attempt to disguise it as the real thing. He likens his printed motifs to 'logos' of reality, and the wood-grain pattern is his identikit logo for floor-board or plank, just as the red-brick motif he has adopted for recent projects (such as *NewBuild* at New College, Oxford in 2005[3]) is his logo for 'house', or more broadly, for ideas of domesticity. Like stage scenery, these prints are exaggerations of reality that announce their 'pretend' nature even as they function as real floors or wall-coverings. This theatrical effect characterizes all of Woods' installations, but it was crucial to *Re-fit*, a 3,000 square-foot printed yellow floor made for the dining room of Tabley House, Cheshire, an eighteenth-century Palladian-style country house. With its cartoon-like graphic character and vivid colour, this trompe l'oeil floor emphasized the stage-set presentation typical of many historic house interiors, which were styled for a deliberate display of wealth, an effect further exaggerated when rooms are arranged to accommodate a present-day audience of paying visitors.

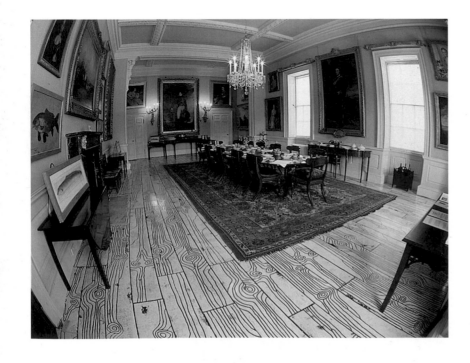

SIMON PATTERSON
(born UK, 1967)

Time and Tide, Plantation Lane, 2004
Photo-etching on glass,
with stainless
steel and LED light-fittings
Screen, 6 m × 41 m;
Plantation Lane,
approx. 120 m long
© Simon Patterson
and Arup Associates,
British Land and
Michael Light
Photos: Christian Richters

Print has become a favourite medium for temporary public art projects, but this is a rare example of print as an integral part of a permanent public art installation. The work is an illuminated glass wall – or screen – marking one side of a sliver of open space between a city office block (Plantation Place) and the small Wren church, St Margaret Pattens, linking Mincing Lane and Rood Lane. The wall, which is lit from within by ColorBlast® lights, is printed with a photo-etching of the dark side of the moon. The lights, which are evenly spaced at the top and bottom along its length, are animated with Colour Kinetics' solid-state lighting system, causing the wall to change colour. This play of light from within transforms the piece from a static image to a film screen.

The imagery itself – a close-up of the moon's cratered surface – has the virtue of being simultaneously abstract and figurative, familiar but mysterious and mutable. As he has so often done before (notably with maps), Patterson appropriated an existing image for the wall's motif. He reproduced a view of the highlands on the dark side of the moon from the book *Full Moon* by Michael Light (1999) – the original, enhanced by electronic scanning, came from NASA's archive of photographs taken during the Apollo missions.

Carefully conceived as an antidote to those urban public spaces that have been relentlessly commercialized, crowded with a visual cacophony of signage, neon and print advertising, and ill-sited street furniture, *Plantation Lane* gives dramatic purpose and point to a space that might otherwise have been blank, anonymous and redundant. Patterson's luminous wall (and the Pietra del Cardoso stone paving, inset with Jura limestone-lettered fragments of London history and embedded with shards of white light, which he also designed) is a work of public art successfully integrated with its potentially awkward site, drawing the surrounding disjunctions of scale, period, style and purpose into a vivid 3-D collage and linking these elements physically and conceptually.

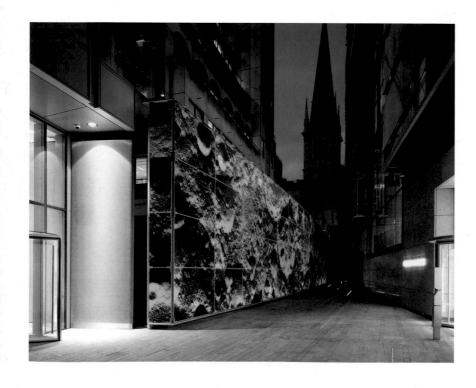

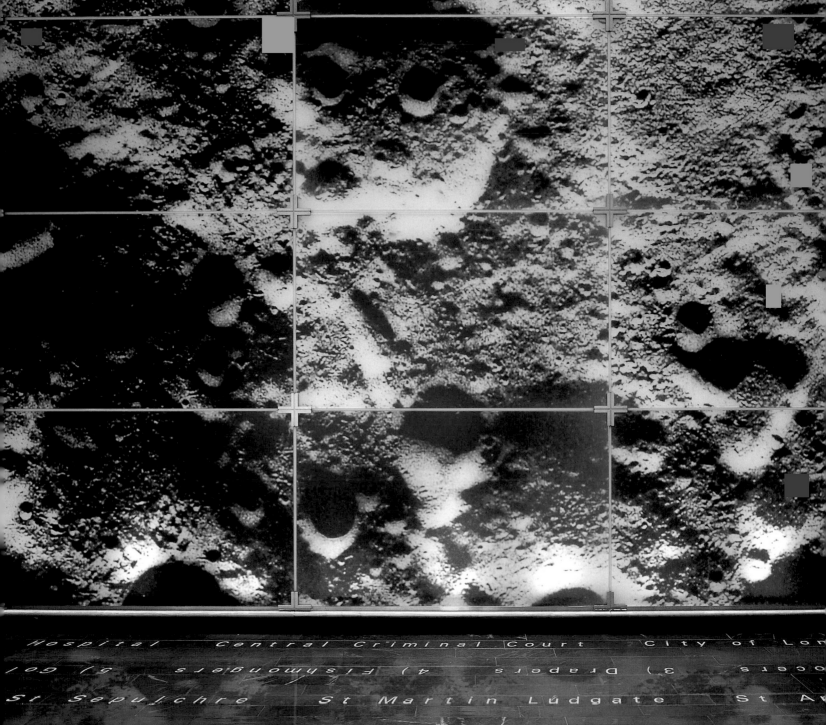

Hospital Central Criminal Court City of Lon

3) Drapers 4) Fishmongers 5) Gol

St Sepulchre St Martin Ludgate St A

Magnus the Martyr St Dunstan-in- Magnus

Magnus Clemens Maximus (d. 38

t of the East & West 17°

Victoria/victory Vu

SHOWROOM DUMMIES
(established UK, 2003)

Folding screen (below)
and wallpaper (facing page)
for Mulberry, 2004
Screen: printed at Omnicolour
Digital inkjet prints laminated
to reverse of perspex panels
200 × 300 × 3 cm
Wallpaper: prototyped
at Omnicolour and printed
at Zen, Lancashire
Photogravure
width of roll 52.7 cm
E.380-2005 and E.258-2005
Given by Mulberry and
Showroom Dummies

Showroom Dummies is a design collective that unites the complementary talents of artist Abigail Lane, fashion designer Brigitte Stepputtis, printer Bob Pain and Edwin Wright, designer and maker of furniture and theatre props. The group has so far specialized in producing wallpapers, fabrics, tiles and furniture printed with everything from dogs, bugs and lizards to erupting volcanoes and frolicking skeletons; their first collection was called *Interior Motives (Natural Histories and Natural Disasters)*. The designs and chosen motifs are bold, dramatic, theatrical and provocative, well adapted to the kinds of eye-catching display that shop windows demand. For Christmas 2004 the Mulberry Company commissioned them to collaborate on specially designed interiors and window-dressing props for their retail outlets, as well as limited edition printed blankets available to buy.

Lane is a contemporary of Damien Hirst, Sarah Lucas and Gary Hume, and was included in the seminal *Freeze* exhibition that launched the careers of the YBA generation. Much of her work has investigated strategies of display, and has included photographs of museum galleries. She had also built up a collection of photographs of stuffed animals, taking in natural history museums around the world, as part of her fascination with taxidermy which, in Lane's words, results in animals that are 'real and fake at the same time'.[4] Her independent work before the setting up of Showroom Dummies has included wallpapers patterned with ambiguous motifs, which she installed as the backdrop to macabre or mysterious tableaux. The Mulberry commission inspired folding perspex screens printed with life-size reindeer, and a wallpaper. Like Lane's earlier papers, this is not quite what it seems; it looks at first sight like an elegant rococo-style abstract design, but up close it is obvious that the patterns are arrangements of bones – reindeer bones.

Bob Pain's print company Omnicolour in partnership with sister company K2 Screen has developed print processes for commercial clients which, in tandem with the services of companies such as the wallpaper specialists Zen, allow them to offer artists a range of services that would not be available in the standard fine-art print studio.

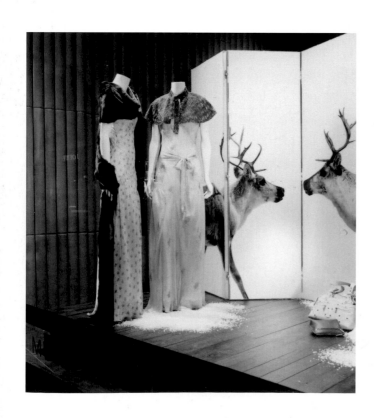

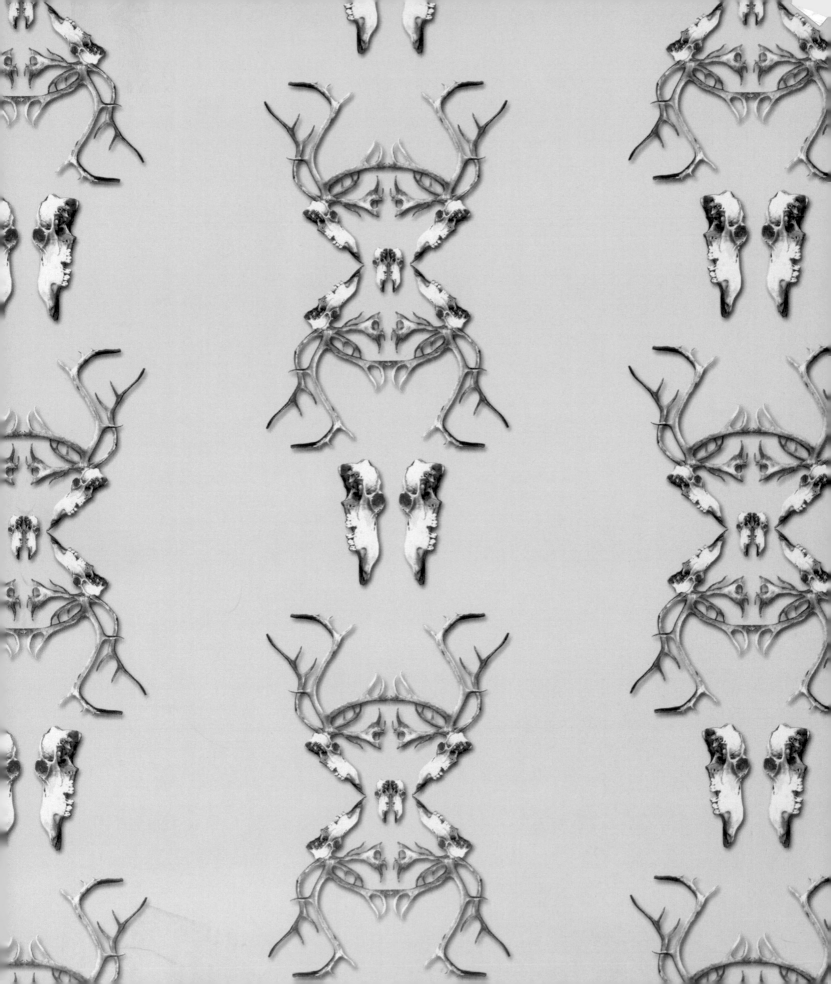

JENNIFER WRIGHT

(born UK, 1961)

DMC NCP36
One of a series of window prints made for *Space Craft* exhibition at the Eagle Gallery, London, 2004
Digital print using ultra-violet inks on opal vinyl
Overall, approx. 186 × 96.5 cm
© Jennifer Wright

Opposite:
Installation view of *DMC NCP36* at the Eagle Gallery, 2004
(with Jane Langley's *Space Craft Painting*, 2004, left)
© Jennifer Wright

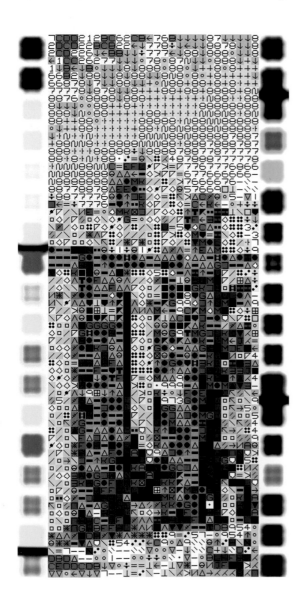

Jennifer Wright is an artist who works with textiles, and in particular with the tools, motifs and concepts of embroidery, but translated into other forms and materials. As part of her installation at the Eagle Gallery (for the exhibition *Space Craft*, with Jane Langley), Wright produced site-specific prints that she used to screen the windows in the gallery. Her starting point was a series of photographs taken through the windows of the gallery of the street scenes outside. These were imported into Photoshop, a standard computer package, which she used to enhance their luminosity. She then transformed these images into layered drawings, lifting certain elements of the visual information to create a mediated version of the photograph that functioned as a selective time-based analysis of the original visual data.

This data was then codified – or schematized – to produce an embroidery-type pattern, using software specifically designed for embroiderers to design and plot their patterns. The colour palette is DMC, a standard brand-name embroidery thread, and the printed pattern itself is expressed both in colour and in DMC code. The result is apparently abstract imagery that nevertheless holds on to vestiges of the information from the photographs – a sense of spaces and outlines, and of course the window structure itself as a framing device. Wright's other works in the exhibition incorporated translations of the window print imagery as panels of digital print on PVC and as embroidery.

Wright sees the computer as the equivalent of a vitrine – a gallery display case – which holds an image in waiting, in a transitional stage between one kind of information and another. By screening the windows with patterns produced in this way, the interior space of the gallery becomes the equivalent of this virtual 'space' behind the screen, a kind of meditative space. This effect is enhanced by the filtered daylight shining through the print-screened windows as if through digital stained glass.

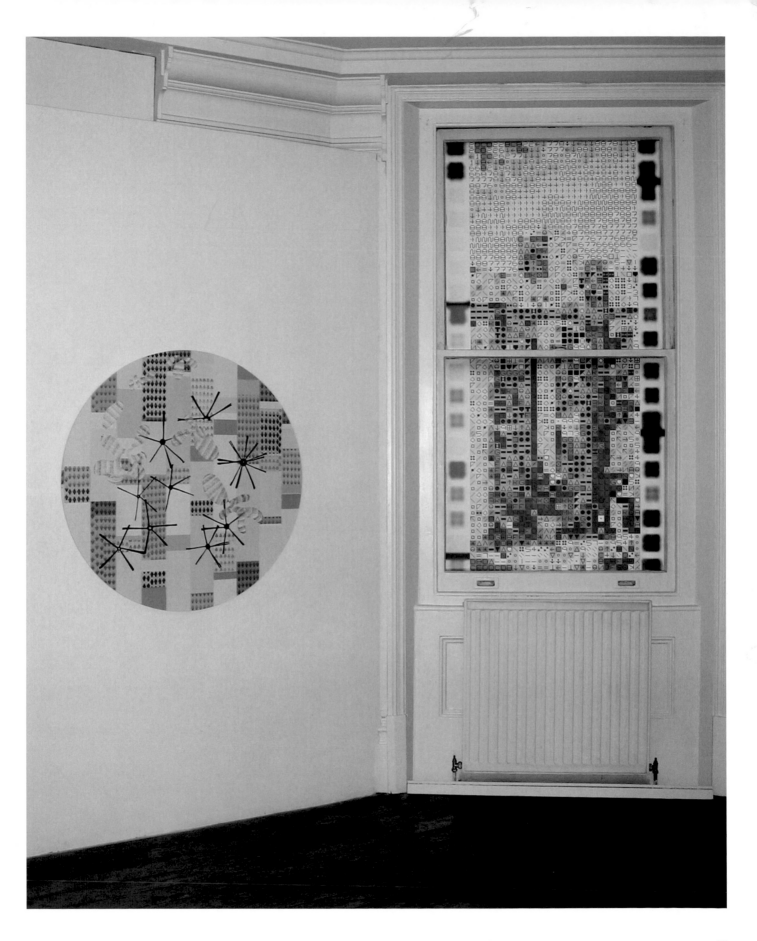

7. PRINT AS PUBLIC ART

The idea of prints as public art is relatively recent; for most of their history fine prints have been very much a private art, kept in portfolios and enjoyed only by collectors and connoisseurs. There was a category of popular prints that included broadsheets and caricatures; these *were* public in the sense that they were passed around, seen and enjoyed by large numbers of people, but until relatively recently those prints that have been displayed in public locations have been for the most part advertisements or public-information notices. Although artists have often been the designers of such commercial graphics, which promote a product or an event, there is now a category of public print that sells nothing but a concept or a visual experience.

Artists have always used the public arena and there is a well-established category of public art. However, the term 'public art' tends to bring to mind things that are substantial and permanent, such as sculpture, fountains, war memorials, mosaics and murals. Artists making prints for public places have generally engaged with the most obvious, insistent and influential imagery already on the street – and that is advertising in

all its many forms. However, some have taken street furniture and aspects of the urban infrastructure and created their own versions to infiltrate public spaces. Only relatively recently has public art come to include other categories such as performance, or ephemeral printed works, which may be site-specific in the case of certain billboards or posters, or randomly circulated in the form of flyers, bags and badges.

When he was asked by the Museum of Modern Art (MoMA) in New York to do an edition of prints, the Cuban-American artist **Felix Gonzalez-Torres** was initially unenthusiastic. He described his reaction as follows: 'I thought, why make an edition, why make a print? The world doesn't need any more prints by artists. So I said no. But then I thought about it, and I said, well, why don't we push the limits and do a billboard? The conditions are such that you can only show it in public. You have to show it in public.'[1] This was the first of several projects for which MoMA has invited artists to work with the billboard format; the results tend to be interpretations of urban landscape and experience, or have an obliquely political content (see Case Study, page 100).

Art with a political agenda, designed to draw attention to matters of public concern, naturally needs a public platform, but there are a number of other reasons why artists might make prints for the public arena. In some cases it is precisely because gallery spaces are closed to them, or because they want to subvert the values and assumptions of the institutional space, or because they want to produce work that cannot be bought and owned by an individual; alternatively, they may want to produce work that will be readily accessible to all.

The New York activist group the **Guerrilla Girls** began their campaign against bias in the art world by fly-posting their messages around the city. Likewise, **Barbara Kruger** and **Jenny Holzer** adopted the language – verbal and visual – of commercial graphics and public signage, and they both, in their different ways, set out to critique the admonitory language of government and corporations, and the seductive language of advertising. Both artists chose to put their work into the kinds of public spaces usually occupied by conventional advertisements, and both first got their work out on to the street by fly-posting around the city at night, using the cover of darkness

Adam Chodzko
(born UK 1965)
Product Recall flyer, 1994
Offset lithograph
29.8 × 21.2
E.319-1995
Given by Chris Titterington

to put out their subversive or confrontational messages.

Fly-posting is of course an established strategy of the anonymous, the impoverished or the illegal, and the tactic adopted by those who have no public voice, no public forum, and by those who are ranged against entrenched corporate or institutional power. Fly-posting such small-scale printed material, with its enigmatic or provocative messages, works like a 'teaser' campaign of the kind often employed by corporate advertisers to excite interest in a new product or an event. The effects are cumulative, and build to a critical mass of interest and awareness – in the case of the anonymous Guerrilla Girls, their tactics led in due course to access to a legitimate high-profile forum – a commission from the Public Art Fund in New York.

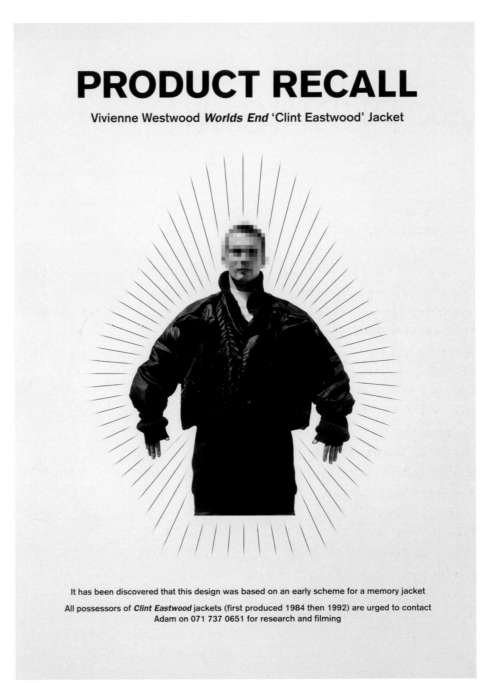

PRODUCT RECALL

Vivienne Westwood *Worlds End* 'Clint Eastwood' Jacket

It has been discovered that this design was based on an early scheme for a memory jacket

All possessors of *Clint Eastwood* jackets (first produced 1984 then 1992) are urged to contact Adam on 071 737 0651 for research and filming

Holzer and Kruger have employed similar tactics, and they too graduated from small-scale and peripheral formats (flyers, stickers, T-shirts) to publicly funded and officially sanctioned sites, such as transportation facilities and commercial billboards. Public art projects are now co-opting a variety of commercial spaces – not only billboards, but any printable surfaces. For their

Imprint project, the Print Center in Philadelphia commissioned six artists to design imagery that was adapted to a variety of formats and disseminated around the city as billboards, bus-shelter posters, magazine inserts and even paper cups in selected coffee bars. Some of the artists involved took an explicitly critical stance to the context, attempting to distance themselves

from the association with commercial and corporate values, and the inherently ephemeral nature of some of the printed materials (see Case Study, page 98).

The artist billboard is now a well established feature of the urban landscape, but the latest medium for the print as public art is the dropsheet, the vinyl tarpaulin that veils

93

scaffolding and hides building work in progress. High-profile construction projects and revamp schemes now commission artists to give these vast blank canvases a visual identity. **Sam Taylor-Wood** famously wrapped a giant panoramic photograph around Self-ridges in Oxford Street for the duration of its makeover in 2000, and **Julian Opie** was commissioned to design the drop-sheet that concealed the on-going redevelopment of the west wing of St Bartholomew's Hospital in London (See Case Study, page 102).

Prints do not always stand alone – often they are part of a more complex situation or a multi-layered project. The artist **Adam Chodzko** has used prints – in the form of posters or flyers – to set in train a sequence of events that become the work. His practice has been described as 'occupying a territory between fiction and journalism'. [2] Many of his projects begin with an intriguing intervention in the form of an ad in the pages of *Loot*, or a flyer handed out in the street. Using these strategies, he finds volunteers who will become collaborators in a larger work. Employing the conventional methods of advertisers, promoters and casting directors, Chodzko initiates narratives about consumption, self-image and social networks. A flyer handed out and fly-posted in London for a piece called *Product Recall* in 1994 invited owners of a particular style of jacket by Vivienne Westwood to contact him. The design of the jacket itself was influenced by Westwood's reading about the so-called 'memory theatres' of preliterate societies. Chodzko brought the purchasers of this jacket

together for a party where they shared reminiscences relating to the buying and wearing of the jacket, and made a short video of the event.

There are a number of artists in Britain using public sites. Some are working independently, but others are doing so as part of 'public art' projects, collaborating with galleries, funding bodies or facilitators. One such is London Underground's 'Platform for Art'. This organization has been especially active in developing partnerships with artists and galleries – both public and commercial – and has commissioned work for projects that range from the highly visible series of billboards sited on the unused District Line platform at Gloucester Road Tube station, to more

Janette Parris
(born UK 1962)
Going South, 2004, at Piccadilly Circus underground station, London (installation view)
Commissioned by Platform for Art, London Underground

low-key projects such as the 'Go to the Gallery' posters put up at various redundant poster sites across the Tube network in 2003–4 (see Case Study, page 96).

Other projects instigated by galleries or community workshops that involve the public themselves in making art can also have a very public visibility. In the summer of 1998, the Serpentine Gallery worked with the staff of the Royal Parks in London to produce *Is Art Beneath You?*. Employing three professional artists, **Wendy Anderson**, **Michael Peel** and **Zineb Sedira**, to carry out workshops, the end product was a range of deckchairs screen-printed with designs arising from the workshops, which included such projects as interviewing deckchair users about their thoughts and dreams, photographing the hands of park workers and visiting the V&A to examine its collection of botanical drawings.

Elsewhere, artists are using cheap ephemeral throwaway formats such as bags and badges. Both are cheap to produce and easy to distribute, and may be used to extend the reach of a public art project, but also have an independent life as multiples (see Chapter 8).

Bags are the perfect medium for portable public prints, and like badges, are often produced in association with exhibitions and events, for which they act as advertisements or samplers. **Jeremy Deller's** slogan-bearing bags for the 2003 Frieze Art Fair were typically enigmatic examples of this strategy (see Case Study, page 104). The artist **Franko B** appropriated the supermarket

practice of selling sturdy, long-life plastic carriers and promising the purchaser a free replacement when the original wears out. His *Bag for Life* was issued as part of the advance publicity for a planned performance at the South London Gallery in 2002.[3] Printed with one of his own photographs of a homeless man sleeping in the street, the bag embodied a neat critique of our society's materialism and wastefulness, part of a value system that encourages a self-fulfilling belief in the expendability of the unproductive, including human life.

Graffiti artists, who previously favoured spray-painting as the most effective, confrontational and permanent medium for their murals, tags and slogans, have also begun to adapt print to their purposes. The best known of these artists – in Britain at least – is the pseudonymous **Banksy**, an artist/activist who uses small-scale, unobtrusive and satirical stencils to leave his mark on the buildings of London. He has now issued printed stickers that adapt the language of street signs and public notices to be employed as guerrilla graphics to undercut the corporate 'ownership' of public spaces.

PLATFORM FOR ART/ MARK TITCHNER

(born UK, 1973)

Platform for Art is an enterprising scheme to install works at various sites on the London Underground rail network. Established in 2000 with an exhibition of sculpture on the redundant eastbound District Line platform at Gloucester Road, it has since commissioned installations on platforms, in subways and in disused retail premises, as well as working in collaboration with commercial or institutional sponsors. Most of the artworks take the form of posters or billboards; recent projects have included works by Cindy Sherman (linked to the show of her work at the Serpentine Gallery), David Shrigley, the artist partnership Muntean/Rosenblum and Zhao Bandi. Last year, London Underground also commissioned Emma Kay to produce a new work of art for the front cover of the pocket Tube map given away free at Tube stations. Her simple but effective design is a target motif, with rings in each of the colours used to identify the various Tube lines on the iconic London Underground map.

A number of artists have made effective use of the poster format: Janette Parris's *Going South* used direct comic book-style graphics for a sequence of posters telling the story of a fictional band (see page 94); produced in association with Tower Records, they were sited near the Piccadilly station entrance to the store. Liam Gillick's *Headache/ Phonecard/ Soda/Donut/Stereo* transposed transcripts of generic TV advertising into a graphic format so that narrative and presentation thwarted one another, and the purpose of the poster form was undercut by dense text and veiled imagery. This series was co-produced with Frieze Foundation, and installed at Great Portland Street, the nearest Tube station for those visiting the 2003 Frieze Art Fair.

Mark Titchner's work, which takes the form of billboard-sized prints with ambiguous demands, announced in bold and elaborate lettering, had a particularly strong impact at the Gloucester Road site. The prints (oil-based inkjet on aluminium) mixed the graphic language of other public art forms – such as trades union banners, corporate logos and advertising slogans – with the dense ornamentation of a more private imagery such as illuminated manuscripts, book illustrations and the pattern designs of William Morris.

The Platform for Art projects are advertised by their own standard-format 'circuit posters' sited on platforms and in subways across the London Underground system; these function like print editions distributed across the network.

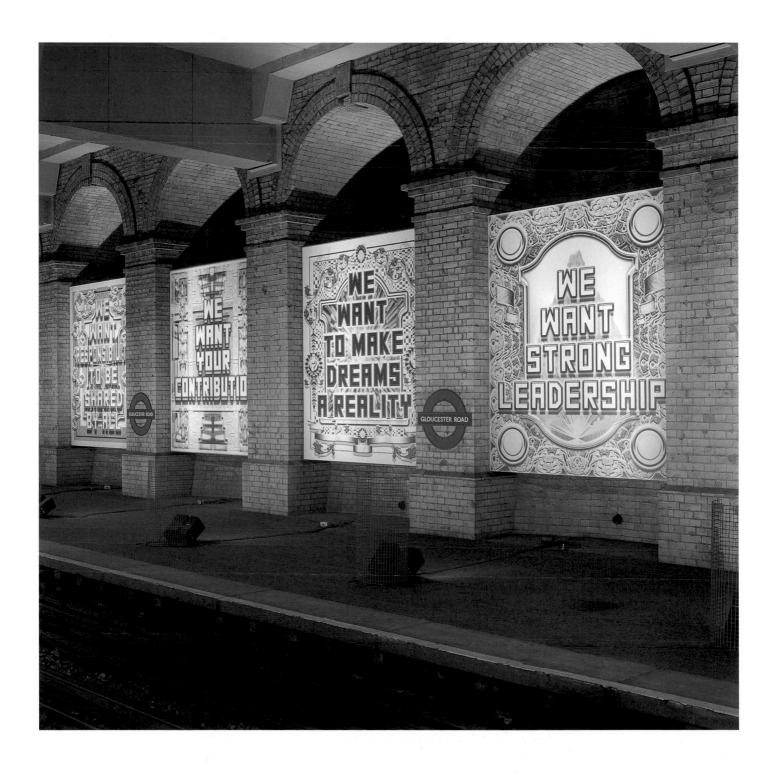

DOTTIE ATTIE
(born Canada, 1938)

SUSAN FENTON
(born USA, 1949)

KERRY JAMES MARSHALL
(born USA, 1955)

VIRGIL MARTI
(born USA, 1962)

JAMES MILLS
(born USA, 1959)

PRINT CENTER PHILADELPHIA

Six coffee cups produced for
Imprint: a public art project, 2002
Half-tone letterpress
Each 11.3 × 9 cm diameter at lip
E.368 to E.373-2005
Given by Rosie Miles

Below:

JOHN COPLANS
(born UK 1920 – died USA 2003)

*Self Portrait (Crossed
Fingers, No.3),* 1999
Courtesy of the Print
Center, Philadelphia

Public projects of this kind are designed to reach 'the accidental viewer', someone who comes upon the work inadvertently, without any previous knowledge or experience of it, and thus without preconceived ideas and expectations.[4] The Print Center in Philadelphia invited six artists to participate in *Imprint*, a project that used print media in a range of urban contexts, from magazine inserts to coffee cups, and from billboards to bus shelters. These interventions were intended to provide repeated but random encounters with provocative or beguiling images. By using print in these formats, the artists were able to reach people when they were least expecting an encounter with 'art' – while shopping, driving, reading or simply taking time out for a coffee.

Using spaces usually devoted to advertising a product or promoting an event, the artists exploited their opportunities subversively. They adopted different strategies, but each in its own way engaged with other kinds of images in the public domain, or drew attention to ideas that are generally taboo in public display. James Mills repeated the words 'blah, blah, blah'; presented in an elegant italic typeface and in diminishing sequences, this was designed to provoke questions about the insidious methods by which advertisers attract us and manipulate our thinking, but it also demonstrates that advertising becomes repetitive and invisible unless it resorts to shock tactics. John Coplans explored one of society's unspoken rules – that the only bodies that can be shown in public are young, smooth and fit. In place of the airbrushed perfection now exploited to sell everything from perfume to ice cream, he presented his own naked body – overweight, hairy and unmistakably old. In doing so, he forced the viewer to recognize that the ageing body has become unacceptable, and that the sexuality of the elderly is consistently denied by a culture that is otherwise relentlessly sexualizing everything and everybody. Coplans was the only participating artist to refuse to have his work printed on a coffee cup, because he was unhappy with the inherently throwaway nature of the product.

None of the prints carried any kind of explanation, any artist's name or title (other than integral text), only 'IMPRINT: a public art project' and the Print Center's website address. (Mills refused to have even this, since he was determined that his work should advertise nothing and should remain opaque and ambiguous.) As the Center's director Christine Filippone put it, 'Print begat advertising and now we're taking it back.'

Imprint
a public art project

Dotty Attie, New York, NY

John Coplans, New York, NY

Susan Fenton, Philadelphia, PA

Kerry James Marshall, Chicago, IL

Virgil Marti, Philadelphia, PA

James Mills, Philadelphia, PA

MOMA BILLBOARD PROJECTS

FELIX GONZALEZ-TORRES
(born Cuba 1957 – died USA 1996)

Untitled, 1991
Billboard
Location: 31–33 Second Avenue
at East 2nd Street, Manhattan
Projects 34: Felix Gonzalez-Torres, 16 May – 30 June 1992
As installed for the Museum
of Modern Art, New York
Photo: Peter Muscato
© The Felix Gonzalez-Torres Foundation
Courtesy of Andrea Rosen
Gallery, New York

Below:

SARAH MORRIS
(born UK, 1967)

Midtown
(Grace Building Billboard)
Projects # 77, 2003
Museum of Modern Art,
New York
© Parallex, Courtesy
Jay Jopling/White Cube,
London

The Museum of Modern Art has commissioned several public art projects featuring billboards, with the aim of exploiting the creative potential of scale, impermanence, the capacity for mass communication and the relationship of image to environment.

Asked by MoMA to produce a billboard in 1991, Felix Gonzalez-Torres said he wanted to 'to be like a virus that belongs to the institution',[5] an impostor infiltrating public spaces. This was an apt analogy, because the artist's billboard allows the artist not only to imitate the format and graphic language of advertising, but also to usurp its place. However, rather than aiming for the hard sell, it works by stealth, subverting or contradicting the kinds of messages that the site and format might lead the viewer to expect. By putting private images into a social setting, Gonzalez-Torres used billboards to draw attention to the disputed boundaries between 'private' and 'public', especially as this related to legislation concerning homosexuality and to public health issues, particularly AIDS. His *Untitled* 1991 billboard, showing a photograph of an empty bed with the impress of two bodies, was an eloquent expression of desire and loss and a subtle rebuke to discrimination and prejudice.

Three artists – Julian Opie, Sarah Morris and Lisa Ruyter – made billboards for New York sites in 2002. All were already engaged in exploring the urban experience, and were interested in commercial techniques and the interface between art and advertising. As digital prints produced by MetroMedia Technologies, these artists' billboards were technically indistinguishable from conventional advertising. Morris used stills from her films, which are dynamic sequences focusing on the buildings, businesses and people that define a particular city; the stills were overlaid with white grids derived from her abstract paintings of high-rise architecture. At first sight her billboards look like real advertisements, but the grid acts as a screening or distancing device – reminiscent of surveillance – which gives a voyeuristic slant to the images and creates a tension between private moments and their elevated large-scale public display. Lisa Ruyter also examined spectatorship and the fact that in any public space – from street to sports arena – we are always being observed. Julian Opie's pared down imagery is designed – like commercial advertising – for rapid single readings. Here, variants of his road scene *I dreamt I was driving my car* offered the passing commuters a seductive vision of a clean, uncomplicated virtual world, a world of speed, space and possibility.

JULIAN OPIE
(born UK, 1958)

*I dreamt I was driving my
car (motorway corner)*, 2004
Unique c-type print on paper
on aluminium
28.4 × 52 cm
Purchased through the
Julie and Robert Breckman
Print Fund
E.3841–2004

Below:
*I dreamt I was driving
my car (country road)*, 2002
Installation at St Bartholomew's
Hospital, London
Inkjet on vinyl
18 × 50 m
© Julian Opie, courtesy
of Lisson Gallery, London

Opie has said, 'I find inspiration in public places (roads, airports, grave-yards, shops) where languages take a form such as signs, gravestones, banners, pop-ups.'[6] His visual language is straightforward – a sophisticated simplification of familiar motifs – and as such, accessible to audiences wherever they encounter it. He has undertaken several commissions for public art projects, in which he mani-pulates these languages and reinte-grates them into their original contexts. Major commissions have included the temporary hoardings around the Tate Britain site, light boxes and com-puter films at Heathrow Airport, bill-boards advertising Blur's *Best of* album and billboards for MoMA projects in New York (see Case Study, page 100).

This drop-sheet, commissioned by Vital Arts for St Bartholomew's Hospital in 2002, is Opie's most ambitious print project to date. It was designed to con-ceal scaffolding during the building of the new Breast Cancer Care Centre (opened 2004). Opie's characteristically bold and legible style and subject matter are well suited to this scale: a sheet measuring 18 by 50 metres was printed with a version of his generic road scene, *I dreamt I was driving my car*. The view of a road seen through a car windscreen is a key subject in Opie's repertoire, explored in many variants (see E.3841–2004). Inspired in part by his own experience of driving across Europe, it has an accessible familiarity and the capacity to produce an open-ended narrative. Used at the hospital site, the image suggests the possibility of escape – escape from the enclosed, car-infested courtyard in front of the drop-sheet into a clean, uncomplicated rural landscape, and escape into the imagination as a respite from one's immediate physical realities. This vista, with its simple clarity and deliberate lack of specificity, allows viewers an imaginative space where they might exchange passivity for control, where they can get into the 'driver's seat'. With its clear outlines and picture-book colours, the image posits a hopeful future, a way forward from present troubles. Like the other artworks com-missioned for the site, Opie's image is designed to take the users of the build-ing – patients, visitors, staff – out of their immediate surroundings to a place they identified as 'anywhere but here'.[7]

Opie relishes public projects as opportunities to develop existing ideas by pushing the boundaries of method, medium or scale. Here, inkjet printing, with its characteristic flat, even colour and its anonymous pristine surfaces, is the perfect match for his pared down 'computer' aesthetic.

FRANKO B
(born Italy, 1960)

Bag for Life, 2002
Colour half-tone line-block
on plastic carrier bag
53 × 45 cm (including handle)
E.3541-2004
Given by Gill Saunders
© Franko B/South London
Gallery

JEREMY DELLER
(born UK, 1966)

Untitled (bag), 2003
Line-block on plastic
carrier bag
45 × 35 cm
E.3540-2004
Given by Gill Saunders

Artists have increasingly turned to cheap everyday printed media – posters, flyers and badges, as well as bags – to exploit the democratic potential of printmaking as a means of putting art into the public domain in an affordable and accessible form. The use of carrier bags as artworks in their own right, or as advertising for an event or exhibition (as in the example by Franko B, produced in association with the South London Gallery) has become a regular strategy.

There are precedents, of course – notably Andy Warhol's paper carriers printed with his iconic soup-can image, and Barbara Kruger's ironic motto for today's' consumer-driven society, 'I shop therefore I am', which has been co-opted by department stores – but Deller's bag is not a reproduction of an image or text already established in his practice, but

an independent original work existing *only* as a bag. Much of his work depends on collaboration in the staging of public events, and a committed engagement with audiences outside the confines of a gallery. He has previously used print – in the form of images and slogans on T-shirts, bumper stickers and small ads in newspapers – for subversive messages that would be seen by a wide public. He has described such interventions as being 'ephemeral and celebratory of its environment' in comparison to the embarrassed bombast of 'official' public art.[8]

This bag is one from a series of four commissioned by Frieze and designed to be given away free (usually with the purchase of a catalogue or guide) at the first Frieze Art Fair in London in 2003. The bag is thus an example of art sponsorship and a souvenir of a major art-world event, as well as a work of public art by Deller randomly disseminated by visitors to the fair. It works as a simple but effective advertisement, not only for the product (the fair), but also for the tastes and attitudes of the person carrying it. As a kind of status symbol, like a bag from a designer store, it is a tool for communication, a means of transmitting coded signals to other members of our 'tribe'. The bag becomes an emblem, like a badge of belonging, which connects us to those who can read the signs. At the same time, however, it enforces a kind of exclusivity, because Deller's bags, with their intriguing but opaque messages, act to tantalize or bemuse the uninitiated.

still life
+RANKO 3

bagforlife

artsadmin SLG

www.still-life-project.com

Should this bag wear out it will be replaced free of charge

8. MULTIPLES

Dan Hays
(born UK 1966)
Sanctuary, 2001
Published by the
Multiple Store, London
Edition of 50
Digital cibachrome print
with lenticular plastic
50 × 74 cm

E.334-2003
Purchased through the
Julie and Robert Breckman
Print Fund

As Dr Stephen Bury has pointed out, the artist's multiple resists definition. The term was first used in the 1960s with reference to an artwork that was designed to be produced in multiple copies, but was neither a print (as conventionally understood) nor a cast sculpture (the other kind of artwork that is conventionally produced in an edition). Today the distinction between editioned print and multiple is redundant, or at least blurred. Many multiples *are* prints, or incorporate print techniques, even if they take the form of wristwatches or silk kerchiefs.

The reasons behind the production of multiples are various – some are commissioned by publishers, art institutions or corporate sponsors, others are generated directly by the artists themselves. For the consumer, however, the multiple is first and foremost an opportunity to acquire artworks at affordable prices, and a means of 'art collecting for beginners'. Gill Hedley, director of the Contemporary Art Society, has described buying multiples as 'rather like buying prints – a way of getting your nerve up before committing yourself to buying something much bigger and more expensive'.[1] For the artist, on the other hand, making a multiple is an opportunity to work on a different scale, to

explore unfamiliar or untried materials and technical processes, and to reach a different market, thereby generating income to support the production of more ambitious or 'difficult' work.

The Multiple Store was established in 1999 with the express intention of 'bringing artists to a new distribution network'.[2] Director Sally Townsend has explained the Multiple Store's role as a publisher as 'trying to enable artists to explore ideas in materials they may not be familiar with, while bringing their art to a wider audience'.[3] So, **Dan Hays** applied lenticular perspex to a digital cibachrome print for his multiple *Sanctuary* (2000), exploiting a commercial technique to produce a print with the illusion of three dimensions, and **Paul Winstanley** used transfers applied to cast plastic to create *Exhibition* (2000), a toy version of his 1998 show at the Tate Gallery. Among their most recent editions is **Cornelia Parker's** series of maps burned by meteorites, an accessible version of her abiding interest in natural phenomena and the effects of destructive processes on made-made objects (see Case Study, page 62).

Since the mid 1980s, the Zurich-based art magazine *Parkett* has been

commissioning multiples and prints to accompany its collaborations with artists. These range from the set of three single records *Mill/Ambulance/Toads* by **Katerina Fritsch**, issued in 1990 and still available at a modest $38 dollars for the set, to a printed silk scarf by **Michael Raedecker** (2002) at $500, and a lithograph with collage elements by **Laura Owens**, for $1,250. The magazine *Contemporary Visual Arts* (since relaunched as *Contemporary*) gave away prints – free with each issue – to subscribers. These giveaways included an unnumbered edition by **Tracey Emin** (a lithograph, *Every Bodies Been There*, 1998[4]) and a numbered edition by **Gillian Wearing** (2003, in an edition of 4,000). Recently, art-book publishers Thames & Hudson have produced special editions of books by **Howard Hodgkin** and **Paula Rego**, each of which came with a print by the artist. Counter Editions, an innovative print publisher, has also worked with sculptor **Rachel Whiteread** on two editioned works, neither of which would appear to be prints by conventional definitions (see Chapter 3 and Case Study, page 52).

The publication of multiples is often undertaken by arts organizations to generate income to support an exhibition programme, and as promotional

tie-ins for temporary exhibitions. The Camden Arts Centre, the Serpentine Gallery and the Whitechapel Art Gallery all regularly publish artists' multiples as well as more conventional print editions. The British Council promoted multiples through its touring show *Multiplication* in 2002–3, with the catalogue itself designed as a collectable artwork, and a printed book bag commissioned from **Sarah Staton** for sale at the exhibition.

Some of the most original of recent multiples by British artists are those that are commissioned annually by Momart, the fine-art shipping company. Every year they invite an artist to design a multiple to be sent to clients as

their Christmas 'card'. Naturally these pieces are seasonally themed, although not always explicitly so, but the specificity of the brief has inspired some original, witty and eloquent works which are now eagerly anticipated by the lucky recipients (see Case Study, page 116).

More readily available multiples have been generated by other corporations with interests in the art world, notably the beer-brewing company Beck's, which has established a distinct brand recognition through its sponsorship of contemporary art exhibitions, events and prizes (such as Beck's Futures). At events sponsored by Beck's their bottled beer is served, and for major exhibitions

it has been customary for the artist concerned to design a special limited edition beer-bottle label. Free to all comers at the opening, these potentially ephemeral souvenirs have quickly become collectors' items (see Case Study, page 110).

Another category of 'free' multiples is the invitations to private views. Artists now regularly design announcement cards and invitations themselves (see Case Study, page 114) and in some cases may even print them too – as **Richard Woods** did for his *Countrystyle* installation at Rove in Hoxton Square. The card – printed on a thin piece of MDF cut to the shape of a gable-end – was hand block-printed as a miniature imitation

Kelly Mark
(born Canada 1967)
Everything is Interesting
(Badge), 2003
Produced for the Ikon Gallery,
Birmingham, UK
4 cm diameter
E.381-2005
Given by Gill Saunders

of the installation itself, which was a life-size, woodcut-printed log-cabin facade.

Printed badges are now a commonplace art world intervention, made for various purposes. In 1997, for example, **Mark Wallinger** was commissioned to make a work about national identity for *Pledge Allegiance to a Flag* by London Printworks Trust. He created *Oxymoron*, a reworking of the Union Jack flag in the orange and green of the Irish tricolour. Badges with the same design were produced as souvenirs of the show, and reflect on the custom of flaunting political allegiance by the wearing of favours, perhaps a reference to the societal and political identities in Northern Ireland.

Badges can be a deliberate – and sanctioned – counterpoint to the official identity of an event, or they may be a note of dissent from the authorized version. At the Venice Biennale in 2003, **Jeremy Deller** produced a badge that he intended as a riposte to the coverage by British *Vogue* of the previous Biennale. Deller had been offended by the magazine's reporting, which trivialized and denigrated both the event and the art on show. His badge adapted the iconography of a very public graphic

form, the British road sign, in which a red circle with a diagonal red slash signifies actions by road users that are forbidden or illegal. Here he used it to cancel the signature *Vogue* typeface in a graphic demonstration of rejection.

Badges are often a cheap, accessible way of extending the life of a site-specific or time-limited project. Like a footnote that has gone astray from the parent text, a badge can point back to the project that generated it. For example, **Alan Belcher** produced a limited edition badge lettered 'Kill Me', which referred to his controversial redesigned billboard project in Toronto in 1997 (and an earlier version for Bizart Copenhagen in 1992). As another means of engaging with an audience, a badge is a simple means of promoting a message. As part of her 2003 exhibition at the Ikon Gallery in Birmingham, Canadian artist **Kelly Mark** used badges, postcards, interventions and installations to extend the reach of the work beyond the institution. Badges and postcards printed with the statement 'everything is interesting' (also the title of the exhibition) were circulated around Birmingham – they were on sale at the gallery but also distributed through letter-drops and mailings. Mark saw these anonymous statements

as small works of art feeding into the fabric of life in the city, circulating her message by an ephemeral low-key strategy characteristic of her focus on the minutiae of everyday life. By disseminating the idea way beyond the circles of the initiated and those who visited the gallery, the badges offered a modest epiphany to an unknown and random audience.

Felix Gonzalez-Torres pioneered this practice of disseminating art – and ideas – by a process of giving away cheaply produced multiples. He produced photo-offset prints in limitless editions, stacking them in the gallery like simple minimalist sculptures, on the understanding that the exhibition label would explicitly invite visitors to take one away with them – in some exhibitions, such as the retrospective at the Guggenheim New York in 1995, special plastic bags were provided for visitors for easy transport of the rolled prints (see Case Study, page 112).

BECK'S BEER BOTTLES

TIM HEAD
(born UK, 1946)

Label for Beck's beer bottle, 1992
Label: Screen print
E.311-2005
Given by Gill Saunders

DAMIEN HIRST
(born UK, 1965)

Label for Beck's beer bottle, 1995
Label: Offset lithograph
E.867-2003
Given by Edwina Sassoon
through the Friends
of the V&A

REBECCA HORN
(born Germany, 1944)

Label for Beck's beer bottle, 1994
Label: Offset lithograph
E.219-2005
Given by Riikka Kuittinen

The beer-brewing company Beck's is well established as the sponsor of contemporary art events, a programme that began in 1985 with the German Art in the Twentieth Century exhibition at the Royal Academy. Since then Beck's has commemorated its major sponsorships and exhibition openings by inviting artists to create limited edition labels, in order to identify the brand image with the perceived attributes of contemporary art – cool, original, young, irreverent, controversial and talked about. The first label was designed by Gilbert & George and there have been twenty-three subsequently. Each label offers us a snapshot of the artist's work within the limitations of a small label. Some are instantly recognizable – such as Damien Hirst's coloured dots, familiar from his spot paintings (one of two labels he designed in 1995) – but others, such as Rebecca Horn's photographic image overlaid with graffiti-style scribble, are a little less obvious.

Tim Head's label, with its life-size images of plastic coffee-stirrers, relates to his interest in the ephemeral and disposable accessories of consumerism – bar-codes, packaging, credit cards, corporate logos, material from fast-food restaurants and takeaways, etc. – which he had been collecting since the late 1970s. Around 1990 he made a series of paintings in which abstract designs were derived from the shapes and patterns he found in machine-made mass-produced objects such as disposable plastic packing trays, and the insides of envelopes. The paintings have been described as 'monumentalizing the prosaic',[5] just as the plastic stirring sticks represented on the label here read as simple sculptural forms or hieroglyphs. Printed in bright yellow on matte black, they refer back to pop art, and have the clarity and legibility of a banner or poster.

In every case, the artist-designed Beck's label represents a fascinating synthesis of art and design, popular culture, marketing and consumption, as well as embodying the youth-orientated character of Beck's sponsorship campaigns.

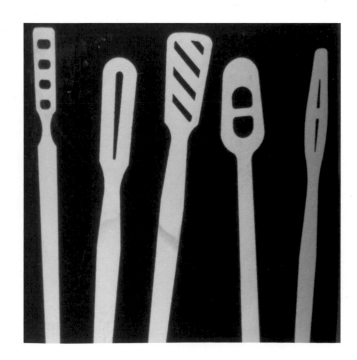

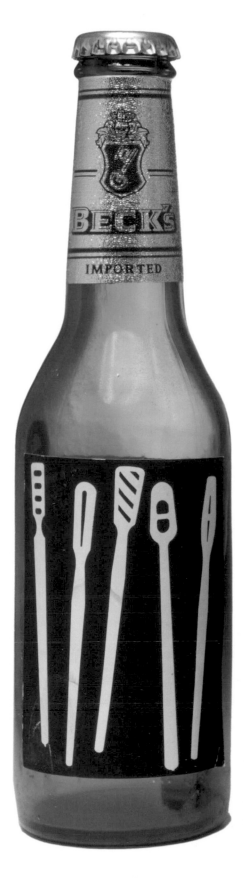
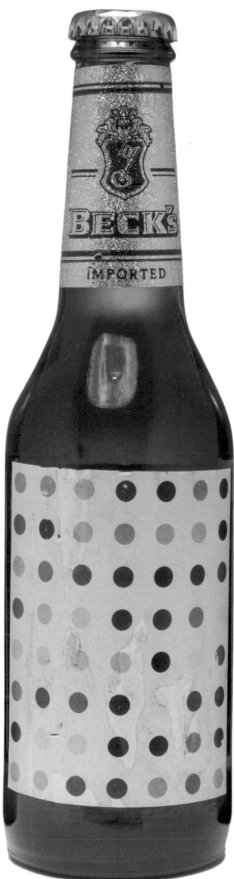
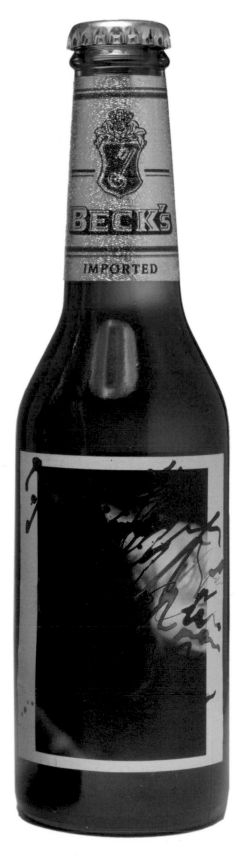

FELIX GONZALEZ-
TORRES

(born Cuba, 1957; died USA, 1996)

'Untitled' (Aparicíon), 1991
Offset print on paper,
endless copies
8 ins at ideal height
× 44 ⅞ × 29 ¾ ins
ARG # GF 1991 - 83
Collection of Fundaçion
Cultural Televisa S.A. Mexico;
courtesy Andrea Rosen
Gallery, New York
Photo: Peter Muscate
© The Felix Gonzalez-
Torres Foundation⁷

Below:
'Untitled' (Death by Gun), 1990
Single sheet from paper stack
Offset lithograph on paper
114.1 × 83.6 cm
(ideal stack height 22.9 cm)
E.220-2005
Given by Riikka Kuittinen
© The Felix Gonzalez-
Torres Foundation⁷

Print was integral to Gonzalez-Torres' work, although he had no interest in the expressive potential of different print techniques. Instead he invariably used offset photolithography, a commercial process with the capacity to produce unlimited replicas quickly and cheaply, which put his prints into the same conceptual category as expendable everyday printed materials such as flyers, leaflets and packaging. This was a deliberate strategy: Gonzalez-Torres presented his prints in exhibitions as paper stacks, and visitors were invited to help themselves. He also instructed that each pile should have an ideal height, and was to be replenished as soon as it had been depleted. In this way each of his print editions is unlimited, perpetuated in 'endless copies'. In permitting, indeed encouraging, this takeaway approach to his prints, he took dissemination – a fundamental purpose of printed art – to its logical conclusion. These giveaway multiples are metaphors for generosity, inclusion and renewal; Gonzalez-Torres saw the stacks as public sculptures, with the individual sheets a medium of exchange between public and private.

The prints themselves are reticent; they take the form of uncaptioned photographic images, blank sheets with printed borders or simple texts (some appropriated from newspapers), but they are designed to raise issues of public debate (including racism, sexual discrimination, the AIDS epidemic and government legislation). However, the stacks – as stacks – had a powerful personal symbolism too. Gonzalez-Torres began them when his lover was sick with AIDS, and said, 'In a way, this letting go of the work, this refusal to make a static form, a monolithic sculpture, in favour of a disappearing, changing, unstable and fragile form was an attempt on my part to rehearse my fears of having Ross disappear day by day right in front of my eyes. It's really a weird thing when you see the public come into the gallery and walk away with a piece of paper that is yours.'⁶ Certainly, these prints overturn all the conventional expectations of art in a gallery setting – you can not only touch it, but also take it away for free. You can then treat it with due reverence as 'art' and frame it, you can pass it on or you can simply throw it away.

The print stack sculptures can be purchased by individual collectors and museums, but those who purchase a stack must sign a certificate pledging to perpetuate the free distribution of the prints, and to replenish the stacks (by reprinting) as they are reduced.

DAMIEN HIRST

(born UK, 1965)

Private view invitation
for *Damien Hirst: Theories,
Models, Methods, Approaches,
Assumptions, Results and
Findings,* at the Gagosian
Gallery, New York, 2000
Letraset on plastic ball;
offset lithography on folded
card and on paper
4 × 4 × 4 cm
E.3531:1-3-2004
Given by Edwina Sassoon
through the Friends
of the V&A

SARAH LUCAS

(born UK, 1962)

Private view invitation
for *Charlie George* exhibition
at CFA, Berlin, 2002
Offset lithograph on cut
and folded card
24.5 × 22.5 cm
E.379-2003
Given by Susan Lambert

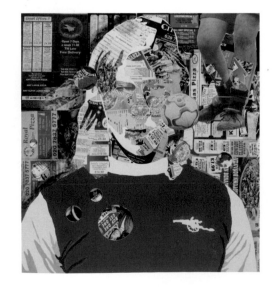

Private view cards are in effect uneditioned prints or multiples, expressions of an artist's work in miniature. Both these pieces demonstrate the ways in which artists are increasingly designing exhibition announcements and other ephemeral promotional material as collectible multiples in their own right, in the process developing new formats for invitations, and extending the definition of a fine-art print.

Sarah Lucas and Damien Hirst are among the best known of the so-called 'Young British Artists' (YBAs), whose work was taken up by the collector Charles Saatchi and promoted via controversial shows such as *Sensation* (at the Royal Academy in 1998). Lucas is often described as one of the 'bad girls' of Britart (along with Tracey Emin), and has presented herself as a laddish, lager-swilling androgynous figure. Her work has continually referenced or appropriated working-class 'tabloid' culture, and its languages – verbal and visual. This card advertising Lucas's *Charlie George* exhibition

in Berlin encapsulates many of her favourite themes. Charlie George is the archetypal working class hero: born in north London (in the same area as Lucas herself), he became an iconic player for Arsenal Football Club in the 1970s. With his ever-changing hairstyles and fluent footballing skills, George was regularly featured in the tabloid newspaper headlines, and not only on the sports pages. Here Lucas combines this popular image of George with a collage of menu imagery and advertising for pizzas. Food has been a recurring motif for her, often standing for sexual slang or as a reference to parts of the body. This card demonstrates her characteristic use of images from popular culture, using strategies of assemblage and appropriation. It also mimics the format of a novelty menu or a flyer for a takeaway restaurant.

Hirst's private-view invitation consists of a ping-pong ball in a box just large enough to contain it, and a folded sheet of paper printed with a diagram and details of Certified Poison Control Centers in the United States. The exhibition, which included sixteen new sculptures and a series of paintings, continued Hirst's obsession with absence, longing, memory and loss, explored through exhibits such as cabinets of curiosities, medical paraphernalia and references to the frailty of the body. The use of the ping-pong ball linked directly to one of the title-piece exhibits – a vitrine filled with bouncing ping-pong balls – and another piece in which a skeleton on a glass cross had rapidly rotating ping-pong balls, held up on jets of air, in place of eyes.

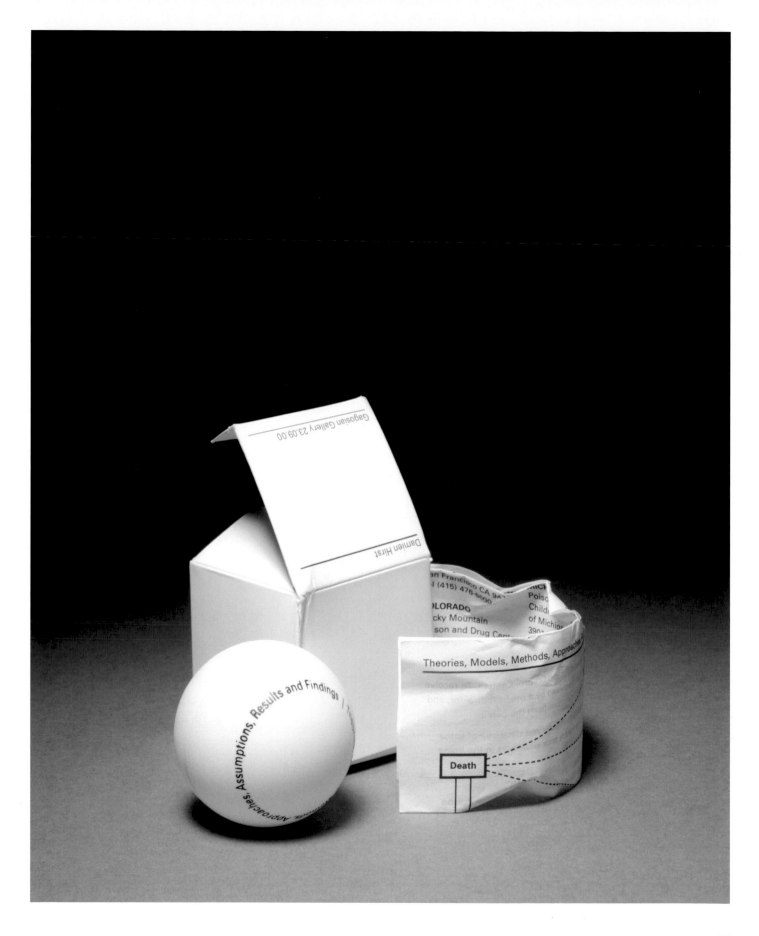

Clockwise from lower left:
multiples by Anthony Caro,
Richard Deacon, Tim Head,
Gary Hume, Tracey Emin,
Mark Wallinger, Langlands
& Bell, Damien Hirst,
Howard Hodgkin
Selected dates from
1987 to 2002
Given by Momart Ltd

Opposite:

PAUL MCDEVITT

(born UK, 1972)

Nativity, 2004
Screenprint on linen
tea towel
79 × 48 cm
E.393-2005
Given by Momart Ltd

Since 1984 the fine-art shipping company Momart has commissioned British artists to design limited edition multiples, which they send to clients as their Christmas greeting. The Momart multiple represents a conflation of various conceptual categories: it is simultaneously an example of art patronage, a subtle carrier of corporate identity and an advertisement for the company's services, as well as being an innovative take on the traditional Christmas greeting card. Of course, the Christmas card is conventionally mass produced and inherently ephemeral, but it has been converted by this Momart initiative into a collectable work of art, signed, editioned and carefully packaged for posterity.

Only a few of these seasonal greetings take the conventional form of a card; these include some of the earlier commissions – the pieces by David Inshaw and Gillian Ayres, which both reproduce one of their own paintings, and Tim Head's kitsch abstract 'holly' motif (1987). Others have eschewed the card format but nevertheless allude to Christmas in either form or subject: Gary Hume produced a fuzzy-felt snowman (2000), Mark Wallinger designed an empty cracker (2001) and labelled it 'it's the thought that counts', and Damien Hirst contributed a perspex paperweight (1997) embedded with screenprinted white dots, like a frozen minimalist snow-globe. Others approach the subject more obliquely: Howard Hodgkin's screwed-up blue paper in a shallow box (2002) is both an abstract landscape and suggestive of gift-wrapping. By no means all the multiples are prints, although several have printed elements – such as Langlands & Bell's wristwatch (1998) with airport codes printed on the face, and Helen Chadwick's kerchief (1992) screen-printed with images of coins and baroque coils of hair. Paul McDevitt uses digital technology to sample and collage elements from the found imagery of a disposable visual culture. He chose a tea towel - the kind of thing which is often given as a gift at Christmas - on which to print a strangely disturbing winter landscape.

Given the corporate purpose and seasonal theme, these multiples are remarkably varied and inventive; each artist succeeds in fulfilling the commission with work that can also be identified in some way with their primary practice and characteristic concerns.

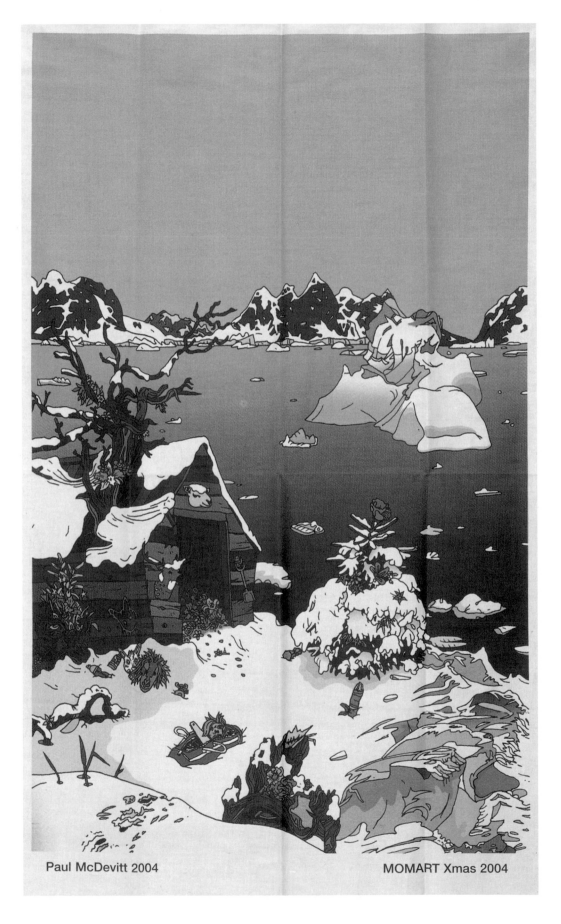

Paul McDevitt 2004

MOMART Xmas 2004

9. COMMUNITY-BASED WORKSHOPS

More often than not printmaking is a collaborative process, and much of the work discussed here has been produced through workshops and studios. Many of these also run outreach programmes involving local communities in projects that ultimately go far beyond the actual printmaking experience. There are many fine examples, such as **Dundee Contemporary Arts**, an arts centre with a fully staffed professional print workshop whose mission is to offer cultural experience to a broad social spectrum of the local community, and to bring top-level contemporary art to this area of Scotland. The centre recently attracted Anya Gallaccio to respond to the challenge of working in a medium that was new to her (see Chapter 2).

One of the most politically active of the community-based enterprises is the **London Print Studio** (LPS) in Harrow Road, West London, which blossomed out of the Paddington Printshop set up by John Phillips in his own kitchen, back in 1972. Phillips is a passionate advocate of the medium and his recent doctoral thesis not only describes how printmaking changed the world, but also relates the key role his own workshop has played and still plays in local society and politics. In 1984 the workshop was central to fighting the sale of the council estate of which it was part to a private developer, and it continued its social involvement, helping to uncover misuse of public funds by the council and so on. During the 1980s and '90s the studio produced many agit-prop posters, but at the same time offered printmaking facilities and opportunities to local schools, walk-in adults and professional artists. In 1995 a local developer offered to buy its old premises and rehome it in a new building as part of his overall development, and in 1997 the LPS became a development trust, receiving government funding to develop further schemes both for the workshop and other local amenities. One of its most ambitious schemes since the new building opened in 2000 was *Our World Today*, a public art project on twenty-five sites around west London, bringing artists from Ireland, Nigeria, Kosovo, Spain and elsewhere to venues such as local schools, cafes and sports centres. The studio continues to work with exchange groups from around the world, most recently with the Katatura

Zakee Shariff
(born UK 1975)
Karokia, 2004
Design for textile, used
for the *West Coast Highway*
fashion collection, Spring/
Summer, 2005 (detail)
Seen here as screenprint
on handmade paper
60 × 205 cm
Copyright the artist

Yin Lam
(b. Hong Kong 1970, d. UK 1999)
Page from the catalogue
for *Masquerade*
Designs by Yin Lam
for her label *unclothe* produced
as screenprints on surgical
garments, 1998

Workshop from Windhoek, Namibia (spring 2005).[1]

The Fabric Workshop in Philadelphia works with fabric of every description, but this involves a considerable amount of screen-printing. It makes it its business to provide artists with facilities and materials which they might not otherwise think of using, thus prompting an extraordinarily imaginative series of productions. The Philadelphia Workshop has a roll-call of internationally acclaimed artists on its books, but also has an important outreach and educational programme operating through apprenticeships, internships, lectures, tours and travelling shows. The work by **Renée Green**, **Carrie Mae Weems** and **Virgil Marti** discussed in this book was produced there, and other artists mentioned here, such as **Willie Cole**, **Yinka Shonibare** and **Rachel Whiteread**, have also been invited residents. In 2003 Marion Boulton Stroud, the founder and artistic director, published a magnificent survey of the workshop's achievements to date, with detailed case studies of a great many works.[2]

Also with roots in fabric printing, London Printworks Trust (LPT), based in Brixton, south-east London,

is comparatively modest but has had a significant impact on local life and the careers of a number of artists and designers. LPT has a dedicated outreach programme – including work with the local prison, children's and old peoples' homes, adolescents on remand, students and schoolchildren – and it has recently established a bursary, providing a bridge to the commercial world for recent graduates. LPT also provides facilities for small businesses – one of its earliest customers was the now highly successful fashion team **Eley Kishimoto**, which used LPT to print its fabrics. Fashion designers **Zakee Shariff** – whose Californian landscapes look as good on the wall as they do made up into clothes – and Bauhaus-inspired **Jonathan Saunders** are also on its books. Installation artists **Sonia Boyce** and **Zineb Sedira** have both made wallpaper here (for Boyce's *Clapping* wallpaper see Case Study, page 122). Encouraging the link between art and design is central to LPT's mission, as a number of their commissioned shows have demonstrated. In 1995 Sonia Boyce, **Bill Woodrow** and **Jo Casely Hayford** explored the place of migrant and refugee. This resulted in LPT's first exhibition, *Portable Fabric Shelters* (see Sonia Boyce Case Study, page 122). In 1996, *Pledge Allegiance to a Flag*

produced **Yinka Shonibare's** ground-breaking *Victorian Philanthropist's Parlour* and **Mark Wallinger's** *Oxymoron*, subsequently shown at the Venice Biennale (see Chapter 8).[3] For *Masquerade* in 1998 the participating artists made some thought-provoking and 'revealing' disguises (see **Ken McDonald** Case Study, page 124), while *Scuffed* used the occasion of the football World Cup to focus young people on issues of national identity, branding and merchandize.

WILLIE COLE

(born USA, 1955)

Loyal and Dependable, 2002
One of a series of 6 plates
Printed at Quality House
of Graphics, Queens, New York
under the aegis of Rutgers
RCIPP New Jersey.[4]
Published in an edition
of 12 jointly by RCIPP
and Alexander and Bonin,
New York
Digital Iris print
on coated paper
Sheet 120 × 89 cm
E.3580-2004
Purchased through the
Julie and Robert Breckman
Print Fund

Below:
Man, Spirit, Mask
Triptych, 1999
Printed by Gail Deery
and Randy Hemminghaus
at RCIPP
Published by RCIPP
Edition of 40
Man: photo-etching,
embossing, hand-colouring;
spirit: screenprint with
lemon juice; mask: photo-
etching and woodcut.
Each 99.4 × 67.3 cm:
overall 99.4 × 201.9 cm
Courtesy the artist
and RCIPP

Willie Cole is renowned for the work he has made with domestic objects, from bicycles to water cisterns, all variously manipulated to recall African sculpture, but it is the domestic steam iron that has been described as his trademark. He has used it in several different ways, but some of his most famous pieces use the iron as the printing plate and the scorch mark on cloth as print and substrate. Patterns are made by repeating the scorching with the same or different irons. The configurations of steam holes and the precise profiles of the plate vary from one manufacturer to another. The suggestions of branding, scarification marks and the transfiguration of the iron's profile to that of mask/house/ship are all exploited by Cole in a series of works that address issues around black history, including slavery and the slave trade, domestic servitude, kinship and cultural ritual.[5] The scorched linen and paper pieces were, however, fragile and susceptible to deterioration, so in 1999 Rutgers devised a way of reproducing the scorched mark without threatening the archival qualities of the paper. In *Man, Spirit, Mask,* a triptych employing screen-print, photo-etching and woodcut, a silkscreen tint base of methyl cellulose (commonly known as wall-paper paste) was mixed with lemon juice, and after printing, gently heated with a shrink-wrapping gun until the lemon juice turned brown – producing a highly authentic-looking alternative to the trademark scorch.[6]

More recently, Cole has turned his attention to digital technology without renouncing any of his fundamental concerns. Working with Rutgers again in 2002, he produced a suite of prints in which six gigantic irons are viewed from above and subtly manipulated – flexes, labels and so on were all digitally removed – to enhance their 'mask' like appearance. The titles of each, such as *Loyal and Dependable, Quick as a Wink* and *Satisfaction Guaranteed,* are taken from the advertising campaigns of different manufacturers. Reflecting the rivalries of different corporate 'tribes', the series says much about industrialized society and consumerism, but the humour is undercut by the fact that the captions evoke those proclaiming the sale of slaves and extolling their virtues, seen on posters and advertisements throughout North America from the seventeenth to the nineteenth centuries.

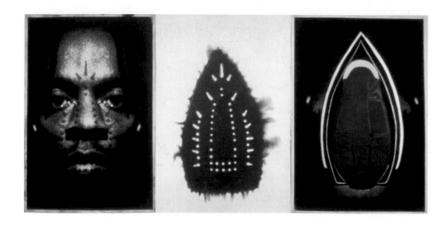

SONIA BOYCE

(born UK, 1962)

Clapping, 1994
Screen-printed wallpaper
for the installation
Wish You Were Here,
with BANK, 1994
Printed at London
Printworks Trust
Width of roll 56 cm
E.596-1996
Copyright the artist

Below:
Umbrella. Made for the
installation at London
Printworks Trust
Portable Fabric Shelters, 1995
Edition of 22
Screenprint on rubberised
nylon fabric
Diameter as open,
excluding finials, 86.5 cm
Collection Rosie Miles
Copyright the artist

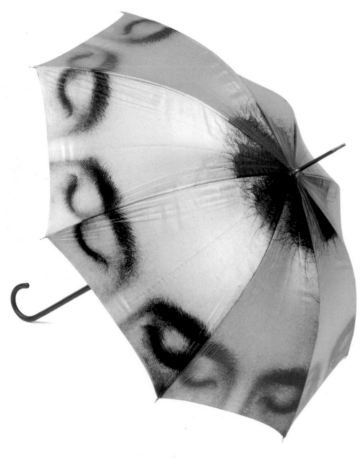

As a painter, Sonia Boyce depicted wallpaper within the picture space, to suggest particular issues around history and racial identity. As she has moved away from painting into installation and from direct commentaries on identity to more generic examinations of personal relationships, wallpaper, as physical object, has played a carefully considered role in her practice. Her first wallpaper, *Clapping* (1994), with its giant repeat images of clapping hands, was designed for a group of domestic-style spaces created by the artists' group BANK, displaying objects loosely connected with concepts of home and comfort. Boyce suggests that the Judy Garland classic *A Star is Born*, with the idea of self as public performance, was inspirational here. Scrolling down the walls like frozen cinema, the image reflects the way film can capture us without our being aware, then – disturbingly – play us back to ourselves. Even our most private moments are subject to scrutiny, if only our own.

Clapping was printed at London Printworks Trust (see page 119), which not only provides facilities for artists but also has commissioned some unusual exhibitions, a number of which have focused on the idea of home. The first of these was *Portable Fabric Shelters* in 1995, in which Boyce, Bill Woodrow and Jo Casely Hayford explored the place of the migrant and refugee, not only as a physical presence in our lives but also within our psyche.[7] A narrative was created around particular kinds of objects, our perception of which was altered through the superimposition of printed images on their surfaces; at the same time the images became integral to the whole, both importing and extending meaning. Boyce made an umbrella, a tent and a blanket, each printed with an aspect of the human head. She spoke about getting inside the head – trying to understand what it might be like to be someone else, or having someone else understand you – allowing the idea of you to have some safe haven inside their head, thus engaging with spiritual as well as physical homelessness. She was also interested in exploring ideas around shared space. Like a mini-tent, the umbrella can create a comforting distance in a crowded urban street, but alternatively, an intimacy with anyone who might come under it with you. The eyebrows and lashes of closed eyes, patterning the border, offer a sense of composure, enhancing the protective nature of the shade.

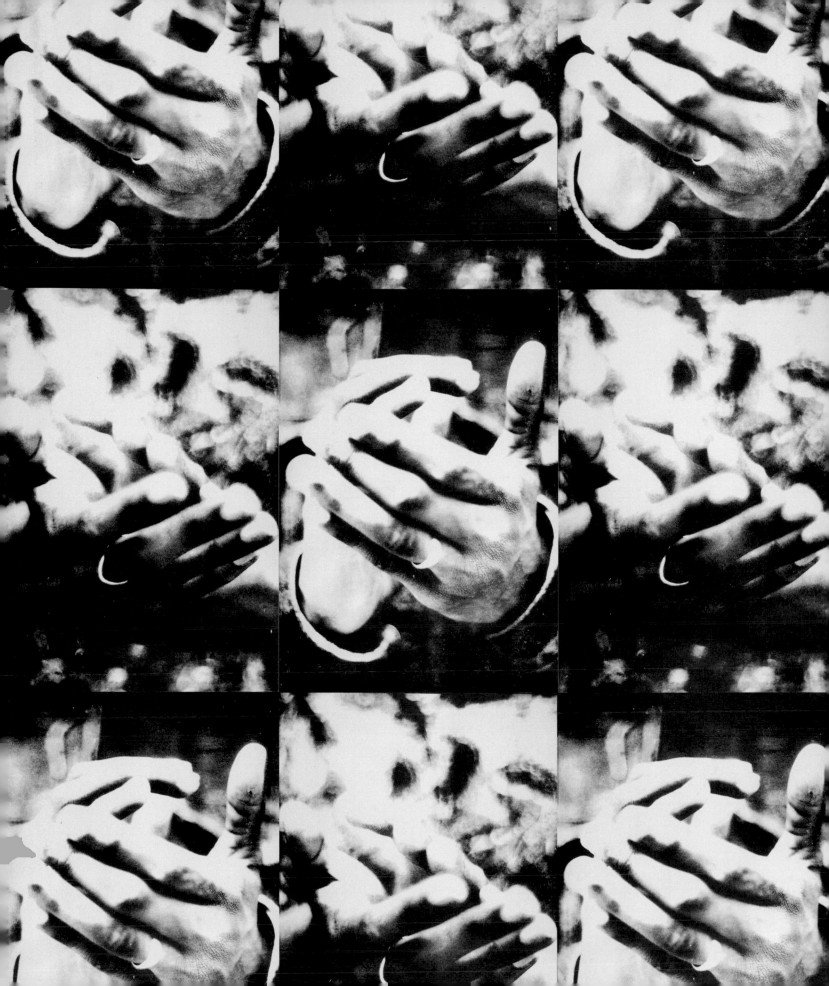

KEN MCDONALD
(born UK, 1951)

Untitled, 1998
Printed by London Printworks
Trust for the exhibition
Masquerade
Woollen coat lined with
screen-printed satin
Length of coat 100 cm,
opening to 148 cm (to include
overlap of 2.5 cm)
E.286-2005
Purchased through the
Julie and Robert Breckman
Print Fund

Masquerade, commissioned and curated by London Printworks (see page 119), was an interactive exhibition that took on the identity of a trendy clothing boutique in Brixton Market, south London. The intention was to investigate and underscore the way in which clothes can change or reflect personality. Beguiled initially into thinking that the boutique was a new retailer, visitors were somewhat disarmed to discover a more than mere shopping experience: they were encouraged to try on things but clothes were not for sale, and they were offered free polaroids of themselves posing in front of specially designed backdrops.[8] Dress here was being used not just to transform our sense of self, but also to break taboos and question stereotypes, with print positioned as a crucial element in interactive performance art.

The contributors were a group of artist/designers. Yin Lam made a number of enormous shirts, each screen-printed with a life-size naked man or woman, in a variety of ages and dimensions. Rebecca Early devised a kick-

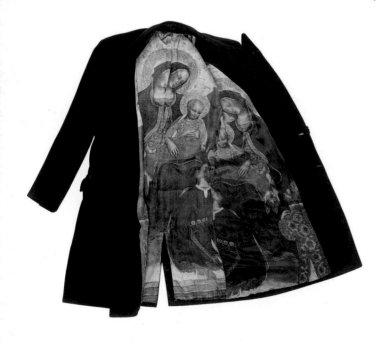

boxing suit, gloves and punch bag in a cloth of pink roses. Sarah Staton made wacky puffa suits and Ronny Fraser Munro printed T-shirts with satirical surreal/political images.

Ken McDonald, who made a number of beautiful but quietly subversive garments, was neither a trained artist nor a designer, but a bespoke tailor who had also been sartorial advisor to Johnny Rotten of the Sex Pistols on their US tour, had run a film club and published an outrageous magazine, *The Fred,* all in the 1980s. He expressed the unreliability of external appearances as a measure of character in some rather outré statements about the clergy and child abuse, for example, by lining cassocks with images of small children. However, he took the notion of external appearance versus soul much further with a worn-looking coat found in a London street gutter – the kind of garment associated with down-and-outs. He directed LPT to screen-print on to satin an image of the altarpiece of the *Madonna and Child with Saints Julian and Lawrence* by the International Gothic artist Gentile da Fabriano (1370–1427),[9] which was then sewn into the coat as a lining. Interestingly, St Lawrence is remembered for his reverence of the poor and indigent, a fact possibly not lost on McDonald. The contrast between the coat's squalid outer fabric (not cleaned in any way before going into the show) and its shining aura when the inside is uncovered is indeed astonishing.

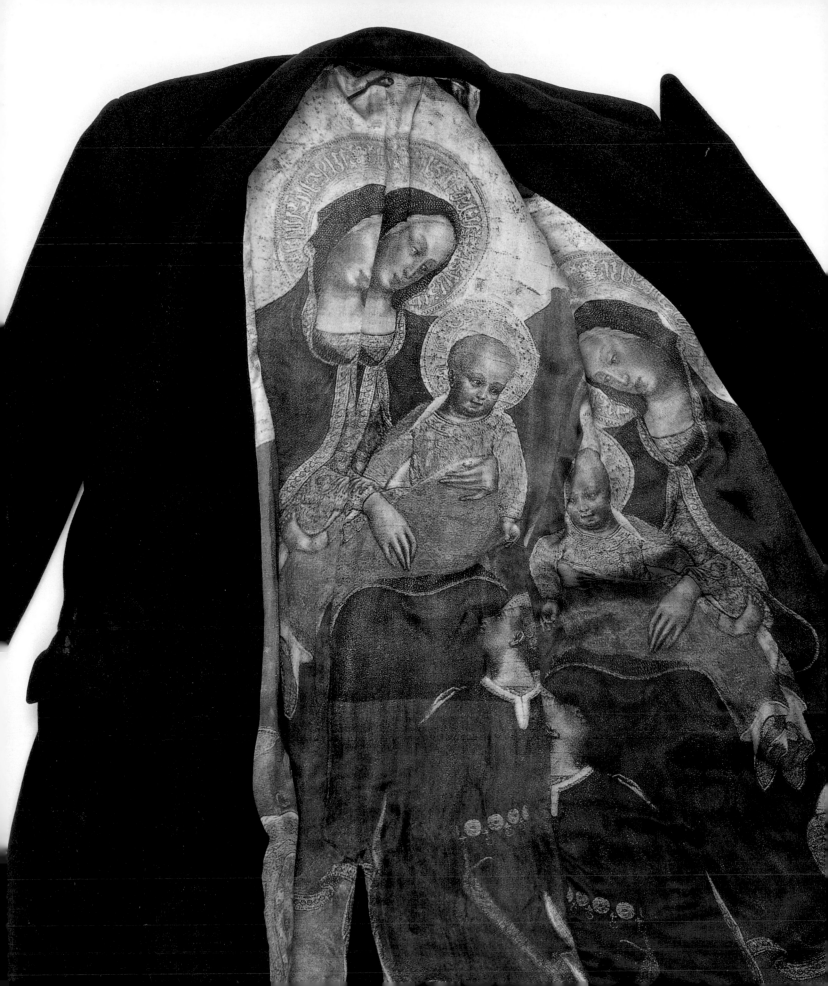

VIRGIL MARTI

(born USA, 1962)

Bullies wallpaper, 1992/97
Fluorescent ink and
rayon flock on Tyvek,
with blacklights
563 × 138 cm
E.277-1998
Given by the artist

Below:
Installation view of *Bullies*
wallpaper at the Wexner Center
for the Arts, Ohio State University,
Columbus, Ohio, during the
Apocalyptic Wallpaper
exhibition, 1997

Marti's *Bullies* wallpaper is now familiar from several exhibitions, notably *Apocalyptic Wallpaper* at the Wexner Center in Columbus, Ohio in 1997, but it was originally conceived for a site-specific installation in the boiler room of an education centre. Shown again at the Wexner (which is on the campus of Ohio State, a university with a reputation for athletic prowess) it demonstrates the way in which site-specificity can be a moveable feast, and a work designed for one space can have an equally powerful resonance in another context.

The *Bullies* wallpaper is a fluorescent flock designed to be shown to best effect in a darkened room. The basis of the design is a floral pattern adapted from a French toile wallpaper. Marti took the faces of the teenage boys, in their trompe l'oeil frames, from his junior high-school yearbook (which, ironically, had the title *The Padlock*). Seen in the dark, these young faces lose their bright, bland aspect and appear to loom menacingly from the walls.

As an adolescent Marti was marked out as being different from his peers, most of them sports-playing 'jocks', and as a consequence he became a victim of bullying. By incorporating the faces of his tormentors (actual or potential) in the wallpaper design, he gives tangible form to the way in which darkness can magnify our fears or anxieties, exaggerating feelings that seem more manageable by day. The lurid psychedelic colours and their luminosity give an intimidating emphasis to the imagined threat, and the space itself is transformed from the comforting familiar bedroom implied by the cheerful floral pattern into a claustrophobic arena for the imagination to run riot.

For the purposes of Marti's project, a floral flock wallpaper serves as effective shorthand for home and middle-class suburban values, and as the antithesis of an aggressive adolescent masculinity. As such it sets up a productive tension between the place it represents and the space in which it is exhibited.

This wallpaper was made at the Philadelphia Fabric Workshop, where artists are given facilities to work with print not only on fabric, but on other materials too. Marti himself is a master printer at the workshop. He reprinted *Bullies* for the recent show of artists' wallpapers – *On the Wall: Wallpapers and Tableau* – at the Fabric Workshop Museum, where it was installed in the men's restroom.

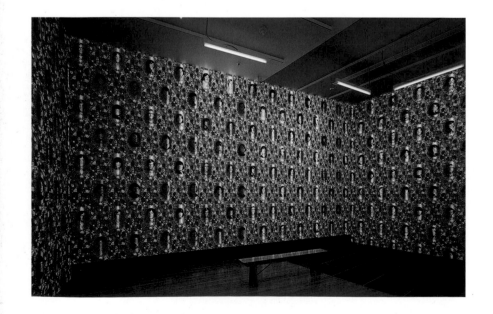

10. GETTING INTO THE MARKETPLACE

After the Second World War, private ownership of 'fine art' in Britain began to be considerably democratized as a result of various new publishing ventures. Following the example of the 1936 initiative, Contemporary Lithographs, these included School Prints, J. Lyons & Co Lithographs and Robert Erskine's St George's Gallery, which opened in 1955. Erskine set the stage for Editions Alecto, arguably the most experimental and go-ahead print publishers in Britain throughout the 1960s and '70s.

At the same time, there was a shift in attitudes towards printmaking among artists themselves, and what was once a secondary activity became for many a primary practice. This fostered the emergence of publishing by major dealers such as Marlborough; in the 1970s the auction house Christies joined the scene with Christies Contemporary Prints. Alecto were also ahead of their time in producing artists' flicker books, to be sold in newsagents, for example, and they were also the first to publish multiples.[1]

From the 1970s to the late '90s, publishing followed much the same pattern as it had during the earlier post-war decades, with dealers and galleries liaising with printing studios and artists, although in 1986 a student in Edinburgh, Charles Booth-Clibborn, launched his own publishing house, Paragon Press, from his home. As a lover of print, Booth-Clibborn was intrigued by the idea of introducing it to artists who had rarely if ever worked with it as a medium, and by doing so finding something new in their work.[2] Recognizing the crucial importance of close communication between artist, printer and publisher, he tends to work only with artists within easy geographic reach. Highly skilled at matching artist and printer, his success is also tied in with the rise of Brit art during the 1980s and early '90s, although not all his artists belong to this group. Running a business out of his private house, he has lower overheads than most commercial galleries, and his publications have provided opportunities to acquire works by critically acclaimed British artists, often at bargain prices. Paragon Press has been responsible for some of the most impressive editions in Britain over the last nineteen years, operating as an outstandingly effective catalyst between artist and print.

However, the electronic revolution has inevitably brought changes not only to the making but also to the marketing of prints. In 1999, Eyestorm became the first on-line gallery in Britain, aiming to sell prints by cutting edge artists to a generation increasingly comfortable with shopping in cyberspace. Matthew Slotover, publisher of the leading art publication *Frieze*, was initially involved, but wanting to offer something a little different than Eyestorm and keen to commission prints, he went on to establish Counter Editions in 2000 with Carl Freedman, who is now its director.[3] Much smaller and more focused, Counter works directly with artists on considered editions with high production values, but offered at affordable prices. For many people, buying prints via the Web is less daunting than visiting West End galleries, and this method of acquisition is accessible to a wider audience at ease with the Internet. Freedman and Slotover launched Counter with the *Independent* as their media partner, and have enjoyed an excellent relationship with the newspaper ever since. Press coverage of each new edition gives a boost to sales and attracts new browsers to the website. Selling online is crucial to maintaining a low retail price for the editions, but Counter now also has a gallery space in Shoreditch to show related work (not necessarily prints).

Bombarded with requests from artists wanting to work with him, Freedman is generally the one who calls the shots, but as a friend and contemporary of the YBAs he is well placed to initiate print projects with the most sought-after and exciting practitioners alongside emerging talent. Like Booth-Clibborn, Freedman is dedicated to ensuring that the technical processes and expertise are the right match for the individual artist. He relishes idiosyncratic and challenging projects, notably **Sarah Lucas'** inkjet-printed iced cakes (see Case Study, page 48), **Rachel Whiteread's** *Herringbone Floor*, for which he found a company of laser engravers in Cambridgeshire, and her most recent edition, *Secondhand*, which represents an inspired application of an industrial 3-D modelling process that involves digital printing (see Case Study, page 52).

Although in production in the 1960s, multiples have grown in popularity in recent years, with several organizations publishing and selling them. These are discussed in more detail in Chapter 8, but there have been several independent initiatives, often artist led, which have reinvigorated the selling of affordable editions and multiples. Most famous of these was the short-lived Shop (sometimes described as a kind of 'art boutique') at 103 Bethnal Green Road, in London's East End, set up in 1993 by Sarah Lucas and **Tracey Emin.** They sold mugs, T-shirts, ashtrays and other items that they had created or customized as works of art.

Artist **Sarah Staton's** project *Supastore* had various incarnations between 1993

Chris Ofili
(born UK 1968)
Afro Lunar Lovers. 2003
Printed by Omnicolour, London
Published by Victoria Miro, London
Edition of 350
Digital print from watercolour
and felt tip pen drawing,
with embossing and
hand-painted gold leaf
49 × 31.9 cm

E.1043-2003
Purchased through the
Julie and Robert Breckman
Print Fund
Courtesy Chris Ofili –
Afroco and Victoria
Miro Gallery

Gayle Chong Kwan
(born UK, 1975)
Installation for *Flypitch*,
Brixton Market, 2003
Carved labelled fruit crates,
fruit, vegetables, artificial
grass etc.
Courtesy the artist

and 1995 – it appeared as a shop and as a market stall, but originated as a kind of performance in which she sold things door to door like a travelling salesman. *Supastore'93* was set up in a derelict building in Charing Cross Road, and sold Staton's papier maché multiples, as well as T-shirts, posters and so on. At the Laure Genillard Gallery in 1994, Staton installed *Supastore Boutique*, where she sold artworks by big-name artists such as Holzer and Lewitt alongside unknowns. In January 1995, *Supastore* went to the San Francisco Art Fair, and in April, represented as a thrift store/garage sale, to Middlesborough. Conflating the roles of artist, shop assistant and curator, Staton provided an outlet for the sale of multiples that reached new audiences, and by the nature of the chosen venues, *Supastore* proved popular with a public generally shy of conventional galleries.

Another recent growth area in the commissioning and selling of prints is the production of editions to accompany exhibitions in public galleries, with proceeds generally going to support the institution concerned. The Serpentine began publishing limited editions in 1989 and has published every year since then, but with increased visibility through the Internet the practice has grown in popularity over the last ten years. Whitechapel Editions is now a fully fledged print publisher (see Cristina Iglesias Case Study, page 38). The Camden Art Centre also produces multiples, while the Hayward Gallery and the British Council sometimes act as co-publishers.

The imprimaturs of the institutions have no doubt contributed to the success of these gallery-published editions, but the practice has also helped to generate wide interest in print collecting. Major commercial galleries with no previous interest in publishing prints are now issuing occasional editions by gallery artists; among these are Jay Jopling's White Cube, whose recent publications include a **Fred Tomaselli** inkjet and an **Antony Gormley** lithograph, and the Victoria Miro Gallery, which published *Afro Lunar Lovers* by **Chris Ofili** (also an inkjet) in 2003. Other galleries, such as Anthony Reynolds and Rhodes + Mann, also publish occasional editions. Again, these relatively affordable prints reach a market beyond the established art-collecting elite and help to build a wider knowledge and interest in an artist's work.

Just as public art projects have engineered random encounters with art in unlikely places, there have been various attempts to offer art for sale by unconventional means. One such is the Hayvend project. This originated with **John Hayward**, who wanted to sell and promote artists' work in a genuinely alternative and accessible way. His idea was to sell small artists' multiples – drawings, found objects, photographs, prints and the like – from reconditioned vending machines. The first machine, which he had found discarded, was installed at Jamaica Street Studios in Bristol during an open weekend in 1995, and the project has developed from there. Hayvend machines are now sited at the ICA in London, Baltic in Gateshead and other gallery venues, but also in selected coffee bars and cafes. For £2 you can acquire a modest work of art – the choice is random, since every multiple comes packaged in a yellow card box – and artists who might not otherwise have a public forum have the opportunity to have their work distributed nationally. The vending machines, however, do not only offer cheap and easy access to art: in the words of one contributor, **Tim Ellis**, they thereby 'question the accessibility and disposable nature of mass production and the issue of commodity in art'.[4]

New directions in curating have also influenced the distribution of artists' work. In 2003, Indra Khanna organized *Flypitch*, a series of one-day installations in Brixton Market in south-east London. These took place each Saturday from early May to late July, literally on a market stall, alongside the regular traders. Khanna has lived in Brixton for several years and the market was her inspiration. Taking their cue from the venue, the artists created installations that implied a relationship with commerce or with the other kinds of objects (or activities – such as hairdressing) that were traded in this space. One of the participants was **Anne Rook** (see Case Study, page 64), whose work addressing the globalization of the food market relies heavily on the ubiquitous printed food label and ready-meal packaging for full satiric effect. **Lee Campbell**, also interested in the implications of labelling, stacked his stall to over-flowing with objects virtually obliterated by being completely covered with stickers of every description.

Anne Rook
(born France 1945,
lives and works UK)
Bookworks, various, 1999–2004
Digital print from CAD
on clear acetate and paper;
clear plastic food packaging
National Art Library

Harald Smykla, for whom print processes contribute to an ongoing series of events, involving such activities as monoprinting from pierced mulberry leaves and creating stencilled moulds from sushinori (dry-roasted seaweed sheets), meticulously drew over the historic figures on the reverse sides of banknotes. The new portraits were always of his 'customers', who offered the notes for transformation. These astonishingly convincing alternative representatives of British nationhood depended entirely on a printed object – the banknote – for effect. Witty and ephemeral, they also touched more seriously on ideas around constitutional representation.

Gayle Chong Kwan carved around the patterns of colourful fruits on the labels pasted on to wooden crates. She then used these decorative profiles to create a baroque proscenium arch above the stall, on the flat surface of which she designed a fantasy landscape from discarded fruit and vegetables found on the market pavements. Some of the artists were selling work directly from their stalls, others were taking commissions, but all were reaching an audience that might otherwise never have come face to face with 'art' in their daily lives, nor have had the time and inclination to seek it out in its traditional home.

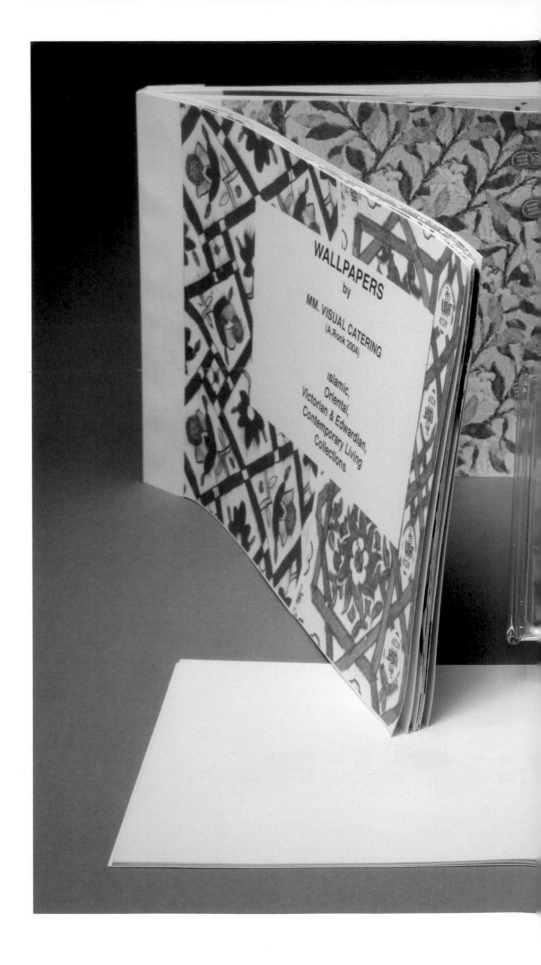

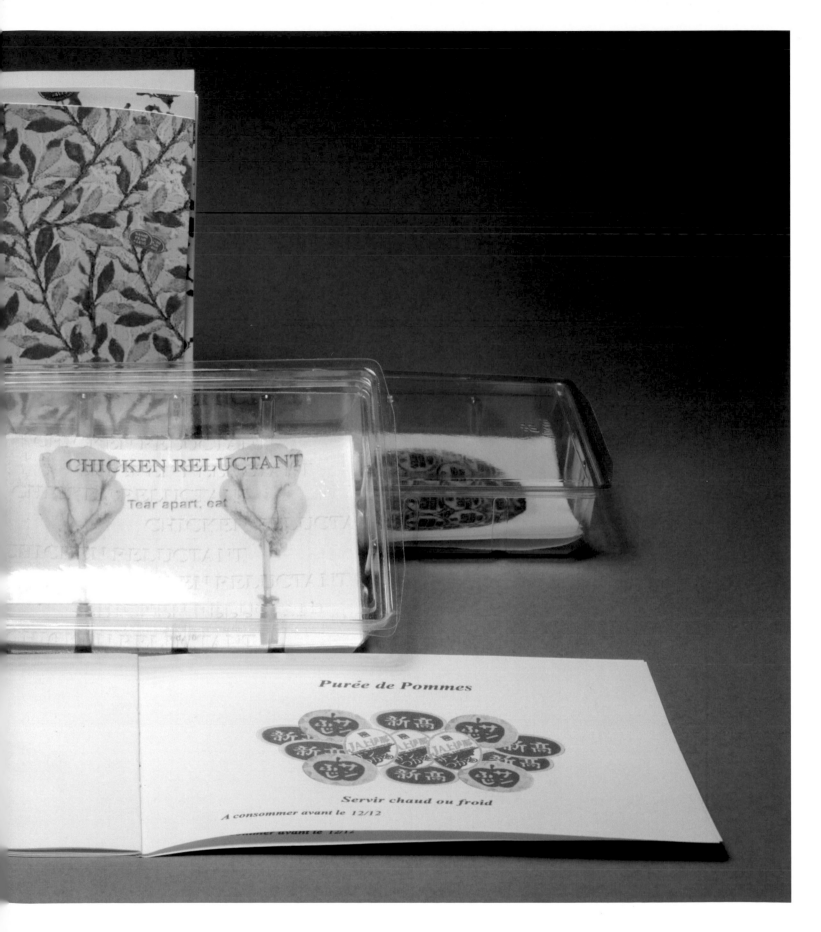

SLIMVOLUME POSTER PUBLICATION, 2002

*Slimvolume Poster
Publication,* 2002
30 prints loose bound
in card covers
Cover: letterpress on card;
prints: mixed media
Dimensions: variable;
covers 42.2 × 30 cm
E.155:1–34–2003
Given by Andrew Hunt
© Slimvolume

Below:
Launch of *Slimvolume
Poster Publication 2001,*
at the Austrian Cultural
Forum, London,
12 November 2001

Slimvolume, a 'not-for-profit' organization, was set up in 2000 (by Andrew Hunt and a Swedish curator, Helena Sundström) to provide an open space for artists to expand their practice within a collective curatorial framework. Hunt has continued the *Slimvolume Poster Publication* as an annual project.

This is the second edition; it contains work by thirty artists – the first fifteen each selected another artist to contribute. The participants are from Germany, Sweden, the US and the UK, and the project is conceived and produced in a collaborative process. However, the artists themselves are responsible for producing their own prints, so there are many different media in each edition, ranging from Xerox to screen-print. The publication is not bound, and functions both as a conventional portfolio and as a ready-made exhibition. The works themselves are simultaneously prints, posters and multiples. An essential feature of the project is its method of distribution.

The edition is allocated to people chosen by the participating artists and the organizers. The recipients are free to exhibit or distribute all or parts of the set, or to keep it intact. As a loose-bound edition, the publication can be used and exhibited in a variety of contexts. Some copies are preserved intact, others may be broken up and disseminated, exhibited, fly-posted or even discarded. The recipients include artists, writers, theorists, curators, musicians, friends and museum collections.

The first edition in 2001 was shown in London, Berlin and Stockholm, the second at Vilma Gold, a London gallery; the third, exhibited at Norwich Gallery, included new work by the thirty artists chosen for EAST 03 (an international open art competition), and editions by Toby Webster and Eva Rothschild, that year's EAST selectors. The 2004 edition was launched at ®edux, a London project space, where it was presented as a traditional exhibition, with each print mounted and framed.

Slimvolume offers a publishing opportunity to emerging artists; it is also a collectable manifestation of the new tendency for artists to make and exhibit work outside the traditional gallery system, using cooperative strategies for publishing, promoting and curating their own work. It demonstrates some of the ways in which artists are working with traditional media – the portfolio, the limited edition, the poster, the artist's multiple and book art – but moving beyond the accepted definitions and established formats.

CHRIS OFILI
(born UK, 1968)

Regal, 2000
Printed by Omnicolour,
K2 Screen and Print Select
Published by Counter
Editions, London
Edition of 300
Lithograph and screen
print from digitally merged
watercolour and etching
29 × 40 cm
E.1570-2001
Purchased through the
Julie and Robert Breckman
Print Fund
Courtesy Chris Ofili -
Afroco and Victoria
Miro Gallery

Below:
*View from top Sagrada
Familia,* from the
suite of 10 plates
To T from B with L, 1992
Edition of 10
Etching
Plate 24.5 × 20 cm
E.681-1993
Courtesy Chris Ofili -
Afroco and Victoria
Miro Gallery

Ofili is one of Britain's most celebrated artists, who is best known for his un-compromising invocation and parody of black stereotypes, jibing at political correctness but nevertheless serious about what it means to be black. Painter of large unframed canvases balanced on decorated balls of elephant dung, Ofili has also produced beautiful draw-ings. These might suggest to some an interest in Max Beerbohm or Aubrey Beardsley, although Ofili has at times surprised the art world with some fairly arcane influences (Trinidadian dry-cleaners for example). His etchings, like his paintings, have echoed the pattern-making of Zimbabwean cave painters. In 1998, to mark his one-man show with them, the Serpentine Gallery published a limited edition print, *Celestial,* which digitally merged a watercolour and etching and furthermore had the delightful capacity to glow in the dark.

The glow-in-the-dark feature, with its evocations of aliens, child's toy and saintly halo, is one of Ofili's magical ploys to merge parody with affection and reverence. It was made possible in the printing by applying a ground of phosphorescent ink, a procedure that is not as simple as it sounds. Phospho-rus tends to float to the surface of the ink as it dries, necessitating a sealant; it makes the ink very thick and difficult to apply. Overprinting is also problemat-ic, as the underlying phosphorus has a deadening effect, especially on blacks.[5]

The printers, Omnicolour and K2, work in tandem as commercial enterprises, but enjoy the challenge of working with artists and are becoming increas-ingly popular with publishers.[6] The resourceful approach of Counter's director, Carl Freedman, to locating the appropriate production lines for his artists, has resulted in some fasci-nating commissions from at first sight unlikely commercial and industrial manufacturers.[7] For *Regal,* however, which Ofili intended as a companion piece to *Celestial,* Freedman followed the Serpentine's lead and also opted for Omnicolour and K2. They were experienced in the tricky business of stencilling out the silhouette figure and details of dress to avoid overprint-ing the phosphorescent screen, and in finding a lithographer who would understand the rather unusual work of printing in what the stencils had taken out – rather more complicated in *Regal* than in *Celestial.* Only the swirling lines of the background, which in Ofili's original artwork were produced through etching, were over-printed by the phosphorescent screen.

Regal 15/300

GLOSSARY

Below is a summary of the terms most pertinent to this book. If explained in the text itself or in the footnotes the term may not appear here. A full glossary of more traditional printmaking terms may be found in several other publications, e.g. Susan Tallman, *Contemporary Print* and Deborah Wye, *Artists and Prints* (see bibliography for details). Susan Lambert, *Prints Art and Techniques* (V&A Publications, 2001), describes all the more traditional processes. Bamber Gascoigne, *How to Identify Prints* (Thames & Hudson, 1986) is a comprehensive guide to manual and mechanical processes. The processes of digital technology are immensely complex but have been described in various websites such as http://en.wikipedia.org/wiki/Category:technology.

Analog/ue printing Uses a system of reproduction in which the image is analogous or proportionate to the original, as opposed to Digital printing where the reproduction is based on dividing the image into a bit map or raster made up of a collection of pixels or dots in a grid.

Blacklights A modified form of lighting. Specially prepared tubes and bulbs do not emit light as normal tubes and bulbs do, but emit light which acts on phosphorus – a substance found naturally in teeth and fingernails but also in TV screens and fluorescent inks for example – to make it glow in the dark.

Brush bite see **Etching**

Chine Collé A sheet of tissue-fine paper glued to the main support sheet for a printed image, to create a subtle change of tone and texture in the finished image

Collotype A process which relies on the hardening of exposed photo-sensitised gelatine to create an image. Photography is used in the first instance to create the image on a gelatine-coated glass 'plate' which is then washed and inked up for printing in a press. The ink adheres to the gelatine plate most densely where the gelatine is hardest and most thinly where it remained softest. The resulting print is one of continuous and subtly changing tone. The image, however, is fragile and only short print runs are possible.

Computer Aided Design (CAD) Made with a computer program. Can be output directly from the computer using a digital printer and transferred by photomechanical means to be printed in another process such as screenprinting, lithography or etching.

Digital Print A digital print is one for which the image has been created with the aid of a computer program in which visual information has been stored and can be retrieved and transmitted according to a numerical system. In this system the image has been broken down into dots of colour or 'pixels', which occur at a specified number per square inch. The higher the number per square inch the higher the 'resolution' or ultimate sharpness of the image. For the sake of argument it may be said that inkjet prints are digital, but not all digital prints are inkjet. Some may be printed through other systems, for example, dye sublimation in which heat is used to transfer a wax-based ink from a ribbon or panel onto the substrate.

Edition The artificially limited number of impressions printed from a plate or reproduced from any other photo-based or digital processing technology.

Etching An intaglio process in which a drawing is made with a specially designed etching 'needle' into a waxy resin or 'ground' covering a metal plate. When the drawing is complete the whole is placed in an acid bath so the metal disclosed by the needle is 'etched' ('bitten') into by the acid. The place is then washed, inked and printed. The depth of 'etch' depends on length of immersion time. Variations can be created. For example: Soft ground, in which the 'ground' can be impressed or lifted with different kinds of objects and tools; or Aquatint, in which the ground is applied in the form of powder or spray adhered to the plate through heat. The acid bites in the interstices and the inked-up plate yields a grainy tonal effect in the print. **Brush bite** is created by painting acid with a brush directly onto an un-grounded plate and is characterised in the print by a build up of ink at the edges of the brushed areas.

Giclée Print (from the French *giclée*: spurt, squirt) Another term for inkjet, usually applied to fine art prints.

Halftone processes Any process – intaglio, relief or planographic – where a photographically produced screen has been introduced to break up areas of solid tone, enabling enlargement and reduction of images without loss of clarity. The screen pattern is usually visible through a magnifying glass.

Inkjet Print Produced from a printer in which the ink is transferred to the paper (or other substrate) from a mechanism comprised of a number of tiny nozzles. Under high pressure, each nozzle sprays ink onto the paper. This process is different from impact or dot matrix printers, in which pin heads, fired out of a mechanism at speed (as in a typewriter), impact on an inked ribbon, thus transferring ink from ribbon to paper.

Intaglio A process in which the ink is pressed into cut-away/acid-eaten areas of the plate and the surface wiped clean. Plate and dampened paper are put through the press together so the ink is forced out of the incised/bitten areas and onto the paper.

Iris Print A print from the inkjet printer of that commercial name, developed by Scitex in the 1980s originally for proofing offset lithography but refined for fine art usage in the 1990s. Originally it used dye-based inks where many other inkjet printers used pigment-based inks.

Letterpress A relief printing process developed for the printing of type, in which the print is usually made by the pressure of a large flat plate onto paper overlaying inked metal or wooden type.

Lithograph A planographic process in which a design is drawn/painted with a greasy ink or 'tusche' on a printing plate (originally stone but now more commonly a zinc plate). The plate is then washed with a mixture of gum arabic and weak acid to make the blank areas receptive to water. It is then washed again with water, which rolls off the greasy drawing but adheres to the blank surfaces. The plate is then inked up, but the ink only adheres to the greasy drawing, not the watery blank surfaces. Plate and paper are then put through the press. The process can be repeated with different 'drawings' for different colours in the image.

Offset Any process (especially lithography) in which the image is taken up onto an intermediate cylinder and transferred from there onto the final substrate.

Photogravure An intaglio process made with the intervention of photography. The abbreviated form 'Gravure' is commonly used with reference to mechanical production in which a half-tone screen is used to achieve tonal variations.

Planographic process One in which the ink is applied to a printing plate which has not been incised or cut away, so the ink lies on the flat surface, with the un-inked areas achieved through a chemical repelling of water by grease (as in lithography) or through the presence of a partially masked screen or stencil (as in screenprint).

Raster and Vector Graphics Both generated within the computer. Raster graphics reproduce an image as a collection of

NOTES

pixels or dots derived from digitisation. Vector graphics reproduce an image as a collection of geometric shapes such as lines, curves and polygons. Each have particular qualities which may be more or less advantageous in the production of an image, depending on the type of image required. Raster graphics will loose sharpness if scaled to a higher resolution from the original, but are best used for reproducing photographic images, whereas Vector graphics may not achieve such precision as Raster graphics but do not suffer from being scaled up and are more suited to typesetting or graphic design.

Relief Print Any process, such as linocut, woodcut or letterpress, where the cutaway areas of the printing block do not receive the ink but the areas remaining and standing proud are inked with a roller and the impression is taken from this.

Screenprint A planographic process in which the 'plate' is a fabric screen stretched taut onto which a design has been applied. This can either be done by adhering a stencil to the screen or by covering the screen with a resist, drawing into this with greasy crayon and then treating the screen so that the drawing is washed away and the rest of the screen blocked. Stencils can also be made using photographic processes and light sensitive gelatine to block the mesh. To print, ink is forced through the mesh of the screen (where the stencil is not blocking it) with a rubber blade onto the substrate. Screenprint can be used to print onto a variety of surfaces not necessarily flat, including fabric and ceramic.

Tyvek™ A cross between paper, film and fabric developed by Dupont, made from very fine high-density polyethylene fibres. It is strong, lightweight, water- and chemical-, tear- and abrasion-resistant and has many industrial and commercial applications.

INTRODUCTION

1. We have not been able to discuss Smith's contribution here, but it is comprehensively discussed in Wendy Weitman, *Kiki Smith Prints Books and Things*, MoMA, 2004. For practical reasons, our survey is focused on Britain and the United States and covers some areas that have been affected by British or American colonial history, but there are many other interesting developments, for example within the former Soviet Union and among Chinese artists, particularly those living abroad.

2. Marilyn Kushner, 'The Lure of Diversity: New Prints 2002 Autumn', *New Prints Program: New Prints 2002/Autumn Essay*, International Print Center, New York, www.ipcny.org.

3. The Fabric Workshop originated as a fabric-printing studio, but now engages with a very wide range of fabric applications, of which print is one.

4. Judith Brodsky and Isabel Nazario, with essays on artists by students, *The Latina Artist, the response of the Creative Mind to Identity, Race, Class and Gender*, 1997.

CHAPTER 1

1. How stuff works, http;//computer. howstuffworks.com/inkjet-printer.htm http:howstuffworks.com/inkjet-printer.htm

2. For a full account of the development of AARON see Harold Cohen, 'Decoupling Art and Affluence' at www.kurzweilai.net/articles/art0406.html

3. The Patric Prince Collection of Computer Art is presently on loan to the museum from the American Friends of the V&A.

4. Deborah Wye (ed.), *Artists & Prints: Masterworks from the Museum of Modern Art*, Museum of Modern Art, New York, 2004, p.286.

5. Correspondence with James Faure Walker, 22 January 2005.

6. Okimate used wax ribbon and came on the market c.1986.

7. Correspondence with James Faure Walker, 22 January 2005.

8. 'In the Beginning', in *Hands on Paper* (supplement to *Art on Paper*), New York, 1997, pp.5–13.

9. Ibid.

10. Recent technology has meant a shift in ink compatibility.

11. Susan Tallman, *The Contemporary Print from Pre-Pop to Postmodern*, Thames & Hudson, London, 1996, p.214.

12. See Pat Gilmour, *The Mechanized Image*, ACGB, 1978, pp.92–6.

13. UWE, Bristol, led by Steve Hoskins with a team consisting of Paul Thirkell, who is specializing in collotype, and Sarah Bodman, Carinna Parraman and Richard Anderton. Conversation with Steve Hoskins and Paul Thirkell, September 2004.

14. An impression of the poster is in the V&A Collections E.176-1994.

15. Formerly the London Institute.

16. Peter Halley in *Playing Amongst the Ruins*, exhibition catalogue, Royal College of Art, London, 2001, p.47.

17. Peter Kennard and Cat Picton Phillipps, 'Introduction', *Award*, published with the boxed set, 2004.

18. Email from the artist, 21 April 2005.

CHAPTER 2

1. Charles Newton, *Photography in Printmaking*, V&A/Compton/Pitman, 1979.

2. From details supplied by Annis Fitzhugh, master printer, Dundee Contemporary Arts.

3. Sonia Boyce, Christine Woods, Andrea Mackean, in *Sonia Boyce, Performance*, pp.34-39

4. Iwona Blazwick, in Iwona Blazwick (ed.), *Cristina Iglesias*, Ediciones Poligrafa, Barcelona, 2002, p.17.

5. Ibid, conversation between Cristina Iglesias and Gloria Moure, p.57.

CHAPTER 3

1. Kobena Mercer, *Yinka Shonibare Dressing Down*, Ikon Gallery, Birmingham, 1998, p.14.

2. Yinka Shonibare in conversation with Stewart Russell, catalogue, *Pledge Allegiance to a Flag*, LPT, 1996.

3. Salah Hassan, 'Introduction', *Insertion: Self and Other*, Apexart, New York, 18 April – 20 May 2000.

4. Andrew Wilson, *Only the Lonely*, catalogue, Bridget Smith, Fiona Banner, Frith Street Gallery, London 1997.

5. The romanticized version of
the wars that she grew up with.

6. Conversation with the artist,
November 2003.

7. Ibid.

CHAPTER 4

1. Zineb Sedira in conversation
with Edith Pasquier, in *Out
of the Blue*, exhibition catalogue,
Glasgow Museums, 1997, p.23.

2. Oil on canvas, 1654, National
Gallery, London.

3. Lucio Fontana (1899–1968),
Argentinean-born artist renowned
for slashing and puncturing his
canvases to establish the painting
as object as well as surface, an
inherently violent process.

4. *Five Billboards Body and text
removed*, 2003.

5. *One Year of the News Jan 1st –
Dec.31st*, 2003.

CHAPTER 5

1. Susan Tallman, *Arts Magazine*,
March 1990, pp.17–19; Karin Breuer,
in *Thirty-five Years at Crown Point
Press*, University of California Press
in association with the Fine Arts
Museum of San Francisco, 1997,
pp.49–53.

2. Randy Hemminghaus is now master
printer at Rutgers. Resident professional
papermaker Annie McKeown is equally
important in not only enabling the
artist's vision, but also conceiving the
techniques that will make the work
happen.

3. Etching and screen-printing may
also now be used.

4. See Roger Butler (ed.), *Islands in
the Sun Prints by Indigenous Artists
of Australia and the Australasian
Regions*, National Gallery of Australia,
Canberra, 2001.

5. Brush bite etching is a process
where the acid is brushed directly
on to an ungrounded plate.

6. Christine Nicholls' introduction
to the portfolio *Yilpinji Love Magic
and Ceremony, Flinders University*,
Adelaide, 2003. Published on HYPERLINK
http:www.aboriginalartprints.com.au/
yilpinji_essay3.cfm

7. The artist specifically wished
to acknowledge Foti's crucial role
in the process.

8. In fact the eyes were painted
on the paper before the lithography
took place.

9. Technical and Further Education
Institutes in Queensland, some of
whom had attended further specialist
art courses. See Adrian Newstead, *Gelam
Nguzi Kazi (Dugong My Son)*, the first
exhibition of limited edition linocuts
by the artists of Mualgau Minaral
Artist Collective from Mua Island,
Torres Strait, exhibition catalogue,
Australian Art Print Network, New
South Wales, 2001.

10. Ibid, p.9.

11. *A la poupée*: a method of applying
ink to a printing plate by hand with
a doll-like bundle of cloth. This means
that different colours can be applied
in small areas to the plate for one
printing.

CHAPTER 6

1. Tate Modern (which is in the Borough
of Southwark) acquired twenty-one prints
from the project, along with a section
of the floor entitled *The Ring: Fight On*.
The printed banner is owned by the artist.

2. 'An installation by Richard Woods
and an interview with the artist –
by himself', *Modern Painters*, Summer
2003, p.77.

3. *See NewBuild, An Installation by
Richard Woods: Guide*, 2005 (with essay
by Gill Saunders).

4. Quoted in Daniela Mecozzi,
'Domestic Violence', in *Frame 37*,
March/April 2004.

CHAPTER 7

1. A. Reinhardt, J. Kosuth and
F. Gonzalez-Torres, *Symptoms of
Interference, Conditions of Possibility*,
Art & Design/Academy Editions,
1994, p.76.

2. Michael Bracewell, 'Playing God',
in *Adam Chodzko*, August Media,
London 1999, p.4.

3. The performance was cancelled
by Southwark Council as a response
to fears about the public health
implications.

4. Judy Hecker, 'Art, Advertising
and the Accidental Viewer', brochure
for *Projects 77 Billboards: Sarah Morris
Julian Opie Lisa Ruyter*, Museum
of Modern Art, New York, 2002.

5. A. Reinhardt, J. Kosuth and
F. Gonzalez-Torres, *Symptoms of
Interference, Conditions of Possibility*,
Art & Design/Academy Editions,
1994, p.76.

6. Quoted in *Baltic No.16*, brochure
for *B.Open*, inaugural exhibition
at Baltic, the Centre for Contemporary
Art, Gateshead, 2001.

7. See Archive: *Reports: National
Cancer Centre of Excellence* at
www.publicartonline.org.uk/archive/
reports/cancer_centre

8. *Observer*, 10 October 2004.

CHAPTER 8

1. Judith Palmer, 'Go forth and
multiply', *Independent*, 21 April
1999.

2. Ibid.

3. Ibid.

4. Made in the studios of Alan Cox
of Sky Editions, London, for distribution
to subscribers to *CVA* magazine
in association with White Cube.

5. Marco Livingstone, 'Return of the
Body Snatcher', in *Tim Head*, exhibition
catalogue, Whitechapel Art Gallery,
London, 1993, p.47.

6. Quoted in 'Felix Gonzalez-Torres',
an interview by Tim Rollins, in
Art Press 1993, p.23.

7. Caption text as specified by
The Felix Gonzales-Torres Foundation

CHAPTER 9

1. For further information on LPS
see John Phillips, *Transforming
Print: An Exposition of Key Issues
Affecting the Development of
London Print Studio*, doctoral thesis,
unpublished, 2005.

2. Marion Boulton Stroud (ed.), Kelly
Mitchell, *New Material as Media:
The Fabric Workshop and Museum*,
co-published by the Fabric Workshop
and Museum, Philadelphia, MIT Press,
Cambridge Mass, and London, 2003.

3. The Union Jack in the colours
of the Irish tricolour, not itself a print
but accompanied by numerous printed
badges and mini-flags as takeaway
souvenirs.

4. Michael Kirk of Parsons School
of Design, New York was instrumental
in securing the Quality House of
Graphics Laboratory for the printing.

5. Wendy Weitman, *New Concepts
in Printmaking 2. Willie Cole*, a website
for the exhibition at MoMA, NYC,
9 June–13 October 1998:
www.moma.org/exhibitions/1998/
cole/-3k-MOMA NYC 1998.

6. Deery and Hemminghaus
were responsible for this ingenious
solution, which also enabled them
to make the 'scorch mark' larger
than that from a real iron.

7. Stewart Russell, John Roberts,
Interview with Sonia Boyce, Jo Casely
Hayford, Bill Woodrow Catalogue,
in *Portable Fabric Shelters*, exhibition
catalogue, London Printworks Trust,
22 April–3 June 1995.

8. But the catalogue doubled
as mail order.

9. Now in the Frick Collection
New York.

BIBLIOGRAPHY

CHAPTER 10

1. For this and further information on Alecto, see Tessa Sidey, *Editions Alecto*, Lund Humphrey, 2002.

2. Patrick Elliott (ed.), *Introduction Contemporary Art in Print*, 2001, p.11.

3. We are grateful to Carl Freedman for much of the information on Counter in this section.

4. Quoted on the artist's page at www.hayvend.com/artists/pages

5. Information on this and other printing details: conversation with Bob Pain and Mark Jenkins, 13 January 2005.

6. See Case Study, Showroom Dummies.

7. See Case Studies, Rachel Whiteread and Sarah Lucas.

Works on subject areas are listed under subject headings; artists are listed alphabetically.

GENERAL

Margaret Timmers (ed.), *Impressions of the 20th Century*, London, V&A Publications, 2001

Deborah Wye (ed.), *Artists & Prints: Masterworks from the Museum of Modern Art*, Museum of Modern Art, New York, 2004

Patrick Elliott (ed.), *Contemporary British Art in Print: the Publications of Charles Booth-Clibborn and his Imprint the Paragon Press 1986–95*, Edinburgh, Scottish National Gallery of Modern Art, c. 1995

Charles Booth-Clibborn (ed.), *Contemporary Art in Print: the Publications of Charles Booth-Clibborn and his Imprint the Paragon Press 1995–2000*, London, Booth-Clibborn Editions, 2001

Susan Tallman, *The Contemporary Print from Pre-Pop to Postmodern*, London, Thames & Hudson, 1996

NEW MEDIA

Computer technology: inkjet printing
http://computer.howstuffworks.com/inkjet-printer.htm

Mamata B. Herland, *The Impact of Giclée*, published on http://moca.virtual.museum/mamta/mamta-essay.htm

'Iris Printers' (article on Jon Cone, etc.), in *Hands on Paper*, supplement to *Art on Paper*, New York, 1997

Artbyte (continued from *Hands on Paper*), New York, Artbyte Inc., 1998–2001

Artbyte, published by Eastern Art Publishing, 1992. Published on http://www.eapgroup.com/artbyte.htm

Charles Newton, *Photography in Printmaking*, London, V&A/Compton/Pitman, 1979

James Faure Walker, *Painting the Digital River*, Prentice Hall, 2006

NEW NARRATIVES

USA
Judith K. Brodsky, *Facing Each Other Prints Concerning Identity from the Rutgers Center for Innovative Print and Paper*, exhibition catalogue, Painted Bride Art Center, Philadelphia, PA, Nov 2001–Jan 2002

Judith K. Brodsky, *100 New Jersey Artists Make Prints Fifteen Years of the Rutgers Center for Innovative Print and Paper*, exhibition catalogue, RCIPP, New Brunswick, NJ, 2002

Judith K. Brodsky and Isabel Nazario, with essays by students, etc., *The Latina Artist; the Response of the Creative Mind to Identity, Race, Class and Gender*, New Brunswick, New Jersey, RCIPP (in English and Spanish), 1997

Trudy V. Hansen (ed.), *Printmaking in America: Collaborative Prints and Presses, 1960–1990*, New York, Harry N. Abrams, Inc., NYC, 1995

Southern Africa
Kuru Development Trust, *Contemporary Bushman Art of Southern Africa, Kuru Cultural Project of D'Kar, Botswana*, Botswana, Kuru Cultural Project, 1991

Australia
Christine Nicholls, Essay, *Yilpinji Love Magic and Ceremony*, 2003, Flinders University, Adelaide, Australia. Published on HYPERLINK http://www.aboriginalartprints.com.au/yilpinji_essay3.cfm

Torres Strait Islands
Adrian Newstead, *Gelam Nguzu Kazi (Dugong My Son) the first exhibition of limited edition linocuts by the artists of Mualgau Minaral Artist Collective from Mua Island, Torres Strait*, exhibition catalogue, Australian Art Print Network, New South Wales, 2001

COMMUNITY-BASED WORKSHOPS

The London Print Studio
John Phillips, *Transforming Print: An Exposition of Key Issues Affecting the Development of London Print Studio*, doctoral thesis, unpublished, 2004

The Fabric Workshop Philadelphia
Marion Boulton Stroud, (ed.), Kelly Mitchell, *New Material as Media: The Fabric Workshop and Museum*, co-published by the Fabric Workshop and Museum, Philadelphia, MIT Press, Cambridge Mass., and London, England, 2003

London Printworks Trust
Stuart Russell and John Roberts, *Portable Fabric Shelters*, exhibition catalogue, LPT, London, 22 April–3 June 1995

Stuart Russell and Nikos Papastergiadis, *Pledge Allegiance to A Flag? Ade Adekola Yinka Shonibare Mark Wallinger*, exhibition catalogue, LPT, London, 20 Dec 1996–31 Jan 1997
Stuart Russell, Graham Ramsey, Janice

Cheddie and Dave Beech, *Masquerade*, exhibition catalogue, LPT, London, May 1998

Sian Weston, *Scuffed*, project catalogue, LPT, London, July 1998

Sian Weston, *An Ideal Home*, project catalogue, LPT, London, December 2000

SITE-SPECIFIC PRINT

Donna de Salvo and Annette Massie, with essay by Gill Saunders, *Apocalyptic Wallpaper*, exhibition catalogue, Wexner Center for the Arts, Ohio State University, Columbus, Ohio, 1997

Judith Tannenbaum and Marion Boulton Stroud, *On the Wall: Contemporary Wallpaper*, exhibition catalogue, Museum of Art, Rhode Island School of Design, Providence; Fabric Workshop and Museum, Philadelphia, 2003

PUBLIC ART

Imprint: a public art project, exhibition catalogue, The Print Center, Philadelphia, Pennsylvania, 2002

MULTIPLES

Stephen Bury, *Artists' Multiples 1935–2000*, Aldershot, Ashgate, c. 2001

ARTISTS

Faisal **Abdu'Allah**
Stuart Hall and Mark Sealy, *Different*, London and New York, Phaidon, 2001

Lynne **Allen**
David Kiehl, *Lynne Allen*, in *Excuse Me While I Disappear: Works by Lynne Allen*, exhibition catalogue, Plains Art Museum, Indiana, 22 May–14 September 2003

Ellen **Bell**
Ellen Bell, exhibition catalogue, Rebecca Hossack Gallery, London, 2003

David **Bosun**
see above under Torres Strait Islands

Sonia **Boyce**
Mark Crinson (ed.), *Annotations 2: Sonia Boyce: Performance*, London/Manchester, Institute of International Visual Arts, London in collaboration with Cornerhouse, Manchester, 1998

Judith **Brodsky**
Harry Naar, *Judith K. Brodsky, Memoir of An Assimilated Family*, exhibition catalogue, Rider University and Art Gallery, Lawrenceville, New Jersey, 2003

Maria Magdalena **Campos-Pons**
Salah Hassan and Olu Oguibe (eds.), *Authentic/Ex-centric Conceptualism in Contemporary African Art*, Ithaca, New York, Cornell University Forum for African Arts and London, Art Data, 2001. (Published to accompany Africa in Venice at the 49th Venice Biennale.)

Julia **Herzberg** and Sally **Berger**, *A Town Portrait (History of a People who were not Heroes Parts 1 and 2 Maria Magdalena Campos-Pons)*,

Lehman College Art Gallery and MoMA, NYC, 1998. Published on _ HYPERLINK _http://ca80.lehman.cuny.edu/gallery/web/AG/campospons/DifContents_.

Paul **Coldwell**
Paul O'Niel, Anthony Rudolf and Paul Tebbs, *Paul Coldwell Case Studies*, London, British Council & London Print Studio, 2002

Charlotte **Hodes**
Paul Scott, *Painted Clay, Graphic Arts and the Ceramic Surface*, London, A&C Black, 2001

Cristina **Iglesias**
Iwona Blazwick (ed.), *Cristina Iglesias*, Barcelona, Ediçiones Polígrafa, 2002

Peter **Kennard**
Peter Kennard, with introduction by Amanda Hopkinson, *Dispatches from an Unofficial War Artist*, Aldershot, Hants, Lund Humphries, 2000

Chila Kumari **Burman**
Lynda Nead, *Chila Kumari Burman: Beyond two cultures*, Kala Press, London, 1995

Sarah **Lucas**
Matthew Collings, *Sarah Lucas*, London, Tate Publishing, 2002

Sarah Lucas, exhibition catalogue, Museum Boijmans Van Beuningen, Rotterdam, 1996

Cecilia **Mandrile**
Alicia Candiani, 'Displacement, Hybridisation and Globalisation', *Grapheion* 17, 2002, (Special Issue: Conference Papers for the 3rd International Triennial of Graphic Arts, Prague, 2001)

New Directions in Print, The Borderless State, exhibition catalogue, City Museum of Art, Racokzi, Hungary, 2004

Chris **Ofili**
Lisa Corrin, Godfrey Worsdale, *Chris Ofili*, exhibition catalogue, Southampton City Art Gallery/Serpentine Gallery, London, 1998

Thelma Golden, Beth Coleman, Adrian Searle and Stuart Hall, *Chris Ofili: Within Reach*, exhibition catalogue for Chris Ofili at the British Pavilion, the 50th Venice Biennale, London, Victoria Miro Gallery, 2003

Julian **Opie**
Mary Horlock, *Julian Opie*, London, Tate Publishing, 2004

Cornelia **Parker**
Jessica Morgan, Bruce Ferguson and Cornelia Parker, *Cornelia Parker*, Boston, Institute of Contemporary Art, 2000

Jonathan Watkins (ed.), Jessica Morgan, *Cornelia Parker A Meteorite lands....* Birmingham, Ikon Gallery, 2002

Simon **Patterson**
Time and Tide: Plantation Lane, London, RIBA Publications, 2005

Grayson **Perry**
Lisa Jardine, *Grayson Perry*, Victoria Miro Gallery, London, 2004

Johannes **Phokela**
Bruce Haines, 'Changing the Title', in Salah Hassan and Iftikhar Dadi (eds.), *Unpacking Europe*, Museum Boijmans Van Beuningen, Rotterdam, 2001

Platform for Art
http://tube.tfl.gov.uk/content/platformforart

Jaune **Quick-to-see Smith**
Charles Lovell, *Jaune Quick-to-see Smith Made in America*, exhibition catalogue, Belger Arts Center

for Creative Studies, 2003

Julie Sasse, *Jaune Quick-to-See Smith: Postmodern Messenger*, exhibition catalogue, Tucson Museum of Art, 2004

Anne **Rook**
website _ http://thegardenofearthlydelights.com_

Juliette Brown, 'Born Elsewhere', in *Beyond Borders*, exhibition catalogue, Terra Incognita Arts Organisation at Cable Street Gallery, London, 1999; also published on http://www.ti3.org.uk/bb.htm

Georgia **Russell**
Georgia Russell: Paper Constructions & Bookworks, exhibition catalogue, England & Co., London, 2002

Zineb **Sedira**
Edith Pasquier, 'Zineb Sedira', in *Out of the Blue*, Glasgow Museums, 1997, p.23

see also as for Maria Magdelena Campos-Pons Salah Hassan and Olu Oguibe, etc.

Yinka **Shonibare**
Nancy Hynes, 'Addressing the Wandering Mind', in Salah Hassan and Iftikhar Dadi (eds.), *Unpacking Europe*, Museum Boymans Van Beuningen, Rotterdam

Kobena Mercer, *Yinka Shonibare Dressing Down*, Birmingham, Ikon Gallery, 1999

Susan **Stockwell**
Jessica Hemmings, 'Susan Stockwell: Revisiting the Colonial Project', *Surface Design Journal*, Spring 2005, pp.42–3
Anat Rosenberg, Museum and Gallery Review, *Art on Paper*, July/Aug 2000, p.60

Carrie **Mae Weems**
Mary Jane Jacob, bell hooks, *Carrie Mae Weems*, exhibition catalogue, Fabric Workshop and Museum, Philadelphia, c. 1994

Rachel **Whiteread**
Lisa Corrin, Patrick Elliott and Andrea Schlieker, *Rachel Whiteread*, exhibition catalogue, Scottish National Gallery of Modern Art, Edinburgh, and Serpentine Gallery, London, 2001

Charlotte Mullins, *Rachel Whiteread*, London, Tate Publishing, 2004

Richard **Woods**
'An installation by Richard Woods and an interview with the artist – by himself', *Modern Painters*, Summer 2003: 77

New Build An Installation by Richard Woods: Guide, 2005 (with essay by Gill Saunders)

Jennifer **Wright**
Purl: Six artists Inspired by MoDA's Collections, exhibition catalogue, Museum of Domestic Design & Architecture, Middlesex University, 2004 (with essay by Gill Saunders)

INDEX

Pages with illustrations of prints and artworks by the artists are shown in italic.

ACKNOWLEDGEMENTS

The authors are indebted to very many colleagues throughout the museum for their contributions to the research and writing of this book. In particular we would like to thank Margaret Timmers, whose curatorial expertise has been invaluable, for her advice and unfailing support; the clarity and accuracy of the text has been much improved by her careful editing of early drafts. We would also like to thank Susan Lambert, former Keeper of the Word & Image Department, who enabled the acquisition of many of the works discussed here, and supported the project from the beginning; curators in the Prints and the Book and Contemporary Sections – especially Liz Miller, Frances Rankine, Zoë Whitley, Riikka Kuittinen, Tim Travis, Stephen Calloway and Nazek Ghaddar – who initiated or advised on specific acquisitions, generously shared their expertise and enthusiasm and gave practical help; Doug Dodds, who contributed invaluable information on the history and techniques of computer-aided print. We are also particularly grateful to James Stevenson, Ken Jackson and Ian Thomas for the excellent photography, much of it involving large-scale material, reflective surfaces or awkward 3-D objects. Lee Dunne of Information Systems Services provided invaluable support, enabling us to print from Peter Halley's *Exploding Cell* website. Our thanks also to the staff of V&A Publications, especially Mary Butler and Ariane Bankes for their support and encouragement, and Frances Ambler for all her efforts in sourcing images and clearing copyright for the illustrations.

We are most grateful to all the artists and studios and many dealers for their help and generous information, but most especially to Faisal Abdu'Allah, Lynne Allen, Sonia Boyce, Maria Magdalena Campos-Pons, Paul Coldwell, James Faure-Walker, Peter Ford, Lubaina Himid, Charlotte Hodes, Peter Kennard, Thomas Kilpper, Chila Kumari Burman, Abigail Lane, Margaret Lanzetta, Cecilia Mandrile, Ken McDonald, Johannes Phokela, Jaune Quick-to-see Smith, Anne Rook, Cat Picton Phillipps, Zineb Sedira, Harald Smykla, Richard Woods, and Jennifer Wright; Judy Brodsky and all the staff at RCIPP, *especially* Dennis Hull, who was unstintingly patient and diligent, and Randy Hemminghaus, who offered invaluable detail; Bob Pain of Omnicolour and Mark Jenkins of K2 Screen; Annis Fitzhugh of Dundee Contemporary Arts; Carl Freedman at Counter; Steve Hoskins and Paul Thirkell at UWE; Rebecca Hossack; Andrew Hunt of Slimvolume; Indra Khanna; James Pidcock, on behalf of Julian Opie; John Phillips at The London Print Studio; Mei Lam Rose; Sian Weston and David Littler at London Printworks Trust, and Tina Worsley at Mulberry plc, with all of whom we had important exchanges regarding work and ideas.

We are also indebted to our fellow curators in the United States for their friendship and inspirational example: Deborah Wye and Wendy Weitman at MoMA, David Kiehl at the Whitney and staff at the Philadelphia Print Center.

Most of all, however, we are indebted to Robert Breckman, who, in memory of his wife Julie, has been a most splendid patron and without whose generosity many of the prints discussed here could never have been acquired for the museum and without whom the project could never have happened.